THROUG
PARISIAN E

OTHER WORKS BY MELINDA CAMBER PORTER

POETRY AND PAINTING

THE ART OF LOVE

FICTION

THE MALE MADONNA

IMOGEN

FLOATING BOUNDARY

FRANK

BADLANDS

TRANSLATION

BARDOT, DENEUVE, FONDA

PLAYS

BOAT CHILD

NIGHT ANGEL

THROUGH PARISIAN EYES

Reflections on Contemporary French Arts and Culture

Melinda Camber Porter

DA CAPO PRESS • NEW YORK

Library of Congress Cataloging in Publication Data

Porter, Melinda Camber.
 Through Parisian Eyes: reflections on contemporary French arts and
culture / Melinda Camber Porter.—1st Da Capo Press ed.
 p. c.
 Includes index.
 ISBN 0-306-80540-5
 1. Arts, French—France—Paris. 2. Arts, Modern—20th century—
France—Paris. 3. Celebrities—France—Paris—Interviews. 4.
Intellectuals—France—Paris—Interviews. I. Title.
NX549.P2P67 1993 93-8440
700é.944é36109045—dc20 CIP

Material on Anouilh (January 28, 1976), Brook (December 29, 1975), Carné (April 7, 1975), Costa-Gavras (July 16, 1975), Duras (December 3, 1975), Eustache (July 5, 1975), Ionesco (February 12, 1974), Lonsdale (March 11, 1976), Malle (June 5, 1974), Malraux (January 15, 1975), Robbe-Grillet (October 29, 1974), Rohmer (September 23, 1975), Sartre (March 10, 1976), and Truffaut (February 19, 1975), published in earlier versions in *The Times* of London, copyright © 1974, 1975, 1976 by Times Newspapers Limited, is reprinted by permission. Material published in earlier versions in the *New Statesman* and *The Observer* is reprinted by permission of the copyright owners.

To my husband, Joe Flicke, with love

First Da Capo Press edition 1993

Published by Da Capo Press, Inc.
A Subsidiary of Plenum Publishing Corporation
233 Spring Street, New York, N.Y. 10013

Foreword

M elinda Camber Porter in her essay on Alain Robbe-Grillet touches on the conflict between the creator and the critic. Are they forever destined to live apart? Tom Stoppard did quite a lot of damage to the critical fraternity, or at least its lower echelons, in *The Real Inspector Hound*. The public image of the critic is all too often that of the recluse, a slightly furtive figure scurrying away from first nights the moment the curtain comes down and preferably before the applause starts. Old scores are imagined to be paid off on battered typewriters. Critics are seen as Beckmessers or, put another way, just failed creators.

There are indeed those critics who would rather undergo minor surgery than meet on social or even professional terms those about whom they write. And they are entitled to live like that. Happily, other critics and writers think differently and see themselves as a bridge between the creator and the public. Melinda Camber Porter is one such.

Most of the pieces that go to make up *Through Parisian Eyes* are based on interviews. Interviewers come in varying shapes and sizes: some hector and harry, others think themselves clever enough to trap the subject into an unguarded or outrageous statement, a third group is merely content to touch the hem of the star's garment. But the best interviewers tend to be the best listeners, selecting their persons with care and then applying the gentlest of directional nudges during the conversation. And so it is in *Through Parisian Eyes*. Those who talk in these pages are, with very few exceptions, intellectuals. They have something to say and they are allowed to say it without let or hindrance, barring the regulation tape-editing. Through their words, and

Melinda Camber Porter's choice of subject, emerges the cultural life of a European capital seen first in the mid-seventies and then from the vantage point of a decade later.

At the forefront, quite rightly, is the cinema. Paris, not Los Angeles, is *the* city of film: the town where today as in 1975 there are still queues outside the first-run houses and where in much more modest premises the cinéaste can pick up movies that the rest of the world has half-forgotten. Festival Delmer Daves, Festival Jean Delannoy. . . . Whether it is through the mouth of Montand or Resnais, Vadim or Rohmer, in Paris the big screen still speaks loud and clear in *Through Parisian Eyes*.

Several pieces in this collection began life on the Arts Page of *The Times*. It is an honor to have acted in a tiny way as midwife to some of the children of *Through Parisian Eyes*.

London John Higgins
October, 1985 Executive Editor
 Arts and Features, *The Times*

Acknowledgments

My thanks go to all who appear in *Through Parisian Eyes*, and to countless others I consulted and interviewed over the years in France. I am deeply grateful to John Higgins of *The Times* of London, whose guidance and encouragement have been invaluable, and to Curtis Church of Oxford University Press for his sensitive and inspiring contribution as editor of the book.

Contents

History and Responsibility

François Truffaut
Marcel Ophuls
Costa-Gavras

For François Truffaut, 1975 was a year of fruition. Since 1966, when he shot *Farenheit 451*, he succeeded in making one film a year. In 1974, he lay fallow; but, in 1975, he would complete two films. When I met him in his offices on the Champs Élysées, he told me that the first project, *Adèle H.*, was already underway.

Truffaut described it as "an unquestionably sad love story . . . about Victor Hugo's second daughter, a young girl who is in love with an English lieutenant who does not love her, or even wish to see her. She follows him everywhere. In general there are two people on the screen in a love story, but here I show only the young girl. It's like a piece of music with one instrument." The second film, *Small Change*, is about childhood and is a mixture of true stories, culled from newspapers or provided by friends, and "fictions" that caught Truffaut's attention.

Truffaut says that he has learned from experience that the public tends not to like those films of his in which the male character is the center of attention, especially when they are his own age. He too prefers working with women and children. An apparent paradox, when Truffaut admits that in all his films he is talking about himself.

"I identify with female characters more easily than with male characters, which does not mean to say that my films are feminist." The identification with children is even more direct. "I am like a child," he says shyly, "and I often behave like a child with people I don't know. I am very slow at comprehending what is happening around me and often incapable of dispelling misunderstandings."

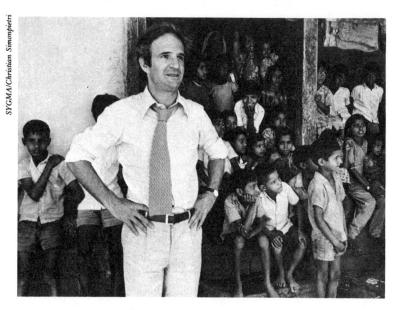

SYGMA/Christian Simonpietri

François Truffaut, as an actor, on the set of Stephen Spielberg's *Close Encounters of the Third Kind*, in India. "I am like a child," he says shyly, "and I often behave like a child with people I don't know."

Part of the fascination the cinema exerts over him stems from a wish to recapture happy experiences from his own childhood. On the whole it was an unhappy time, but watching films provided a refuge for him. He says that the shooting of films re-creates the atmosphere of summer holiday camps, one of his few joyful childhood experiences. Whether he refers to these past experiences directly, as in *The 400 Blows*, or to their transposition into the present, as in *Day for Night*, Truffaut almost always manages to incorporate in his films the joy and playfulness he feels on the set.

"One makes films because one desires to fit things together, to make people meet each other, and to create situations. It's like a child with a Meccano set, or a child telling himself a story that might perhaps interest others later on. But it's a game. If people believe that they have got a lot of important things to

tell the public, they shouldn't make films. They should say them directly."

I asked Truffaut whether he felt that the indirect communication which he prescribes is akin to lying. "Direct truth is not interesting. If one is alone and is talking to many people, as in a film, lying is necessary. In a conversation between two people you can tell the truth. You can also manipulate the person you are talking to; but conversation should be democratic. In a speech or a film you cannot be democratic because you are outnumbered. Manipulation is necessary. In any case, the cinema is a game for the person making it and the people watching it. Implicit in the rules of this game are the notions of lying and manipulation."

But Truffaut reserves these methods for his films. In conversation he is direct and democratic and his childlike spontaneity prevailed. Only at one point did a certain unnaturalness appear, when he said: "I prefer working with English actresses because they are more professional than the French and more feminine than American actresses. They also ask brutal and frank questions, which isn't done in France, and this amuses everyone on the set and makes them drop their masks. I think it might be because the English have a better education."

Truffaut's second project is a further essay in autobiography. "When the people see a child on the screen they have the impression that they are watching the child do something for the first time. There is the impression of spontaneity. There is always a second scenario that is superimposed on the written one. And it is created by the child: the process of discovering life and childhood in general. Because of this one needs few events in a film dealing with children; a script that would be boring with adults is exciting with children.

"When you film an adult you film that particular person. With a child you film that particular child *and* childhood in general. Children have a wonderful sense of reality and can collaborate enormously, not on the level of ideas, but in the execution and the details. With children one must accept the fact that the script is provisional."

And it was *L'Enfant Sauvage* that gave him two important insights into his work: that he always makes a film for very

personal reasons, and that the constant theme in his work, if he were to hazard a guess, would be the search for identity. "Even in *Adèle H.*, the main character is someone searching for what she is or what she wants to be. Adèle wants another name; she always introduces herself under another name, although she is proud of being Victor Hugo's daughter."

Truffaut's interest in himself matches his sensitivity to his audience. He feels a great sense of responsibility towards the public, especially when dealing with topics such as childhood. He says that his main concern is to respect the needs of the public—their desire for enjoyment—without presenting them with a falsified, misleading picture of life as it is.

"In a film the director gives the audience a promise of pleasure. One keeps one's promise by providing an exultant ending. The laws of the film are closer to those of a concerto rather than a novel. In a concerto there is a final movement that reunites the previous movements. In the last ten minutes of each of my films there is a rising, mounting curve upwards. And yet this promise of pleasure poses moral problems. For the rhythm, the curve of life is the opposite of this. It progresses towards decadence, decrepitude, illness, and extinction. The curve of life is descending and that of the film rising.

"I try to respect both curves in the dramatic progression. One achieves this by the manipulation of elements. For instance the last word in a speech and the last reel in a film are the ones that the audience goes away with, remembers, and is most affected by. If you conclude a depressing speech with the word 'happy,' people will remember that and leave content."

François Truffaut died on the 21st of October 1984 at the age of fifty-five. Those who knew Truffaut mourned the loss of a man whose warmth and imaginative truthfulness extended beyond his films into his life.

"François Truffaut was the man behind the scenes who got *The Sorrow and the Pity* out of its unseen role as a martyr of French censorship," said Marcel Ophuls, the director of the *The Sorrow and the Pity*, a film about the French collaboration with the Nazis. Ophuls has continued to make extraordinary documentaries, like *A Sense of Loss*, and *The Memory of Justice*, and a

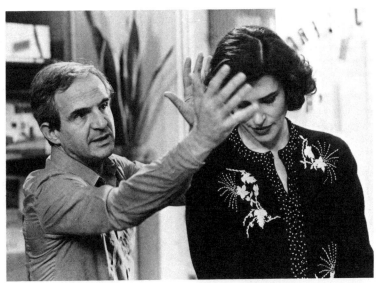

François Truffaut directing Fanny Ardant, who starred in his last film, *Vivement Dimanche* (1983), with Jean-Louis Trintignant.

feature film, *Banana Split*, with Jeanne Moreau. As we talked in Ophuls's home in Neuilly, it became apparent that François Truffaut had been instrumental in every stage of Ophuls's career. "As soon as he saw the film (I was working in Hamburg at the time, and had to send a letter to the producers to get permission to show it to him), the next morning he called me. And he talked to me about the film for a half an hour. Nothing I've read (and God knows, there's been a lot of prose about it) has ever been as coherent and intelligent and detailed. He had total recall. Practically a photographic memory. He always spoke in concrete terms, never in abstractions.

"And I had the feeling of being totally understood. Having a man at the other end of the phone understanding exactly what I was trying to do. And the message getting across, which rarely happens in show business, since success is usually based on a misunderstanding. In the case of *The Sorrow and the Pity*, that's certainly true. People think that it's a subtle film which refuses

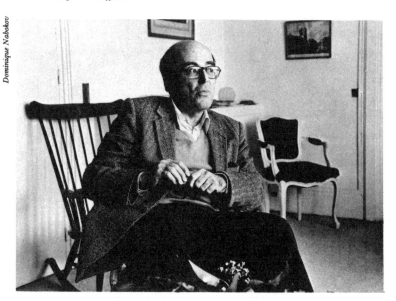

Dominique Nabokov

Marcel Ophuls in his living room in Neuilly, where we met. "François Truffaut was the man behind the scenes who got my film, *The Sorrow and the Pity*, out of its unseen role as a martyr of French censorship."

to judge people and therefore that it's very tolerant and very trendy because it refuses to judge. It's not that. It's a Western. It's the baddies versus the goodies."

I told Ophuls about the interviews I did with Truffaut in 1975. I was impressed by his gentle and kind manner. I had been taping the conversation for about an hour when Truffaut asked to hear a moment of the tape. When we played it back, all we found ourselves listening to were indistinct, slurred sounds. Truffaut took me out to the Champs Élysées and pointed to the shop where I could get the machine repaired. He immediately made an appointment for the next day, and tried to console me by saying that our next interview would be even better than the previous one. We had gained some practice. I was touched by his reaction.

Ophuls concurred enthusiastically when I suggested that Truffaut was a generous man.

"Do you want a list of how many times he helped me? Well, he helped the Ophulses and not just me. He is the man I consider to be at the origin of my father Max Ophuls's rehabilitation as a major film maker and his posthumous fame. And most of the people who have been writing criticism and film history about my father—they've all gone back to the original statements that François made, very quickly, very spontaneously, and very generously, about his discovery of Max Ophuls's work in the last years of my father's life. Then, they developed a great friendship, and I think my father was one of the people who influenced François a great deal. For François was a self-made man. He was always looking for mentors."

Ophuls pointed out that Truffaut's generosity was not confined to himself and his father. "He helped me make my debut as a film director in France, first by setting up a whole production of sketch films, which became an international project called *Love at Twenty*. And he did it mostly so that the young Rosselini and I would get a chance to direct sketches. Then, I met Jeanne Moreau through François, and I was able to do my first feature film in the 60's called *Banana Split*. At the time of the New Wave he was a very influential figure, and he used to carry round a black book. When producers asked him, as they always did, who the next young man should be to give a film to, he offered up his secret list of people. And many of the directors who made their name at that time owe their fame and fortune to François."

Ophuls, a German by birth, who later became a French citizen, is sensitive to the xenophobic character of some French people he has encountered. He appreciated Truffaut's open-minded, international spirit, which defied chauvinism. "He was not a protectionist. He was totally open. And in fact there must have been some hidden complexes in the back of his head about the Anglo-Saxon world for he was desperately trying to learn the English language. And for some strange reason, he never quite succeeded. He said he disliked politics and politicians

and didn't want to be involved. But when the chips were down, he always took a risk for something he believed in."

Ophuls defines himself as a "humanist, anti-fascist, Social Democrat," and he feels that his centrist position is rare in Parisian intellectual circles. It is fashionable to be of the extreme Left or extreme Right, and centrists are considered to be ineffectual liberals. Truffaut was one of the few who refused to follow this fashion: "He defined himself politically as a man of the extreme center. And if you know anything about France, you'll know what a wonderful statement that is. It's a statement against all the intellectual terrorists who say that only extreme people resist. It's the Social Democrats, they'll tell you, who sell out, and only Communists and Jews go to concentration camps. It's really very silly to talk of extremism as if it were purity. When he called himself a man of the extreme center he was parodying the New Left and the Nouveaux Philosophes, and other forms of intellectual terrorism, and denouncing the idea that you can only be honest if you're an extremist."

Ophuls may not hold extremist political views, but he is a man with intensely passionate opinions. He vehemently dislikes the Parisian intellectual arena and often backs up his feelings with sound reasons. But he is careful to draw the distinction between the French and the Parisian intellectual.

"Some of the Parisian intellectuals are so self-important. And you don't run across that self-importance in other countries. I mean people like Günter Grass have a pretty firm hold on reality and evaluate their importance in Western Culture realistically. The same thing with English writers. They all know that the action is no longer in Europe anymore. That's not the way in France. They don't seem to realize that they're operating in an empty shell. That the only nice and attractive thing left in Paris is the architecture, which is left over from secret harmonies which are no longer there."

I asked Ophuls why he would live in Paris if he felt this way. "I don't have any roots. But I have ties. I am an outsider, an observer of the thing, and I know the passwords. But I don't use these intellectual passwords because I don't like them. But the French are part of my life. I also have very deep ties to the Anglo-Saxon world and to America. I have traditional ties

through my mother and father to Germany. But I hold an American and a French passport. I do have a cosmopolitan approach to French life, and I'm deeply sceptical of the French variety of intellectual nonsense."

Ophuls does, however, feel that the intellectuals' current obsession with the French wartime collaboration deserves respect. *The Sorrow and the Pity* was the first of many films to deal with this period in French history. Later on, novelists and directors followed suit. I asked Ophuls what he thought of films like Costa Gavras's *Section Spéciale*, Louis Malle's *Lacombe Lucien*, and Losey's *M. Klein*, and of writers like Bernard-Henri Lévy, who deal with this subject matter.

"Well, *Lacombe Lucien* was rather ludicrous. And Bernard-Henri Lévy, the writer, and I had a disagreement in public over the collaboration. I told him: "I think you're making a mistake by assuming that Jews are rootless because we are condemned by anti-Semitism. And, in your theory of the French collaborationist mentality, you add that you like parking lots but don't like the countryside, and you put in the list of 'anti-Semitic' attitudes everything that is threatening to you personally in French traditions. Now as long as you do that as a young French Jew after Auschwitz, then it's fine. If you make it a personal statement. But you make it a general theory. And you end up looking silly, when you make remarks against the French countryside and collaborationists all at once.

"I basically said to him, 'So maybe you don't like trees. But what has that got to do with anti-Semitism?' But that doesn't mean that I don't agree with him on a lot of things. I do agree with him more than with Régis Debray, with his talk about America being responsible for everything that's bad in the world. As if it were the successor to the Nazi party. Really. I've had it. I found it murderous. The young Lévy is quite harmless in comparison to Debray."

Régis Debray drew an analogy between certain Parisian intellectuals' "collaborative" infatuation with the United States, and the French collaboration with the Nazis during the Second World War. He has suggested that American culture is a form of imperialism that will overwhelm French culture. Bernard-Henri Lévy, however, loves America, and uses the wartime

collaboration to point to a continuing streak of racism in the French character. Ophuls does not come to any of these conclusions. But he does feel that it is a healthy sign that the past is now open to discussion.

"One thing they are right about is that they have come to recognize the central importance of the collaboration. And it is a symbol of their behavior in crisis. For instance, I think they now know that Sartre had a "Lord Jim" attitude toward life. It took them a long time to realize that Sartre did not resist. And I think Bernard-Henri Lévy and Régis Debray would agree on this point. It's a particularly acute problem in France, the collaboration, because it has some special aspects which you don't find in Denmark or Holland or even Italy. Italy was a fascist country but it did not collaborate in quite the way the French did. And this goes back to the Dreyfus affair, and to L'Action Française. I mean, the French landscape was already prepared for the Munich crisis, including the Right and Left: they were pre-collaborators. They were laying down the foundations for what they did later.

"And so they are right when they finally recognize this as a central factor in their lives. In the way they determine themselves and their behavior, and the way they judge themselves. And now, they ask themselves, what would I have done if I had been in my father's shoes during the Occupation? I think it's basically a sane reaction. Because it has been the most acute crisis the French have faced in the twentieth century. So when I say that Henri Lévy and Debray are wrong, all I mean is that they're wrong to take themselves so seriously. But when they talk about this collaborationist mentality, I feel they are making an important point, even if I don't agree with many of their conclusions."

I was aware that Ophuls could appear to be a rather disgruntled man, particularly when he damns certain writers and trends. And yet his tone was good-natured, rather witty, and self-mocking, and he had been encouraged to continue in this vein for I was laughing with him. We began to talk about the ethics of interviewing.

"You do not use individuals' lives or individuals' statements or the reflection that they give of themselves as objects or tools. So you do not script in advance. You don't say, 'We're going to

go and see so and so because he'll tell us about this or that. Right. And that's where the big difference is between making a feature film and a documentary. An actor has been paid to be put into a fictional situation. And paying actors is the least exploitative way of going about making a film. I don't like documentaries and I often don't like documentary filmmakers. Nor did my father. For actors are professionals who create an illusion which then tells us something about the truth or reflections of a reality. That's wonderful."

Ophuls wanted our conversation to move along freely, without paying attention to the prepared questions. At one point I asked Ophuls whether we should continue talking about the collaboration or move on to another question about documentaries. "Well, you know," he answered, "this is a very interesting set of questions and things bounce off. We can keep that question in mind and come to it later, but let's stay with topics as they come up spontaneously, if you don't mind."

He went on to tell me about his many discussions with François Truffaut on the ethics of filmmaking. "You begin to realize that there are forms of self-expression that are harmful to others. And society must find a way to cope with forms of self-expression, like murder, that are harmful. That implies a form of censorship. But nobody is sent to jail because they make a film that's harmful. So what we have to do, as filmmakers, is to create some form of self-censorship. All intellectuals consider self-censorship nonsense. We're used to thinking that self-censorship is terrible. Or that you're a coward if you apply it to yourself. And the interesting thing about François Truffaut's attitude—and it was typical of his turn of mind—was that self-censorship is nothing more than a sense of responsibility. You have to assume responsibility for what you show in the mass media. Of course, one should be against government censorship. But much of the talk against censorship nowadays is really a flight from taking responsibility for what you show the public."

Ophuls is aware from his many years of documentary filmmaking that when one deals with factual material, one is never dealing with a given reality. Each cut and juxtaposition of the footage changes the material and expresses the director's vision. Ophuls does not pretend that his finished product contains no

personal judgment of the material. But he finds himself working within severe restrictions when he uses people, not actors, to tell a story. He would prefer to make feature films for this reason. And he is also tired of dealing with the harrowing subjects he has worked on for so many years—France during the Occupation, Nuremberg, Northern Ireland—and now he might make a film about the Barbie trial.

"I am a French comedy movie director by nature and by inclination. I never volunteered to make *The Sorrow and the Pity*. There was no inner urge in me to confront these issues. It just happened because I had a flop, and I went into French television, and got into reportage which had nothing to do with the Nazis or the Third Reich. And then, the producers had on their hands a project of contemporary history which turns into three and a half hours on the Munich conference. *The Sorrow and the Pity* was just a follow-up on that. People always assume I wanted to make *The Sorrow and the Pity* because I'm Jewish and because I lived at the beginning of the Occupation. And because my father was a refugee. No. The answer is that there's something special in the way I handle the material because of my background."

Ophuls is not sure that films like *The Sorrow and the Pity* necessarily have an important function. Of course he hopes to bring an increased awareness to his audience, but he does not enjoy working on films that deal with the most brutal sides of human nature. "I often ask myself: What is the social function of people who are in this profession? People who make films like *The Year of Living Dangerously* and *Under Fire*? I suppose I try, through subjectivity and storytelling, to break through barriers so that people will have some temporary insight. But I'm aware that insight can be based on total misunderstanding."

I asked Ophuls the obvious question: If he was so keen to direct feature films, did his father's presence as a celebrated film director influence, surreptitiously, his shift to documentaries?

"Let's not get into psychoanalysis," he said, "even though it's very difficult in this case to get away from it! I originally went into movies, or rather I dropped out of the Sorbonne in my last year and became an assistant director, because I was fascinated by my father's world. As a teenager, I saw my father

as living in a world that was not so very different from *Photoplay*. A rather naive view, I admit, of making movies: That it would be fame and glamour and so forth. My father tried to keep me out of show business as much as he could. And it was hard because I was growing up in Hollywood, and going to Hollywood High School. He didn't want me to go into films.

"He was also very pessimistic about the future of films. He felt that all he loved about making movies would be drowned by market research. Oh, there's an article which he published in François Truffaut's weekly. It was in connection with *Lola Montès* and Madison Avenue. And all that. Yes, he foresaw what would happen to Hollywood. He was a very brilliant man. I am a great admirer of my father's work. I think he's one of the great filmmakers of all time."

Ophuls asked if I would like to return to my initial question, which we had not discussed fully. For we had moved from one topic to the next, allowing ourselves to discuss whatever surfaced. When I had initially asked Ophuls how a documentary film-maker manages to present a spectrum of viewpoints, and still present a coherent vision, he had replied: "One must not tailor other people's opinions to what you think they ought to be or to what will fit in with your point of view or prejudice. I try to maintain a point of view throughout these marathon documentaries, and make it clear to the audience, partly by letting them know the questions I ask. And I often keep questions in so that I will show that my point of view is—let's call it a humanistic one. And I hope that my point of view will come through by the way I juxtapose sequences. And it's very important in the selection of people you use in a documentary, and in the way you juxtapose them, that you watch yourself carefully, and never use them as instruments of your own propaganda. And the best guideline is usually entertainment. If you use show-business guidelines, that's often the best way to guarantee that you don't use them as pieces of a puzzle to bring out some sort of political message. And when you do interviews, you mustn't create a sort of complicity with the person. That's bad for documentary work. You should avoid traps, too. so what is the best way of doing it? The way of doing it is having conversations. I suppose."

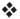

"Since *Z* and even before, I have been making films about the relationship between men and power. One could, I suppose, call it politics. But what fascinates me are the mechanisms invented and set into motion by men which escape their control and end up by controlling them," said Costa-Gavras. In his film *Section Spéciale* (1975), he illustrates his central theme with a particularly provocative and uncomfortable epoch of French history: on August 23, 1941, at the instigation of the Minister of the Interior, Marshal Pétain's government promulgated a law creating the "Sections Spéciales," which had the authority to judge communists and anarchists. The law was not only retrospective; it also gave the judges the power to condemn to death any individual, without specifying the crime. Five days later, six men with minor criminal or communist records were judged and guillotined the next day.

Admittedly, the government was under pressure to pacify the Nazis after one of their men had been killed by some young members of the Resistance. But Costa-Gavras was fascinated by the fact that the most prominent and respected magistrates and judges were chosen and accepted to participate in this mockery of justice. For it revealed that, under pressure, even the exceptional human being could choose to follow the orders of superiors rather than the dictates of his own principles.

Although Costa-Gavras blames society and the hierarchy of power, he shows how the problem initially arises out of human nature: "One cannot separate politics and human nature. I was not making a film about justice and power, but rather about the men of justice and the men of power. And the type of power that was used in Vichy is still used today. At Bordeaux a magistrate who saw the film told me he was at a loss without orders from his superiors. And having spoken to magistrates all over France I began to get an insight into an extraordinary topsy-turvy world. But one can relate the particular problem of

Vichy to a more common, familiar problem, that of personal responsibility. The fact that one accepts or refuses to do something that goes against one's principles. For example, you may eliminate or stress certain things I say for reasons that might not be your own."

Strangely enough, Costa-Gavras referred to this activity of selection and elimination to justify the methods of narration he employed in the film. For he and Jorge Semprun created a dramatic and exciting spectacle out of Hervé Villeré's thoroughly documented but undramatic book on the "Sections Spéciales."

And it is questionable whether Costa-Gavras should use the powerful rhetoric of fictional devices, humor, and hallucinatory images when he presents the film as an honest and accurate statement of fact. Costa-Gavras agreed that the particular subject merited a documentary treatment but continued, "it would have been impossible to make a more documentary film. Most of the participants are dead and those who are alive would talk rubbish. In any case, it is necessary to extract the essential and to reduce the material to human proportions. And the Ancients always used the power of the spectacle to communicate their philosophies and beliefs."

When I asked him why he had made liberal use of farce rather than irony when dealing with a subject he took seriously, he replied, "If there is humor and caricature in the film it is because it is there in the story, and it was not imposed. But the main reason the audience laughs during the film is more complex. Because we have participated in similar or comparable situations in our life, we reject the spectacle by means of laughter. It is a way of exorcizing oneself."

But when I persisted, Costa-Gavras admitted that his film could not give a totally accurate analysis of the subject. "It's impossible for a film to give a perfect analysis of a problem, at least for the moment. Films are closer to dreams. When we try to analyze the relationship between the images of a dream we find no logical link. Images do not have the same power of explanation as words." But Costa-Gavras's film version of the "Section Spéciale" has gained more attention and a larger audience than Villeré's treatment of the subject. Does the image,

because it is closer to dreams and is less susceptible to reason and logic, have a more immediate and forceful effect than words?

"What is a film in society? It is less than a book because a book lasts longer in one's memory and takes longer to digest. A film has a short life. And the reactions that it provokes must be strong enough to allow it to last longer than its life on the screen. Explosive reactions force one to reflect and consider afterwards. And that is why I chose to make a film about Vichy: it provokes violent reactions because there are many survivors and because the true story is just beginning to come out into the open; the attitude of the French is astounding. I have been to see the film all over France. People have walked out in a fury. The reaction has been violent in every way."

But Costa-Gavras is perhaps optimistic in believing that violent, emotional reactions inevitably lead to reflective judgments. Or perhaps he was generalizing from his own experience: "When I came to France from Greece at the age of eighteen my first reactions to life were brutal, superficial, and unreflective. I had come from a badly educated country. Then I had studied in France, and I learned how to think and make films like the French. I began to reflect. But the two personalities are still there. One can't get rid of eighteen formative years. It's probably the Greek part of myself which causes me to make films that lie outside current trends in France. Because I am a stranger I see things from a distance."

But the Greek part of Costa-Gavras was certainly not in evidence. Throughout our conversation he spoke in a calm, controlled voice, never became irritable when contradicted, yet rarely smiled or laughed. When he said, "For me Vichy was the Middle Ages, the most monstrous epoch we have known. In my view one must condemn it outright and at all costs," he continued to speak in the same measured tone and his expression betrayed no emotion.

In 1985 Costa-Gavras was preparing his American-financed film, *War Days*, to be shot on location in the States. He has been the director of the national film institute, the Cinémathèque, for the last three years, and is therefore responsible for part of what the French call their "patrimoine," or heritage. For the

French, "le patrimoine" has a plethora of associations. But perhaps the most crucial aspect of a national heritage is that it should be preserved, and should retain its specifically French characteristics. Jack Lang, the Minister of Culture, asked Costa-Gavras if he would be willing to oversee the Cinémathèque. Costa-Gavras, who is Greek and came to France at the age of eighteen, is a shining example of a foreigner who was welcomed and accepted by the French.

He describes his early days in Paris: "When I arrived in France, I discovered culture. For I'd come from Greece, and the culture there was medieval, and very backward, because of the political system and Civil war. My first reactions were very impulsive, very Greek, and very primary. I plunged into Parisian daily life, with its immense possibilities, in all domains. . . . I spent the first years here like someone who was drunk. I became an alcoholic of French culture. And it's here that I learnt everything I know. There was an empty space in me, when I came from Greece, for I lived in very tough conditions, in a poor village during the Occupation, and I'll never forget those days. It's true, that like many foreigners who take on French citizenship and who live here, one can become nationalistic and chauvinistic very easily. One has to be careful."

Costa-Gavras studied literature at the Sorbonne, but he inter-rupted his studies to enroll in L'Institut des Hautes Etudes Cinématographiques (The Institute for Film Studies), or L'IDHEC. He made friends easily, and soon became part of a circle of filmmakers and writers. Yves Montand and Simone Signoret were part of this clique, and they helped him to get his first film made: "In a city like Paris, which is so large, one finds oneself living in clans. Or in microsocieties. I found myself in one of these groups, and it's true that I was very influenced—even in the kind of films I make—by these friends of mine. Simone and Yves were wonderful to me. I happened to be René Clément's assistant at the time. I came across a book called *Sleeping Car Murders*, and just for fun, without having the right to the book, I wrote a scenario of the book. I gave it to Simone to read, and she said, 'If you like, I'll play the role of that actress—if it'd amuse you.' . . . I was very surprised. And Montand said, 'You've written a very good scenario. So, tell me,

which role shall I take?' I told him he could choose. So that's how it happened. The film went into production just like that. And so thanks to them, I made my first film, thanks to their friendship and their acceptance of me."

But before he directed *Sleeping Car Murders*, Costa-Gavras had served his apprenticeship as an assistant director. He had worked for Marcel Ophuls on *Banana Split*. "I enjoyed working with Marcel. It went very well, and we have remained friends. At least, I hope we have. Because I like him a great deal, and I admire him. I think it's mutual. He's made the most extraordinary films, and he's a man with deep passions . . . but it's hard for him being the son of such a famous man, like Max Ophuls. It's terrible to be the child of someone famous. I can see it happening with my own children. They'll have problems . . . and yet I think Marcel has freed himself from these complexes, because he has made films that bear the stamp of his own personality. But, you know, I think he should not try to make the kind of films he makes in France. I don't think it's the right place for him."

I did not quite understand why Ophuls' films were harder to produce in France than elsewhere. Admittedly, he had made films about the collaboration, but the topic was now in the open. And Ophuls was more interested in making features than documentaries. "Well, in Paris, you have to sell yourself. You have to be your own public relations person. And you have to have a loud voice, and make your worth known. Marcel, like many other people, doesn't have that mentality. He does wonderful work, and he doesn't shout about it. And because of that many people have tried to appropriate his work. Do you know that with *The Sorrow and The Pity*, there were people who played a minor role in the film who told everyone that they had actually directed the film! And they didn't even mention Marcel. . . . And he is a modest man, and so he didn't do anything about it. But, you know, Parisian life can be very difficult."

I wondered if Costa-Gavras was referring to the verbal cruelty and personalized debates that are fought out in the media. I often had the feeling in Paris that intellectual debates had taken the place of sports. For the intellectuals are usually interested in defeating the opponent, and winning the argument, rather

than in discussing an issue. There is little sense of fair play. The debaters often use ammunition of a personal nature. And the fights continue in private as well as in the newspapers and on television.

"I think you've given the answer that I would give," said Costa-Gavras. "I think that the duel with a sword or pistol has evolved into intellectual debates. In a sense, it's a form of progress. For it's better to attack people verbally than to kill them. But there are victims. And, I actually don't participate in these media debates, because it's rather sterile. But the problem is that there are some people who don't have the capacity to reply to such attacks. And you can be destroyed when you don't reply with the same dexterity as your opponent."

Costa-Gavras is also aware of an evolution, and improvement, in French attitudes towards immigrants. I was rather surprised, for at the time of our conversation, there were increasing incidents of violence towards Algerians and the popularity of Le Pen (a politician whose views can only be described as racist) has grown. Costa-Gavras pointed to the younger generation as the source of hope.

"I believe that the problem is that the French have never mixed too well with strangers. And an example of this attitude was the awful anti-Semitism during the Occupation. Now they treat the Arabs and the Turks in the same way. But now it's different because there are millions of people who are living in France who are not French, and they will not be leaving either. The French will have to get used to it. They haven't yet. But I feel optimistic about the problem. For I think they will have to get used to it. And I've discovered a whole generation of people in their early twenties who don't have a racist mentality. Young people understand that the Algerians are French. There are two to three hundred thousand Algerians who were born in France in the last twenty years, and they consider themselves to be French. It's irrational to think they are not French. I really believe that assimilation won't happen through the foreigners adapting to the French. I think it'll happen the other way around. The French will be assimilated by the foreigners. Because if they don't it'll be the French who have to leave France."

Costa-Gavras and his wife produced a film for a young Arab writer, Mehdi Charef, of his novel *Le Thé au harem de Archi Ahmed*. The film, entitled *Le Thé au harem d'Archimède* (*Tea in the Harem* in English), won the 1985 Jean Vigo prize. "When I suggested that Mehdi direct the film, he didn't leap at the opportunity. He asked me to give him two weeks to reflect. I was so impressed by his reaction, and it gave me even more confidence in him. And so I produced the film with my wife. And it turned out beautifully. You should see it."

Costa-Gavras feels that cultural differences need not lead to hatred. For, in Costa-Gavras's mind, a "cultured" person is a tolerant person. By "culture" Costa-Gavras seems to mean an individual's understanding of himself and the world. But he fears that the modern world pays little attention to the evolution of individuals, and judges progress in terms of economic growth. He feels this problem is particularly acute in America, and this perception will be one of the themes of *War Days*, his American film project.

"The best part of man is his mind. That's to say, his 'culture.' It's his capacity to make himself more aware and happier—if happiness existed—and his capacity to cultivate his mind. That is progress. I think it's a catastrophe when people call progress material gain. And this attitude leads to a kind of fragility of the human spirit. One can't improve one's life by buying more fridges and houses in the country and by putting more money in the bank. You can only improve your life by reflecting on yourself and the world around you. And the more our societies devote themselves to some kind of materialistic perfectionism, the more fragile man becomes. In any case, the world is fragile. It'd take three terrorist attacks to stop the world. So, the need for understanding between people, and an understanding of oneself, is absolutely essential to the world right now. That's a little bit the meaning of *War Days*."

Costa-Gavras feels that the United States epitomizes this obsession with materialistic growth. France may share a similar attitude, yet he feels that political extremism is now the main obstacle to progress in France.

"If we take it a little closer to home, we can see that the real impediment to understanding is extremism. People catalogue

you as being Left or Right Wing. Automatically. And that makes absolutely no sense. . . . When I look at what's going on in France at the moment, I feel I'm living in the most underdeveloped country in the world, because everyone is always arguing about politics. But none of it actually makes much sense. There are so many different parties and debates on television. I've always tried to distinguish myself from this kind of fanaticism. It's a dogmatic fanaticism.

"What does it mean to be Left Wing in France today? What is one? A communist? A socialist? For instance, I sometimes agree with the socialists, particularly with their attitudes toward culture, and the importance the government gives to culture. Fine. But I don't consider myself to be Left Wing. And I don't define myself through some of my political opinions. I think we need to have a spiritual attitude—and I don't mean a religious attitude. In any case, religion has often put a halt to cultural development. And my mother was a fanatic Catholic, so I've had experience of that. No, I'm talking about the inner world. Man's spirit, or his mind. If we don't nourish that, we're heading straight for a real catastrophe in the world."

Costa-Gavras believes that Mitterrand's government has recognized the crucial importance of culture to the nation's well-being, and not only because the government has spent more on the arts than any previous government. He feels that the socialists understand the value of culture in a way that Giscard's government did not. "I think the government's cultural project is important even if people put it down. The first gesture the socialists made was to increase spending. And they've had excellent results. But culture, or at least my definition of the word, implies the capacity to talk to the Caledonians, rather than bombarding them. It's the capacity to discuss a problem, rather than taking a violent solution."

So Costa-Gavras, finding himself in agreement with the government's cultural policy, decided to accept the position as director of the Cinémathèque. It is not a post with a salary, and Costa-Gavras goes into his office once or twice a week. "I decided to take the job because the Cinémathèque was dying. We know that in England you have the British Film Institute that does a superb job. So, I told the Minister, Jack Lang, "I'm

going with you to London, to show you the BFI. You should see what the British have.' And I took him and said, 'You can't allow France to have less than that.' And he poured in lots of funds into the Cinémathèque, so, soon, we can be as proud as you British are of your BFI."

Costa-Gavras went into some detail as to the improvements he is in the process of making. "There wasn't any real library. We had about twenty thousand nitrate films, stored all over the place—in friend's houses, in castles—and now we've put them in safe conditions where they will survive, and we're doing the inventory of what we have and storing it in a computer. We manage to restore about one hundred and fifty nitrate films a year. Also, the library was opened at the Palais de Chaillot, and there are about six thousand visitors a year to the library. It's much easier to do research now. And we have the intention of opening a very large film center which would be ten times as big as what we have now. And I think the President had just given the go-ahead, so we will be able to start moving in a year from now."

Costa-Gavras has the ability to see the merits and the beauty of different cultures, while maintaining a critical perspective. He evidently feels strong emotional ties to France and wishes to help preserve her heritage. I sensed a deep excitement when Costa-Gavras spoke of his work at the Cinémathèque. And I also heard the same enthusiastic tone when he spoke of working in the U.S. Although he made the American-financed film *Missing*, and has experience working with American actors, the film was shot in Mexico. This is his first film to be shot in America.

But unlike Louis Malle, who left France in order to live in the United States and make films there, Costa-Gravas does not feel that he needs to make this move in order to make American-financed films.

Costa-Gavras is aware of his own limitations. He is not capable of making a film about contemporary American life although he has spent time in Hollywood and elsewhere. Rather, he will use the device that worked so well in *State of Seige*. The film is about a small group of individuals who could be living in almost any Latin American military dictatorship.

"I wanted to spend a lot of time in America before shooting a film there. Because it's so difficult to capture the American mentality. But, luckily, I chose *War Days*, because it's a completely unusual situation and nothing to do with everyday life. It does, of course, contain some of my thoughts on the States, but I've taken a moment in time when ordinary life is destroyed."

I told Costa-Gavras that I felt it was impossible to even try to talk about "an American mentality." For the attitudes vary in each state and each district, and the country is too large to generalize easily. He did not agree: "Nevertheless, all Americans belong to the same nation and there is an American nationalism. I feel there's a permanent search for security in the States. Security in terms of money, and a future, and a house. . . . I think there's also a refusal to accept that death is part of life. They work as if they are going to live for two thousand years. And when I lived in Hollywood for eight months, the most curious thing happened to me. I realized that I was only aware of what was going on inside America. I felt that the world outside was this vague cloud, and I could only picture America. There were certain parts of the world, like Israel, that were in focus. But I felt, fundamentally, that America was the only place on earth."

He feels that America is the perfect place for his story because it is a society obsessed by materialism. I felt that his comment could equally apply to any country in the world. The fact that the American economy appeared to be strong was no reason to suppose that American were more obsessed than other people with their economy.

Costa-Gavras explained that he was only using America as a symbolic place. And he agreed that materialism is a problem worldwide. His story shows what could happen if the material benefits of a Western country were suddenly eliminated.

"The book *War Days* is a sort of extrapolation on . . . the effects of a small-scale nuclear attack. It would be very limited. That's to say in America there would be maximum of fifty million deaths. Two or three cities would be destroyed but the rest would remain intact. But the whole electromagnetic field would be destroyed. There would be no more television, or fridges, or kitchens. . . . And I've focused the script on a family.

SYGMA/Christian Simonpietri

Costa-Gavras directing Sissy Spacek in *Missing* (1982). "Making a film is a sort of symbiosis with another person."

One doesn't know what's actually happening outside their own experience of this situation. They have to make a journey from New York to Los Angeles, because Los Angeles hasn't been hit. So it's not about America, but rather about some Americans. And it could actually happen in any society in the West. It couldn't happen in the Third World, because they are used to surviving without material goods."

Costa-Gavras added that he does enjoy the benefits that come with making films in America. "For us film directors it's paradise. When we arrive we're given hotels, cars, and all that. For a director, it's ideal on a materialistic level. But I'm not talking about the creative side, which is different. American companies seem to see directors as people who bring in a film on time on

budget. They don't see him as a creator. But I've been lucky with my producer and the people at Universal. They are interested in creating a work of art, not just a product that sells. I've also asked if I can work as I do in France, without a huge crew. And they accepted. I will have an American crew, and a few people from France . . . I'm used to working with.

"Actually, American cinema had a very decisive influence on me, and my whole generation. . . . Hollywood, and the stars. . . . I'd say that for a film director going to Hollywood is rather like going to Mecca or Jerusalem for someone religious. And I am a little religious about the cinema. I am a believer. But, you know, I did something rather revealing when I was out in Hollywood for *Missing*. I asked my producer to get me a return ticket. And I kept it in my pocket all the time that I was there. In a way, it was a joke. But I still feel that I want a return ticket, even though I want the ticket to Hollywood."

Costa-Gavras did not find it very different working with the American actors, Sissy Spaceck, Jack Lemmon, John Shea, and Melanie Mayron, on *Missing*. They soon became friends. "When you're working with people who love what they do, things usually go well. And a film is a sort of symbiosis with another person. You always leave a film with new friendships, and a backlog of new experiences. I think one actually becomes a better person—not in a Christian sense—but perhaps in what I call a cultural sense. Of course, you have to like people to start off with. You have to focus on their good qualities. Because people always have characteristics you can criticize. But once you've made that move, then . . . you know, I think it's one of my weaknessess, my wish to like people. Because what does it really mean? . . . it probably means, deep down, that I want to be loved."

The Theatrical Establishment in Renewal

Jean Anouilh
Jean-Louis Barrault
Eugène Ionesco

The pitfalls of quoting and synthesizing a conversation become apparent when you talk to Jean Anouilh: to communicate the wry humor, the tone of good-natured resignation which accompanies his remarks, would demand a dramatic representation. Sitting in the lobby of a Lausanne hotel, he is oblivious to the reaction his views provoke in the curious spectators. It is difficult to tell whether he intends to set himself up as a fall-guy in order to criticize a society in which he has served and from which he has exiled himself.

"I am played in private theaters, so I write for the bourgeoisie. One has to rely on the people who pay for their places; the people who support the theater are bourgeois. But this public has changed: they have such a terror of not being in touch, of missing out on the fashionable event that they no longer exist as a decisive force. I think this public has lost its head. They now say that a play can't be that good if they can understand it. My plays are not hermetic enough. It's rather Molièresque, don't you think?"

Anouilh might laugh at the foibles of his public, but his exile in Switzerland suggests a refusal to comply. He once referred to the audience as the most important actor in a performance. Disillusioned with his principal actor, one wonders to whom he addresses his plays. His past successes have been assured a public by being incorporated in school syllabuses throughout the world. But he no longer writes for the bourgeoisie or any avant-garde.

"Intellectuals bore me. They have their private, exclusive language. I can understand them, but I think the theater is a

rudimentary art because it is collective. It's not the same as addressing a reader or the audience in a cinema. Past dramatists, including the Greeks and Shakespeare, have known, by instinct, that the theater is not a hermetic art. Even the great ancient philosophers try to express themselves clearly and simply. The mind is still the same instrument and the Greeks knew as much about human nature as we do."

Anouilh, out of sympathy with modernist theater, fraternizes with his mentors, replacing contemporary gossip and cabal with historical anecdote; he talks of Molière as if he were a close friend. Every generalization takes flight in a detailed hagiography of the playwrights he learns from and feels obliged to measure himself against. But his easy familiarity with the past can get him into difficulties with his contemporaries:

"Nowadays, imbeciles think intelligently; one can appear to be intelligent in modern terms while remaining essentially stupid. The intellect has been popularized and mass-produced. Once it was reserved for the innately intelligent people. Engines should only be made for the Rolls-Royce. I'm not a socialist and I come from very simple origins. That's not in good taste nowadays, is it?"

Anouilh's reverence for views that were once conformist transforms him into an outcast and rebel. His inability or refusal to voice views that are acceptable to contemporary society makes him appear to be a writer coming before, rather than in advance of his time. But this does not mean that his views are any the less subversive.

"I do not use the instrument that is used for thought. I work by instinct; I never intend to communicate a defined idea. I never know what will happen in my plays; they aren't reflective, serious, or thought out. When I've finished a play it doesn't obsess or haunt me afterwards. It's a job, and that's how Molière and Shakespeare saw it. I get irritated when people call me a man of letters. I have a defense mechanism against the world of literature. The idea that I make a living by exposing my states of mind is very disturbing for me. Aristocrats, in the past, shuddered at the thought that they might be classed as writers."

This heretic form of traditionalism is revealed in his play, *L'Arrestation*, which was showing in Paris at the time of our

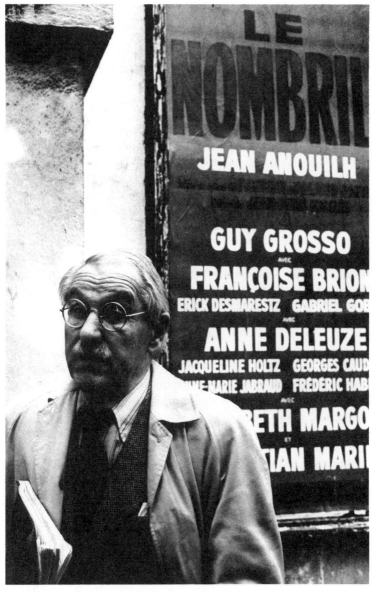

Jean Anouilh returning to Paris briefly from his exile in Switzerland.

conversation. He attempts to reinterpret the Day of Judgment in his own terms, which disregard atheistic and Christian doctrine. He approaches a disquieting subject with supreme calm and reassurance. Humor, which he uses as a weapon in both his life and work, alleviates the macabre plot: one learns that the action is merely the imaginings of a criminal in his death agony. But it is a double-edged wit which prevents the audience from aggrandizing and elevating the problem of death. One is even more surprised to learn that Anouilh derived such fun from a tragic moment in his own life:

"At my father's deathbed I said to myself that he was sinking into the interior of his last dream. He was smiling happily. I see no reason why one has to give up one's last second of consciousness. I believe sincerely that one can live forever that last moment of one's life; but there is an operatic side which transforms the worst horrors. The theater allows everything to become a game. In the theatre, you lie for nothing. The actors mime the feelings they do not feel. It's a religious phenomenon—a ceremony of lying. But it resembles the games of a child. When children pretend to be ill to avoid going to school, they are indulging in a lie that is close to the theatrical lie."

Throughout his career, Anouilh has tried to persuade his audience that he is like an irresponsible child, having a good time, or a conjuror who is able to move puppets but never ideas; in the last resort, he refers to himself as a shoemaker, except that he happens to make shows, not shoes. This attempt to absolve himself of responsibility for his views might be intended to save the public from feeling the need to listen to justifications or critical interpretations. But it becomes more suspect when Anouilh tells one that he is intoxicated by the power he experiences when watching his plays performed.

"What is so marvellous about the theater is that you have a group of people with different fantasy worlds and lives and you impose another reality on them. You impose a reality that is not real, but you make it real for a group of people. They abandon themselves to a collective reality. It is only possible in the theater. With a book or a film you 're-read' your fantasies in solitude. I am often ashamed of the feeling of power this gives me."

Indeed, during the Occupation, when *Antigone* was performed, Anouilh managed to create a collective experience for people with very different fantasies and lives: both the Resistance and the Nazis thought that Anouilh was on their side. Anouilh will not take a stand on this matter. Such an extraordinary and extreme situation does, however, highlight the disquieting implications of his playful stance:

"When people ask me whose side I was on, Antigone's or Creon's, I can't reply. To write a scene convincingly you must be on both sides. You must be two characters at different moral poles."

Yet again it is the distant past which offers an explanation and gives an authenticity to Anouilh's apparently hypocritical position: the most traumatic and terrifying experience was coupled with a fortuitous, but extraordinary joy. In his formative years, two poles of experience became indissolubly linked. He relates one of the few memories of childhood which returned to him very recently: for the first time he became conscious of his motive for the method of writing.

"My mother was a musician and so I would go to operettas every evening, for about four years. I still know all the scores by heart. I still see the theater through the stereotypes of these operettas. Anyhow, one evening I was taken to a puppet show of *Romeo and Juliet* and I stayed out in the cold too long and caught a fever. I nearly died. But during the eight days of delirium I relived continuously that puppet show. And the images recurred with less violence throughout the forty days of fever. I think that the extraordinary shock of seeing a puppet show prolonged and realistic during the eight days of a mortal fever imprinted me with this desire to write plays." ❖

J ean-Louis Barrault has had the most extraordinarily unfortunate destiny when it comes to finding a theater. When in 1980 the government forced Barrault to give over his theater at the Gare d'Orsay to be converted into the Museum of the

Ninteteenth Century, I was not surprised. A more dramatic upheaval had occurred in May 1968. André Malraux was Minister of Culture and until then a supporter of Barrault and his work. Barrault was nonetheless dismissed as director of his theater at the Odéon for showing solidarity with a group of students who occupied it in May 1968. Barrault wrote up this incident in his autobiography, *Souvenirs Pour Demain*, and though he devotes pages to describing Malraux's early support of him, he passes over the betrayal in silence. When we met, for the first time, at his new theater at the Rond Point off the Champs Elysées, I asked him whether he did feel anger over his misfortune and why he had decided to pass over his reaction in his autobiography.

In response, Barrault voiced an opinion that I have often felt to be crucial to an artist's work: "It's my modest conviction," he said, "that you cannot make a positive criticism of people, unless you love people. First, it must be an act of friendship. Anger is a feeling I don't have. Because you are asking me an important question, I will tell you: I lost my father when I was very young, during the First World War. And so I was eight years old when I encountered death. And I also experienced a feeling of solitude. And I also knew what it was to be alone, since I didn't have a father. And it was then that I became two people. That's to say, I belong to the race of people or animals who can live, and simultaneously, watch themselves living. At this precise moment we're both looking at each other, as if the other person was a spectacle. It's just like that. Except one looks at oneself.

"So, I am a spectator of my own life. And when an accident happens, like a railway crash, like May '68, I'm not going to bear the world a grudge, as if I were God. When there's a disaster, all I try to do is extricate myself from it."

Barrault is true to his words. He has always managed to extricate himself from disaster, and there is no sign of bitterness in his demeanor. He is a friendly, and ultimately comforting person to talk to. Age has not worn out his enthusiasm, or his energy. His first concern when we met was to make sure I was at ease, so he asked me to lead him to the part of the theater where I would feel happy conducting the interview. A few nights before, I had seen his adaptation of *The Birds*, and on

Jean-Louis Barrault looking at a poster of himself in New York at Alice Tully Hall in June 1981. "I belong to that race of people who can live and simultaneously watch themselves living."

stage he gives the same impression of being at ease as he does in the world. He went on to tell me how he had developed and worked on this feeling for life:

"I gradually realized that one eventually encounters destiny. And I believe that destiny is something that is exterior to oneself. It comes along and hits you in the face. And instead of trying to escape the pain and unhappiness of certain experiences, you have to eat the experiences. You must have the courage to absorb and digest the event. Then you can convert something that is unpleasant into joy. In my view, joy is born out of the absorption of destiny. So with May '68, it was bad destiny. They threw me out of the Odéon. And I didn't intend to bear a grudge against the people who had been unfair. It was up to them to feel ashamed. But at that moment I happened to find the text of my adaptation of Rabelais in one of my trunks. And I knew it was a play that would work better in a gymnasium than in a theater. The Odéon wasn't the right place to stage it. So I did just that. I found a better place to stage the Rabelais, and turned 'destiny' into 'providence.' And I've done that throughout my life."

Barrault's primary aim is to communicate pure joy to the spectator. In *The Birds*, Barrault made sure that the play could be enjoyable to children, who would not pick up on the satirical comment on contemporary France and human nature. It was full of silly humor and a slapstick vivacity, with Barrault presiding over the stage—making fun of French politicians and showing us his dream of how the world could be if he had his way. But he makes it clear that his vision is just a fantasy, and not a proposition:

"One doesn't make plays in order to teach people how to live. There are people who do. But I've had to put up with enough people who wanted to teach me how to live in my life. And I prefer to live the way I like. Don't you agree? I think theater was invented so people could have a big party. Theater should be a celebration. I have no time for intellectual or educational theater."

When Barrault read Aristophanes' *Birds*, he saw in it, quite simply, an expression of man's desire to fly. And he sympathized with this dream and was attracted to the play partly because it

makes a statement about emotions in physical terms. "Human beings have always longed to have wings, and they suffer from the feeling of heaviness, of the weight of gravity. Don't you often have dreams about being able to fly? Well, I think it's an ideal that people aspire to. So when the two characters leave the world of men to live with the birds, they're also looking for harmony and friendship and joy."

But the world of men is, according to Barrault, "jealousy, conflict, prisons, persecution, and torture." Within this painful reality, Barrault has seen ways to create his oasis. The theater offers him the possibility of bringing people together, to experience, momentarily, a sense of brotherhood. Also, in his marriage with Madelaine Renaud, he has created another world where life is not cruel. "There is only only one religion for me, and that's love of humanity. So I believe that one has to sow the seeds of a celebration, and of mutual friendships, and within that atmosphere, in the theater, one can say things to people. In *The Birds*, there is a satire on humanity, of course, but I do it in a friendly way. Everyone takes a knocking, but if I did it with malice, I know it wouldn't work."

But Barrault has not chosen to stage plays to please an audience. As a producer, he helped establish the careers of Jean Genet, Eugène Ionesco, Samuel Beckett, Marguerite Duras, and Nathalie Sarraute. He staged Genet's *Les Paravents* during the Algerian crisis in April 1966. The theater came under attack from various political factions, and many evenings the actors, including Barrault and Renaud, played to a violent audience.

I asked Barrault what had attracted him to the works of these then-undiscovered authors. Is there a particular feeling that a work of genius inspires in him?

"First, one has to be moved. And, in general, one feels more alive while reading the play. But all the plays I've put on have been the ones I'd like to see myself. And also it's a question of desire. If there's one thing that I care most about in my life, it's feeling desire. I am constantly on the look-out for this feeling of desire.

"I am often drawn to plays that express the painful experiences of a poet's life. There are two kinds of works: There are plays that fall like fruit from the tree, which don't really belong to

the poet. And then there are works that poets create which they never complete. And these works stay within them for the rest of their lives. The umbilical cord is never cut. For example, with Flaubert, *Madame Bovary* was a fruit. But the *Temptation of Saint-Antoine* remained within him. It's the same with Claudel. You have *Tête d'Or, Partage de Midi, Le Soulier de Satin, Christophe Colomb*—they all remained attached to Claudel. Whereas *L'annonce Faite à Marie* was a fruit. It was a fruit that fell.

"As for me, I'm more attracted to the works that never break free from the poet. Because these plays tell me a lot more about the human drama of the poet. Do you follow?"

It seemed clear that Barrault's life had not given him too many ready-made joys. For him, most fruits are the fruit of his labors, and only come after he has "eaten" and absorbed misfortune. It would be likely that he would find himself drawn to plays that tell of experiences that he can invest himself in.

"Of course," he added, "I do feel joy. But I am also anxious. There's no one more anxious than me, and, at this very moment, I am thinking that I have to get on the stage, and do *The Birds*, and I'm dying with stage fright."

"Really?" I asked in disbelief.

"Oh yes. I'm overcome with panic. It's terrible. I don't know whether I should stand up or sit down. Or have something to eat. I really don't know what to do."

"Is it always like that?"

"Always. It's a horrible torment."

"And afterwards, when it's over?"

"Oh well, if it's gone well, I'm happy. For you know, theater is really like meeting someone. Of course, there are people who aren't worked up at the thought of meeting a young girl. As for me, I tremble with fear. Actually, I used to tremble. But it's still quite overwhelming, the thought of meeting someone you don't know."

But I was not convinced. For Barrault behaves in a warm, outgoing manner. And though he may be afraid, he has consistently taken risks. For Barrault, joy may be a result of hard work and preliminary pain, but he has always searched for happiness, and has known how to create it:

"Yes. I think I kept a peasant atavism from my father's side

of the family. My grandfather had a vineyard at Tournus. And we still have the estate which was bought by the first Barrault in 1698. So there are three centuries of wine in my veins. I was brought up in that atmosphere. As a child we'd go to Bourgogne every summer. I learnt how to trim the vines, and harvest the grapes, and tread the grapes, and make wine.

"When I wake up in the morning I want to feel hungry for life. Desire is what drives me. When I go to sleep, I feel I have experienced a small death, so that I can wake up in the morning renewed and reborn. And the four seasons of the year correspond to the four seasons of life. But one returns, always, to where one started. Life is based on the law of eternal return: One sleeps at night in order to be reborn. And one wakes up, like a child." ❖❖

"Thank you so much for watching my film. The English are so polite. In Paris they walked out after ten minutes, in Italy they would have left after five minutes, and the Germans would have gone to sleep," said Ionesco after his first film, *La Vase*, had been shown at Oxford. "Has your film helped you to solve your personal problems?" asked one aging undergraduate. "Perhaps yes, perhaps no," answered Ionesco, who continued to play the role of clown, as he had done in his film.

The snores in the audience were at times indistinguishable from the sound-track. Only one couple slipped out; the rest stayed to the end, to watch Ionesco play "a part of himself," an isolated old man whose awareness of oncoming death is translated into images reminiscent of *L'Age d'or*: crumbling walls, fragmenting mirrors, clouds accelerating past windows that were never quite transparent. After a series of close-ups of rotting substances, it was a relief to see Ionesco himself, covered in white paint, lying dead in a river, a latter-day Orpheus, his dismembered limbs decomposing. His one eye stares at a grey sky which Ionesco intended to be blue. In this case it is the eye and not the voice that provides the optimistic ending. "Are there

any psychoanalysts in the audience who can explain my film to me?" . . . The audience of dons, émigré Frenchmen and undergraduates trickled out of the cinema, some bemused, some smiling.

When I spoke with him, Ionesco was more serious and weighed his words carefully. "I find it difficult to talk to a large audience. But I was grateful that people sat through the film because I know how painful it is to watch."

The focal point of Ionesco's metaphysics is death. "Death is our main problem and all others are less important. It is the wall and the limit. It is the only inescapable alienation; it gives us a sense of our limits. But the ignorance of ourselves and of others to which we are condemned is just as worrying. In the final analysis, we don't know what we're doing. Nevertheless, in all my work there is an element of hope and an appeal to others. It is the eye at the end of the film that symbolizes our awareness. And I hope that is what I bring to my readers."

All the more puzzling, then, that fraternity and relationships make no appearance in *La Vase*. "Love was absent from the film, not because I believe that it is irrelevant, but rather because its absence was the core of the character's problem. He had no one to help him live. Without love the world is unbearable. I don't know why but it's true. That's another reason why I don't believe in revolution. It is a venting of hatred, rather than love." He shares with the psychoanalysts he admires the belief that all our problems arise from a limited number of very simple and basic causes. Although he has never been in analysis, he spent several months in Switzerland having lengthy discussions with a Jungian analyst. They concurred that one must use the individual and particular case as a basis for generalization.

Ionesco was born in 1912 in Romania of a French mother and Romanian father; his formative years were spent in France. In 1925 he returned to Romania when he learnt the "native" language. He subsequently taught French. He now lives in Paris. Does a perfect knowledge of two languages enrich one's appreciation of language in general?

"Bilingualism involves a sort of intellectual acrobatics. I think that it is indispensable for my work as a writer. But I don't believe that different languages represent totally different visions

of life, nor that nationality is an isolating factor. From my experience as a bilingual speaker, I would say that there can be an exact translation from one language to another, because there is a commonly shared structure which is permanent and universal. Although children learn a different language depending on where they were born, nevertheless the process is the same in all cases. For we all have the same anxieties and ask the same questions; and nationality, like politics, is secondary to the central problem of man's existential condition."

Ionesco recently accepted a prize from the Welsh Arts Council which was awarded in recognition of his achievement as a writer, but more particularly because of the concern he shows for minority cultures. For he feels strongly that Wales should keep its own language. "Nowadays imperialism is decried, but it still goes on surreptitiously. Minority cultures are subjugated by larger nations, and I think we should realize that these smaller cultures must be helped. They have a great deal to offer us." Politics, it seems, is relevant to Ionesco's work when it concerns the individual, the personal, and the particular.

In his film he works from the case of one individual, hoping to make general statements about mankind. "As André Gide says: 'That which is most personal, most intimate and most individual is that which is most universal'. There is no point in generalizing from the abstract as one does in politics." So in *La Vase* he acted the main part himself. But was it himself?

"The character was a part of myself that I had freed myself from. I had expected to enjoy making the film, but it was a painful experience: physically, because I had to lie in the mud for several hours, and emotionally, because I was forced to come face to face with this person from my past. I used my own personal experience; I wrote it up; I acted it. And I was very moved by the fact that the audience did not clap at the end of the film. I think they were aware of the personal element involved. But the very fact that people take an interest in my work means that they have the same problems as me. If not, I would be talking to myself like a schizophrenic. The response they give me means that I am not alone. . . . Of course, there is the problem of solitude. It is a death within life. But isolation is different from solitude. In my solitude, when I am writing, I

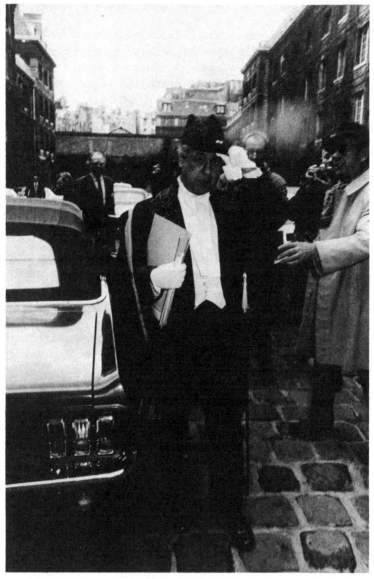

Eugène Ionesco, arriving at the Académie Française. "In my solitude, when I am writing, I meditate and regain equilibrium. I leave behind the social being to find the universal being."

meditate and regain equilibrium. I leave behind the social being, the inessential, to find the universal being. Real conversation does not take place in social gatherings or even between two people. It exists via the medium of a work. It is difficult to communicate, but it is not impossible. I believe that the language of a writer can break through the incommunicability implicit in language.

"I am going to write one more play, publish a third tome of my diary, make another film, and then I'll have said all I have to say, and I'll be ready to retire."

As in the case of Cocteau in his later years, for Ionesco diversification is a rebellion against the limitations of time.

Foreign Connections

Breyten Breytenbach
Michael Lonsdale
Peter Brook

B reyten Breytenbach, the South African novelist, painter, and poet, had a dream of Paris. "When I left South Africa at the beginning of 1960, I had been studying painting, and at that time people mistakenly still believed that Paris was the mecca for painting. So, if you wanted to make your name as a painter, you had to live there. So I went, and of course it was impossible. I mean, how the hell can you just arrive in Paris as a real country hick and expect to stay there? It took me a long time. I tried several times and eventually managed to get my little foothold and my little space in the big city."

Though Paris was not the mecca of painting, it was a place which encouraged Breytenbach to grow and blossom as a person and as an artist. At first, he was overwhelmed by the openness of debate, the lack of censorship, the multitude of passionate viewpoints that all seemed to find a hearing. Breytenbach did not realize how South African life had stunted his development until he arrived in Paris: "I suddenly realized how blunted I'd become myself, having grown up in that kind of environment in South Africa. You know, I shudder sometimes now when I think of my own naiveté, and the prejudices that I brought with me, and the stereotyped cultural images I came away with. Looking back now, I know I must have hurt a lot of people, without knowing it, and without wanting to hurt people. And so when I came to Paris, it was like a slow process of being born. You know, I was coming out of a chrysalis, out of that restrictive envelope, as it were, or husk of being a white South African. And just becoming alive, to being a human being."

While living in Paris, Breytenbach devoted part of his time

to an anti-apartheid organization, and returned to South Africa on a mission for this organization in 1975. He entered the country under an assumed name and in disguise.

Breytenbach's "mission" was to get in contact with some black trade unionists, who would then liaise with his European anti-apartheid movement. He also intended to meet up with some members of an underground group called Okhela which he had helped found in 1972. It was composed of white militants who, like Breytenbach, wanted to put an end to the apartheid regime. But the police caught him and he was sentenced to nine years imprisonment for his anti-apartheid activities.

"When I was imprisoned, suddenly Paris became my real home. That was where all the beauty was, that was where the life was, that was where I was going to return to. I had become so much part of France that some fellow prisoners even said: 'How come you speak such good Afrikaans for a Frenchman? Where did you learn your Afrikaans?' It was only normal that I should return to Paris immediately after I was released. And now, I'm the only Afrikaaner poet who is writing French poetry."

When he was released, seven years later, he published a collection of his prison writings under the title *Mouroir*. But the fact that he had been released and was living in the safety of Paris did not free Breytenbach from his prison experience. He needed to work through it again, in his writings and paintings. *The True Confessions of an Albino Terrorist* (1985) was the lyrical, autobiographical account that allowed Breytenbach to enjoy his freedom.

"When I wrote that book it was practically immediately after being released and it was still very raw and fresh. When I look back on it now, and I see myself, I realize that I was not able to see what I can see now about the possibilities of experiencing freedom. My personal contradictions of being an Afrikaaner living in France had not been resolved. So there was an anger pushing me forward to try to break through that unbearable contradiction of not being at ease with myself. And now, having gone through that barrier, I am more at ease with myself. I feel, for instance, that I'm not living in exile anymore. I will probably never return to South Africa. And this is not something

Jerry Bauer

Breyten Breytenbach, the South African novelist, painter, and poet, who now lives in Paris. "Writing in France, in a democracy, is a wonderful relief."

that bothers me. I've come to terms with that, in the sense that the anger is gone."

Breytenbach's desire to be an activist has also gone. He now feels that he can best make a contribution through his writing. When he lived in South Africa, and later on, still blinded by the legacy of his South African past, he had been unable to entertain the notion of being able to make choices. Now, in Paris, he sees that he can make the choice to write. He explains that his political activism stemmed from an entrenched belief that he had no choice but to take direct action:

"Nobody had any choice about apartheid. It's a horrible thing. That's the most totalitarian aspect of everything that happens in South Africa, that you have no choice. Now I realize that if a writer is going to be realistic, he can contribute towards the struggle perhaps more effectively by doing well what he can do, and leave activism to people who are far better at it. In my case, I showed so ingloriously that I did not know how to be an activist. So I'm not rejecting what I did. But I cannot see myself ever doing something like that again."

The Parisian tradition of intense political debate showed Breytenbach that words can be as effective as direct actions. "Moral commitment to politics is still an important area of discussion here. And politics, as such, are important for that matter. The role of the intellectuals in politics is still being debated all the time, and people jump when they are faced with this issue. It's still very interesting, and sometimes exciting, the way that people like Bernard-Henri Lévy and other brainy writers react. It's a continuing tradition and I think it's a good one. It keeps up the quality of thinking in Paris."

But Breytenbach does not agree with Lévy's conclusions that France is at heart a racist and fascist country. "I think there is a real democracy in France. And there always has been. It finds its expression in different ways. I mean, take for example the deeply ingrained French resistance to authority, even to the idea of authority. At the moment it happens to take on Rightist tinges because those in power are on the Left. And I'm convinced that when the Right comes back into power, as seems a foregone conclusion, that people will swing back to the Left. I don't think

there's any danger of France going even further Right, when the Right is in government."

Nor does Breytenbach sense that Le Pen's popularity represents a major racist element in French society: "Le Pen and his National Front are not dangerous because he might become a majority party in France. They're dangerous because they banalize (as we say in France) a certain racist discourse. Now it's becoming quite fashionable to make racist jokes and talk about 'les nègres' and things like that again. That had disappeared in France and gone underground for quite some time. And they're dangerous in that within any given electoral contest within the near future they may very well end up holding the decisive edge between the Right and Left winning out. If a coalition Rightist government has to depend on their support, then they will end up being a force. But I don't think that France is at heart a fascist country.

"I would put it this way: in South Africa there's always been a minority, a very small percentage of white people, who are committed liberals. And in France there is a very small minority of people who are deeply committed to racist and xenophobic ideologies. This xenophobia tends to wane and grow depending on certain conditions. At the moment it's on the increase again. It tends to vibrate, to touch on something in the French psyche which is dangerous. But I don't think there's any danger of it overflowing."

I asked Breytenbach whether his writing has changed now that he is free from censorship.

"Yes. I would say two things about that. If you write from within a totalitarian setup you have this exciting sense which may be illusory that what you write is of far more importance than it is in a democratic country like France. Because there is so much censorship and repression, South African writers feel they are far more involved in affecting the morals of the people. You don't have that feeling in France at the moment. But writing in France, in a democracy, is a wonderful relief. You can sit back and write about anything you want. You can publish fairly easily. And I don't have to go through the hassles of hiding my opinion. In South Africa, you're never quite sure

whom you're talking to. So many people that walk by you on the street cannot but be informers or collaborators. It affects one's writing. People start writing symbolically. And it becomes obscure, and accessible to a very small circle of people. In fact, one has to twist one's mind to survive in a totalitarian setup, and one never does that with impunity.

"But I think there is always a certain amount of self-censorship that can go on. Even if it's only economic self-censorship. Supposing I wanted to write a book about roses (which I don't), perhaps I wouldn't have done so, because I would have said, 'Well, there's no chance of selling it in the present economic and social and intellectual climate, I'd better write a hair-raising book about prison experiences.' Isn't that a form of censorship too?"

Breytenbach has also felt pressure to become an intellectual. "In Paris you cannot be a writer or painter unless you enter intellectually. The two go together here. It's a terrible handicap. I actually see myself now as a Frenchman trying very hard to be intellectual. And I am accepted as such by other French people, which makes me think very hard about the depth of their intellectuality. You see I know my own depth, and if they take me as a fellow intellectual it must mean that we are all involved in a tremendous sham."

Breytenbach's experience of being a French intellectual has made him wary of devoting too much time to such Parisian activities. He spends half his day writing, and the rest of the day in his studio, painting. But at one point he became caught up in the typical agenda of the intellectual: "There are terrible things attached to being a writer in Paris. You are supposed to be on call for all kinds of subsidiary activities, like giving seminars. Being an intellectual in Paris is really a form of cannibalism. It's an incredible world. It is really a question of sharing one's self out and being eaten by other people. I have some experience of it. One is probably devouring other people, too, but it's essentially cannibalism.

"It's also very destructive because you end up completely erroneously thinking that you have the answer to everything. One doesn't come across people anymore who say, 'I don't know the answer. I don't know what I think about M. Mitterrand. I

have no idea.' You know, no self-respecting intellectual ever admits to that. You could wake up a Parisian intellectual any time of the day or night and ask them a question and they'd give you a thesis. And this is so deadening. But, actually I'm being a little too derogatory about the life of the Parisian intellectual."

Breytenbach feels that the media attention given to writers and intellectuals has contributed to their arrogance and omniscience. "I think that once you've been on television once or twice, you become a walking dictionary. You are expected to be one of the people who has an answer to everything. It's not only that. It becomes a very clannish thing. But I mustn't be too hard on them. They do take account of important issues, like the third world. But what is happening in France is that if you are good at politics or philosophy, it's also assumed that you can write a book, too. Everybody is writing a book nowadays."

As Breytenbach spoke of the vanity and the excesses of the French intellectuals, his tone was affectionate and self-mocking, for he has been welcomed into the arena. But he has also disciplined himself to devote most of his time to his work. The beauty of Paris and the passionate debates act as a backdrop which Breytenbach delights in. "I think Paris is a very stimulating environment for creation. Very much so. The basic nature of French intellectual life is still stimulating. The quality is still high. And the things that people consider to be important, like thinking, are still very much a force in French life."

And Paris is exceptional among the capital cities in its devotion to its philosophers and writers: "Of course the importance of thinking is confusing for a non-Frenchman, because it's so rare. But then, I am no longer a non-Frenchman, and it's very stimulating. Painting has gone through a very strange phase. When I returned to France after seven years—when I left, it was all happening in galleries representing bigger galleries from abroad, you know, like the Marlborough and others. Now it's all happening in museums, and there are some incredibly beautiful shows. The Manet and Rousseau, the Kandinsky and Bonnard, the Balthus. There's a great popularization of art going on. This is something completely new. But painters are

still as marginal in the society as they were before. Except that there are no great masters who can draw attention to contemporary painting."

Breytenbach feels that Paris is still a vibrant cultural center, although the death of many major figures has created the false impression that the city has lost its inspirational quality and its importance as a center. As the internationally known French masters died, and many of the expatriates left, Paris survives as the center of cultural activity in France and continues to attract writers like Milan Kundera and film makers like Polanski and Losey. The government has been keen to foster international talent and generously finances the work of theater directors like Peter Brook and Strehler.

"I don't think that the actual quality of life in Paris has gone down, and I'm not at all disillusioned with life here. What's happened is that some other centers have come up, and that has drained off some vitality from Paris. In painting it would be Germany or New York. In the sixties it was London, with the result that Paris had some competition. Also, the American writers used to live here, and so did some of the better-known international figures. But some people still do. Therefore, Paris is losing its place as the first among the cultural centers, but it's still a very stimulating city to live in. We're going through a bit of a low period because so many of the *monstres sacrés* died like flies over the last few years. They all got taken away all of a sudden and there was no one to take their place immediately. But it's very, very exciting here, and a good, well-trained French mind is a beautiful thing to watch in operation, but one mustn't expect it to be self-deflating or too light."

Breytenbach says that he will remain in Paris. His time in prison taught him not to depend on his surroundings, and created a fear of trusting in others, which he still is victim to. Paris ushered him out of his Afrikaaner vision, which he describes as prejudiced and naive. He now feels himself to be part of the scene. His South African past no longer alienates him, for he is able to discuss his political commitments with writers who are as passionate as he still is about such issues.

The city nourishes both his painterly and writing selves: "I spend most of my morning writing. Then, I go into the studio

in the afternoon and it's like going into heaven, because it's wonderful, it's a new smell, it's physical, it's creating something which you can see immediately. It's a relief. I work until the light fades and then go back home and write, and maybe draw a little bit in the evening if the writing doesn't come. To be able to write one has to be at the same time sane enough and insane enough. You have to be sick enough and healthy enough. It exposes you to insights about yourself. But at the same time it's the umbilical cord of survival. It is your contact with yourself."

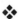

M ichael Lonsdale, one of the most protean and familiar actors of the French screen and stage, had just completed working in English on Joseph Losey's latest film, *M. Klein,* when I met him in London. He welcomes any reason for returning to his homeland, for his father is British and he was eight before he adopted the French language. He now realizes that his adult life in France has not submerged the influence of his early upbringing.

"It was a wonderful discovery and surprise to act in English, and Losey creates an open and sympathetic working atmosphere. I felt that the words were coming from very deep inside me. The English language is a pleasure to articulate. The intonation and rhythm is very different from French. In French you have to add words to a phrase in order to communicate strong emotion. Exclamations cannot be incorporated into the intonation. In English you can integrate an emotion, and different emotions into a single phrase. English has a great variety of registers."

Lonsdale discovered that the versatility and receptivity of English is reflected in the acting tradition. Looking back on his career, he notices that he has, unwittingly, remained faithful to his image of the English tradition. "British actors can put aside their personal dramas, and they have the capacity to transform themselves in each new role. They have captured the secret of disguise. They rather enjoy it when the public doesn't recognize

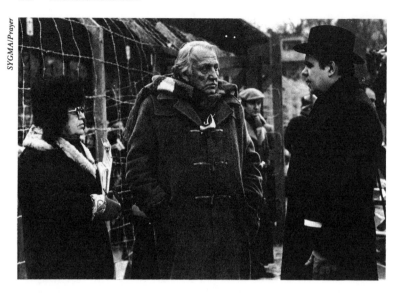

SYGMA/Prayer

Joseph Losey (center) directing Michael Lonsdale (right) on the set of *M. Klein* (1976).

them. French actors don't want to transform themselves. Acting is based on personality. Gabin is always the same and the public would be disappointed if he were someone else. I have never wanted to be categorized and typecast. I played too many police inspectors, and people relied on me to play that role convincingly. But I put an end to it."

Londsdale experiences the public's demand for stars and their wish to confuse the actor and the role as a threatening conflict, rather than a reward. For public recognition does not imply the acceptance of his identity, but of the momentary personalities he assumes. The more he achieves success through his diversity and ability to become another, the more he risks losing sight of himself.

"Often when I'm out in public people recognize me and I say to myself: 'But that's not me that they're gossiping about.' I try to be natural, but then one can't contrive to be oneself. It's a problem, because one always plays roles and it's up to others to

tell me whether I'm myself. Most people want to see the image and not the person. As an actor one has to be very wary of success, money, and fame. It's dangerous to take pleasure in being recognized because it's momentary. In this profession one never knows how long one's talent or popularity will last."

The degree of autonomy or independence that an actor can honestly experience is a question Lonsdale has left unanswered. He admits that he depends on public approval for his self-assurance and the nature of the profession prevents him from carrying out a self-appointed task. "People don't realize that one invests a part of oneself in a role, even when one isn't playing onself. We exploit and expose ourselves and we are notoriously fragile beings. When people criticize a performance it can destroy us. It's especially afterwards, when people make judgments, that I feel vulnerable. For the desire to be an actor is linked up with childhood dreams (as in my case), to the wish to be a healthy person and to sublimate. So when you fail you feel it goes further than failing to interpret a role."

Lonsdale has created a name in the cinema, after working for many years as a director of musicals and as a stage actor. Now he seems to be able to take guidance from the director. He still believes that it is more satisfying to work with directors like Losey* and Buñuel than the hesitant director who depends on the actor's contribution. But does this suggest that Londsdale's participation diminishes whenever he works with an able and masterful director?

"When I worked with Buñuel on *Le Fantôme de la Liberté*, I came across a brilliant man who had been so influenced by Surrealism that he saw everything in terms of unimaginable people meeting in absurd situations. He didn't ask the actors to act well, and so they didn't. In his films one is not expected to play a credible human being and so the actors aren't really important. With Marguerite [Duras], in *India Song*, I was able to collaborate and construct, but that was because she is a relatively young director and she isn't quite secure in the

* Joseph Losey died on June 22, 1984 at the age of seventy-five. He spent the last years of his life in Paris. After directing *M. Klein* (1976), he directed *Les Routes du sud* (1978), *Don Giovanni* (1979), *La Truite* (an adaptation of a novel by Roger Vailland, 1982), and *Steaming*, his last film (1985).

medium. I think all great directors know and should know exactly what they want from the actor. Zinnemann, in *The Day of the Jackal*, was the only great director who asked me for my suggestions and took them into account. But in the final instance, you have to rely on the director because he knows the angle he'll be shooting from, and a change in perspective can transform a simple gesture in the cinema. Each different angle demands a different interpretation. At first I panicked before the cold eye of the camera, but now I enjoy films as much as theater.

"I'm an instinctive actor; I am never quite sure how I will interpret a line; I'm constantly working in the unknown. I dislike rehearsing and am using improvisation more and more. This forces one to be overattentive and oversensitive to oneself and others. By trying to capture the appearance of valid emotions and then to reconstruct them, one ends up being oversensitized to others. I never understood why actors were capriciously intolerant of others, but I begin to understand. We are so aware of gestures, tones of voice, and expressions that we can decipher what people are like. That is one of the pitfalls, but one has to take risks." ❖

T he Parisians felt that they had discovered a Shake-spearian reincarnation in Peter Brook. Affectionately, they nicknamed him "Brook, le Shakespearien" or "l'Elisabé-thain" because in his years at the Bouffes du Nord he has attracted a vast popular following and has given the intellectuals and theater lovers enough food for thought. It was almost impossible to get tickets for *Les Iks*. Learned journals churned out dissertations on Brook's revolutionary ideas. He seems to disprove the rule that you can't have a *succès d'estime* and a *succès populaire*.

The French surprise and enthusiasm partly springs from a historical complex they nurture and bemoan concerning their own theatrical tradition. The classical work of their national

heroes, like Racine, resulted in a rebellious move towards a popular theater, liberated from the constraint of rules and precepts. But each rebellion has tended to filter off into yet another esoteric movement. Brook's success is astounding because it bridges a gap that the French have always had difficulty in crossing.

Brook's happy relationship with the French does not only spring from the fact that he imported a much needed and foreign element into French theater. In many ways, he embraces French obsessions. Even in 1965 a bevy of critics hurried over to London to see his production of *US*, delighted to find that an English producer was "politisé." *Les Iks*, based on a book by Brook's old friend, Colin Turnbull, the anthropologist, also has political overtones. The Iks had been living quite happily in Uganda until 1946 when the government transformed their territory into a national park. They were prevented from hunting and were forced to turn to agriculture. Everything in their tradition opposed this, and the play reveals the consequent disintegration of their society, and humanity. On the simplest level, the play could be considered as an empathetic study of the violence of cultural impositions on minorities. Obviously, a worthy subject for committed anti-imperialists. But Brook is not self-righteous or content with a solely political message.

The documentary anecdote became the basis for a more personal and mythological statement. Brook involves the audience from the outset by presenting the actors as individuals before the moment when they assume their roles. We witness their transformation into Iks. As their human feeling and society breaks down, we are prepared to follow the reverse process, the dismantling of their personalities. The open presentation of all that normally goes on behind the scenes is not merely a gimmick. In *Les Iks* it offers the possibility of entering into an unfamiliar world and an even stranger disintegration.

Brook's insistence on theatrical research and his revolt against certain traditions would probably have gained him a following among the avant-garde. The reasons he gives to justify his approach and his willingness to theorize make him a true compatriot of the French. But he has gained a popular following because he has valid and proven reasons for working in an

unconventional, dilapidated theater, for dispensing with profes-
sional actors, make-up, and costume. Neither his intellect nor
his revolutionary bent would have given him a *succès populaire*.

For the majority, he is a man of simplicity whose work is
refreshingly accessible. When Michel Guy signed him up for a
five-year contract in September 1974, he already had a history
of triumphs: in 1955 at the Théâtre des Nations with *Titus
Andronicus*, in 1963 with *King Lear*.

Peter Brook's trust in his own intuitions has grown over the
years, and his confidence has radically altered his way of
directing. He is now able to accept more and more uncertainty.
Brook no longer feels he should greet his actors with a completed
vision of what he wants to achieve. "However long I spend in
front of a manuscript, I now know that there is an absolute
limit to the discovery one can make by intellectual means, and
that the moment you start working with the actors, it takes the
work into a different compartment of the mind, which is, in
turn, linked to the impressions that come from movement and
sound, and the physical presence and psychological presence of
the actor. So that the meaning of a scene is changed because it
has become a living experience. Let's say that the big difference
in my work now is that it is fed more and more by other people.

"And therefore the forms change, and it's very dangerous:
for I work more and more by eliminating any formal thinking.
And I try to let the final form that the audience will see come
as late as possible. When I say it's dangerous, I mean that at
any moment one takes the risk of having nothing prepared
formally. And one works with the danger that the form may
never be found."

Brook gives the impression that he depends on his actors for
his ideas, and this is not the case. He tells, with some amusement,
how easy it is to misunderstand his approach: "At the first
rehearsal of *Timon of Athens*, I said to the actors, French actors,
most of whom I was working with for the first time, 'I don't
know this play. I'm going to discover it with you.' And as I was
walking out I overheard one of them saying, 'Is he trying to
have us on?' Because for them I was this English authority on
Shakespeare, and they expected me to lay down exactly what
they had to do in each instance, and this actor couldn't believe

it. What sort of hypocritical English game could this be? It couldn't be the literal truth, which was what it was."

But I was unwilling to believe that Brook allows the actors' interpretations to become the play. His work is never muddled; in fact, one has the impression that Brook treats a text like a rough slab of marble, searching, like a sculptor, for the hidden form. He gives us a vision, not a conglomeration of viewpoints. Brook agreed. "Yes, you have defined it exactly. In that way, one knows that there is a form somewhere in the text. And what makes one constantly go on and on working and changing and searching is that until you've found this hidden form, you are not going to be duped by provisional forms. You dig in it and you find in the middle of a square block, you find the beginning of a few curves, but you know quite well that it's not this hidden form. When you hit the form, there's no question, you know it. That's what I mean that there's a relation between the intuition and the form."

So Brook does come prepared with the intuitions which will guide his research with the actors. These intuitions are not as yet sensuous or visual. In fact, their formlessness becomes the spur to action, and drives Brook to search for concrete forms. "I'd say that the very reason for choosing a subject is that it is as yet a formless hunch. It's very hard to define more than that. But it is something on an instinctive level. From all one reads, Fellini dreams and in his dream he sees a sequence, and then sets out to execute it. But I've never had visions of that sort. For instance, you often talk of people who have a sense of direction. Well, it's like that. They set off without a map and yet they sense their way. Or another analogy would be what happens when you see a photographic enlargement being developed. It fascinates me to see one bit gradually appearing, and then another bit, and gradually it comes together to make a picture. But if something comes out well, one sees in retrospect that the first hunch was pointing in the right direction. If it turns out badly, one sees that the first hunch was feeble."

Slowly, as he rehearses with the actors, Brook comes to recognize the form he had intuited. When I asked him why he chose to work with an international group of actors, it became perfectly clear that he does not depend on his actors for ideas.

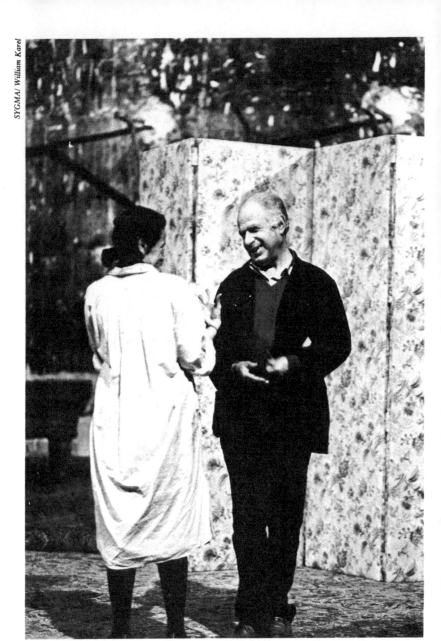

Peter Brook in 1985 at his theater, The Bouffes du Nord, Paris: "Let's say the big difference in my work now is that it is fed more and more by other people."

"I think you could use the analogy of color. Some painters choose to do a Rose or a Blue period. They work entirely within one color. This can produce enormously rich work, but it's still within one color range. It's something quite different when you have a whole palette. And I think this is exactly what happens when you work with people of different colors. There is a totally different color of temperament. And it isn't so much ideas. It isn't so much the effects of culture that interest me. It's culture in the real sense—that each culture has its own characteristic. And so when you have a mixed group, not only does a different sound emerge, but you also touch on some aspect of theater that is fundamental: You begin to play with real contrasts and oppositions. The theatre is always the meeting of opposites."

When I met Brook at the Bouffes du Nord, he had just returned home to Paris, after one of his many journeys to India to research the *Mahabharata*. Brook's journeys have become a tradition. Since 1970, when the Centre International de Recherche Théâtrale was created, Brook has been across the world, researching the sources of his plays in their original location, and performing for native audiences. Brook does not travel in order to borrow or imitate local theatrical styles: he is not interested in overt differences between cultures. "With the actors, I don't try to tie each person to his background. I don't want an actor to become, quite literally, a representative of his country. In fact, I tend to do the opposite. For instance, an African will often play a white man, and a white man plays an African. A fat person always plays someone slim. And women have played men.

"One can easily fall into musical comedy, if one tries too much to imitate the forms of a different culture. Just recently, I've taken the actors to see some quite extraordinary things—on the spot, in India. Things that people never see, ceremonies and performances. And it's so exciting, and yet, in a way it's frustrating, because everyone who sees this longs to do it. We do it for ourselves. It's almost for our own enjoyment. One comes home and practices those kind of movements. But we know we can't perform them like the people who have been spending their lives doing it. We can, however, suggest it. And it's that 'in-between' that we try for. The essence of theater lies

in suggestion, and one just has to find out how far one can go. That was what *Les Iks* was all about. I mean, if the actors had not been in Africa, they wouldn't have been able to do it.

"For instance, in *Les Iks* we had one little moment of pygmy song, for just a few seconds. 'But there were no white people with black faces doing tribal dances with spears. That would have been the opposite technique from what I do. I've seen that done quite seriously, people trying to imitate as authentically as they can the real thing. But it can't be done. I don't know how one can say it in English, but the French have a way of using the word 'folklorique' with utter contempt. There is nothing more horrendous in theatre than this sort of folk culture. It's phony exoticism."

Brook's habit of delving behind surface appearances to find the source and inspiration of a work led him to discover the *Mahabharata*. "I encountered the *Bhagavad Gita* while doing *U.S.* And I was struck by the physical situation of a man going into battle and stopping dead in his tracks, and saying, 'Why should I kill these people?' And years later this remained with me as an image that was so strong and so relevant to the present day. But I wanted to find out what situation the *Bhagavad Gita* comes out of. So I went to a Sanskrit scholar with Jean-Claude Carrière. And he started to tell me what came before the *Bhagavad Gita* in the *Mahabharata*, which I'd never heard of. I didn't realize that this episode was part of an enormous epic. And this scholar said, 'Well, it's all in the *Mahabharata*, all that happens before the battle. And I can't make you understand this episode without telling you what came before.' And then, half the night had gone, and we decided to meet again.

"Over several months we received the *Mahabharata* actually the way the Indians do, which is orally. The person telling the story never tells it in chronological order. In fact, you ask him, 'Who is this character?' and he says, 'Well, yes, there's an extraordinary story of how that character was born.' And then you'll ask another question and he'll say, 'Oh that's because later, at the very end of the story, this character meets that character. And so, gradually, over a number of months the story unfolds. And one night Jean-Claude and I looked at each

other and said, 'We must transmit this to other people. This must be made into a play.' "

Brook had, in fact, come across an eighteen-volume epic which, together with the *Ramayana*, is at the source of the Asian and Greek epic traditions. Eight years ago Brook asked his long-standing collaborator, Jean-Claude Carrière, to write a play based on his impressions of the narration. When Carrière came up with a first version, Brook then decided to start again, using the complete eighteen-volume text of the *Mahabharata*. "My first job was to find the volumes, because there isn't a complete translation in French. There is a nineteenth-century English edition that is complete. And it took several months going through the bookshops by the British Museum to collect the complete set. There are in English, and now in French, condensed versions, where each editor makes his selection. Once we had the eighteen volumes, Jean-Claude and I started making trips to India. We started working with our old Centre group. We had a Kathakali teacher, and we brought a Kathakali company into the theater and spent three days with them. We worked on the *Mahabharata*, bit by bit, along with all the other plays we were doing."

Jean-Claude Carrière has adapted to Brook's own style of working. He must be prepared to rewrite his work continuously, because Brook rewrites his thoughts up until the last moment, and he asks of his team to withstand the anxiety of working with shifting, constantly disintegrating forms. He shuns easy resolutions and treats each draft and each performance as a provisional form. "Carrière has been through our journeys, our auditions, all our preparations, so that his writing is an unbroken process. We started rehearsals of the three big plays, and he's rewriting them all the time, and he's still going on rewriting. The fact that he is a screenwriter is of enormous importance in one respect. A good screenwriter is someone who has a very strong point of view and a strong imagination, and at the same time, understands the collaborative process. And a nonscreen-writer—someone coming from a more literary background, of even novel writing, or play writing—someone who sees himself as a writer—has a very different point of view—and he may be

perfectly sincere—in believing that when he's written something it's very difficult for him to rethink it and change it. Screenwriting really prepares someone for this understanding of the pragmatic nature of our work."

Peter Brook is more than willing to explore the evolution of his approach to directing, and he talks with intense concentration, as if he is trying to answer these questions for the first time. He is not wary of coming up with ideas about the way he actually works. But he is truly mistrustful of theories and preconceptions that would determine, and stultify, the process of discovery in rehearsals. He believes that fixed ideas, and dogmas, are destructive, not only to the director, but also to society.

"The tragedy of the twentieth century is that people with mental concepts fail to understand the difference between a mental concept and life. They try to impose, at gun point, a mental pattern, and then find, quite tragically, that life is something different. So that when you see the horror and suffering and the tragedy of the global situation, however deeply you are moved by it, you have to recognize that none of these solutions, formulae and methods that are proposed for bringing about radical change, actually work. Which doesn't mean that we must abandon the wish to change things. The small degree of change that's possible has to be fought for every inch of the way."

"The most radical change that can be made in human existence is by one person on himself. This is hard, very rare. But it happens. There have been individuals who, by their own bootstraps, have turned themselves inside out, and pulled themselves to another level. That is possible. The next possibility is in small groups. And, in a small group you can go a long way towards building a new world. And the moral and exemplary nature of theater is not in a political theater, in the sense of projecting a political idea. If you do that, you're back again in this area of attractive mental concepts that don't work."

I wondered why Brook has chosen to make his home in Paris, a city where ideas, dogmas, and theories for political change proliferate and dominate daily life.

"It's funny. I came to Paris for a number of reasons, partly

personal ones, and along with that was the sort of coincidence that is the contemporary word for destiny. I had started in '68 quite by chance a workshop here, an international workshop. We did it in Paris for three months and had to stop in the middle of the year and take it back to England. We did a performance at the Roundhouse. It was the first time I did this experiment with a workshop with actors of different nationalities, which seemed to me very interesting. And so when I came here I thought to have an activity outside the Royal Shakespeare Company. I was still commuting between Paris and London. And I felt, at the time, that I had everything I could possibly want. But then I wondered if I could develop something in Paris which doesn't happen anywhere else. And an international group brings something different from a national group. So I started this first three-year project which was really purely research. Mainly, for my own interest, and for those people who were working with me. After three years, I still had no sense that I was going to belong here."

It was a sense of gratitude that prompted Brook to stay on in Paris. "After three years of almost secret work, I felt we had an obligation towards the French. We had received things from France. They didn't give us money, but they gave us premises. I felt we must do something publicly in Paris, with this work. And so we found a theater and did *Timon of Athens*. Then the actual work began to develop further and prompted us to stay on. When I went back to London to do *Antony and Cleopatra* it was like going to circumstances that were no longer mine. Because I had gradually developed a way of working that took root here.

"And then, retrospectively, one sees there was a certain logic in remaining in Paris. For Paris has a tradition of being an international center. There always has been that tradition. And now with the *Mahabharata*, we have had enormously generous and understanding support from the French government, from the admirable Minister of Culture, Jack Lang. And I would say that what I'm doing today in theater could not be done in Thatcher's England. Even the National Theatre can't keep its experimental portion going.

"I believe that there is also a respect in Paris for a certain

kind of freedom of work in the theater. Here, we're not yet broken by industrializing, and the other side of it, which goes together, unionizing. The essence of our work is handmade theater. What took me to Africa and India is that you can still see the basis of theater happening. Theater can happen out of nothing—on any piece of earth you choose. Well, that is to a large degree still possible here. And it has been with French movies. The French movie has survived because you can make small films. Which is really the handmade versus the industrialized. And if you look at the situation of the big theaters in London, the Barbicon and the National, they do have fantastic opportunities, fantastic casts, but they are under the tremendous pressure and conditions of industrializing."

Brook may see the strains that expansion and industrialization impose on the individual, but he does not use his own, handmade theater as a haven, and an escape. Rather, he opens up his work to a constantly expanding flow of new material. It is as if he attempts to transform his theater into a microcosm of the disintegration he sees within contemporary society:

"There is a reality which I can't deny, and that is that in any large conglomeration of human beings—in a city, let's say—people aspire to unity. But they are incapable of living that unity. Fragmentation is the natural process of agglomeration. And there is something of vast importance in attaining a temporary sense of unity. Perhaps this is the most fundamental and ancient meaning that the theater can have.

"I've heard it said, and it has always attracted me, that theater is related to a myth, a cannabalistic myth, of a body being cut into little pieces and then being magically healed. I'm sure that Greek theater had something of that feeling; when people experience for a moment something they always long for. And they have to accept the loss and destruction of it. But the fact that it isn't lost forever is what sustains a hope and an activity and a courage in life.

"I know, for instance, in *Carmen*, that there was this idealism, this intention, in the singers' relationship with the audience. And also in their relationship amongst themselves. It was as important as all that was apparently important—like the way the story and the opera was presented. Obviously, these two

levels went hand in hand. For the audience came for the purpose of following the story, and possibly the music. But what they actually experienced was relationships which are more intense and free and could only occur through a dramatic story. I mean, for relationships to be more intense and freer than they normally are, you need a context. And the context is a dramatic relationship."

Communication at the Breaking Point

Alain Resnais
Alain Robbe-Grillet
Louis Malle
Eric Rohmer
Marcel Carné
Jean Eustache
Bertrand Tavernier

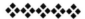

"Every human being knows, only too well, that we are all looking for a partner, for someone to love, and when you find that person, you inevitably reconcile yourself to living in fear: you worry whether the loved one will stop loving you. And you also fear that he or she might die," said Alain Resnais, discussing his film, *L'Amour à Mort*, which tells the story of a young woman who is contemplating killing herself, in order to join her dead lover.

Fanny Ardant, the mother of Truffaut's child, plays a pastor who tries to dissuade the girl from killing herself. But the central couple have their own ideas about death, imagining it to be an alternative life, where they will live together in eternal bliss.

The film tells us very little about love and a great deal about the desire to escape reality: for the man, before he dies, suggests that his lover join him in death. Resnais presents this desire for complete oneness with another as a beautiful and moving emotion. *L'Amour à Mort* is an uncomfortable film to watch, for we are asked to believe that a desire to escape from the world is a form of transcendence and that self-destruction is a necessary part of love. Resnais described his initial idea for *L'Amour à Mort* as an exploration of the fear of losing love, but the theme was obscured as he worked with his screenwriter, Jean Gruault (who wrote the scripts for *Jules and Jim, The Wild Child, Two English Girls, The Story of Adele H.*, and *The Green Room* with François Truffaut). Resnais says "we ended up pushing the story to its logical conclusion." In doing so, an emotionally accurate conclusion was lost. Resnais has always chosen to work with writers who have their own vision, like Marguerite Duras for *Hiroshima,*

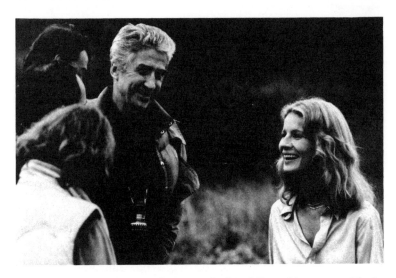

Alain Resnais on the set of *Mon oncle d'Amérique* with actress Nicole Garcia.

Mon Amour, Alain Robbe-Grillet for *Last Year in Marienbad*, and David Mercer for *Providence*. He has given these writers more freedom than most directors allow, for he sees himself as playing a small part in the collaboration:

"I am not at all the author of my films. And it's not my ambition to write my own screenplays. I hate the idea of working alone. But I tend to like dialogues that do not reproduce completely the way one normally talks for I hate films that try to reproduce life as it is. I like to choose a writer and actors who have a very particular sonority. And so I like working with writers who are able to manipulate words, who are sensitive to the music of words. But the main reason I choose a screenwriter is because I get on well with him. I need to work with friends."

Resnais has also chosen to work with his wife, Florence Malraux, on all his films. He is a direly sensitive man, who demands trust and friendship before he will open up to others. An interview is not the ideal situation for Alain Resnais to express himself in. He is helpful and thinks carefully about his

words. But one feels that he is wary of communicating himself to someone who is not an old friend.

I realized, weeks after I met Resnais, that the old friends he had chosen to work with on *L'Amour à Mort* were also closely tied to François Truffaut: Gruault was the screenwriter; Florence Malraux had been the continuity girl on *Jules et Jim* and had told me that she continued her friendship with Truffaut; Fanny Ardant had starred in Truffaut's last films, *La Femme d'à coté* and *Vivement Dimanche*; and I wondered if the original subject of Resnais's film had somehow been overwhelmed by the atmosphere of mourning on the set.

The feelings of grief that had not been absorbed seemed to have invaded *L'Amour à Mort*, and it struck me that Resnais might not have been aware of this problem, for he prefers to let his "unconscious" dictate his work, and shies away from analyzing his working methods:

"I always have the feeling that a film is being dictated to me. The seed of an idea begins to germinate, and one has the feeling that one's unconscious has taken hold of one's self. I try to respect that process to the full. When an image is very enigmatic, and when it stays with me for many days (one day is not enough), I try to integrate it, for I feel it must be important. It transcends me. And I think, oh well, it doesn't matter as long as it's still within me. And if it pleases the actors and the screenwriter then I try to keep it. I'm actually quite delighted when I come across an idea that I can't analyze and explain."

For this very reason Resnais often turns to music to guide him through a film. In *L'Amour à Mort* he decided that the score would be the focus of attention. And in order to make sure that the audience concentrated on certain parts of the score. Resnais actually eliminated images from the screen. He inserts a blank screen (there is sometimes a hint of falling snow on the frame) which cuts into the narrative. The effect is almost as irritating as watching a feature film on American T.V., for the moment something interesting occurs, it is interrupted. I asked Resnais why he had fragmented the film with these blanks. Was it an attempt to create a visual metaphor for the afterlife?

"My only intention was to allow the spectator to listen to the score as attentively as possible. Even before we came up with

the story, my intention was to make a film where the soundtrack would be completely in the foreground. This time the music would almost be telling the story. And it would allow us to have pared-down dialogues, without adjectives or adverbs. The music would be stating what could not be expressed in words. As for the blank sequences, I had intended that they contain no meaning. But perhaps your interpretation is right. Perhaps, unconsciously, we were giving an image of the afterlife."

I told Resnais that rather than making the film more accessible, this technique had a disconcerting effect. Resnais agreed: "Perhaps I should have shown the orchestra preparing to play the piece, before I began telling the story of the film. But we didn't have the money to do it. It's a pity. But that's the nature of the cinema. One never has enough money or time to explore an idea fully."

I was surprised that a director of Resnais's stature would find difficulty financing his films: "Reputation has nothing to do with it. Having a reputation makes it easier to meet people in the film industry, but it's the number of spectators you draw that actually counts. It's true that if I want to make a low-budget film, costing, let's say, five or six million francs, then I won't have difficulties. But if I want to spend more than seven million French francs, it becomes very hard. And a normal (if one can use the word) film costs about thirty million francs. I'm not like Eric Rohmer, who is lucky enough to feel at ease within a budget of seven million francs. He shoots a film quickly, and is quite at ease within this budget. But I'm not."

I asked Resnais whether he had found the same problems in the United States as in France. For he had tried to make a film about the Marquis de Sade, financed in the States, with Richard Seaver. And Resnais and his wife Florence had lived in New York while working on this project: "An American producer will never put any money into a French film before it's in the can. His reply will always be: Listen, go ahead and make the film, and we'll decide afterwards."

But I knew that Costa-Gavras was preparing an American-financed film, *War Days*, and that he had also managed to make *Missing*. "Well, actually Costa-Gavras tried to help me as a friend to get American finance for this film on the Marquis de Sade

with Richard Seaver. He asked around New York. But they told him, 'Look, we like Resnais, he's very sweet. But this is the number of spectators he draws. It's too much of a financial risk.' And, in fact, my films draw between eighteen thousand and two million spectators. That's all. If I were a playwright or a novelist I would be a success. But it's not enough for a filmmaker. Sometimes people tell me that I should try making simpler films. That might work better. So I tried and I didn't gain one more spectator."

Resnais says that he makes films always keeping the audience in mind. He wants to please as many people as possible. He sees filmmaking as a profession, and his choice of subjects often comes from producers, not from himself. "Filmmaking is my job. And it's the way I earn my living. It's quite simple. Most of my works, certainly all that were shot in 35 millimeter, were commissioned. I have never intended to make one kind of film rather than another. I would grab the opportunity of making a film that came up. But I should add that I need to work with complete freedom. I'm quite happy to take a subject that's offered as long as no one interferes with the way I direct.

"And it's hard to find films to direct. The French film industry has been in crisis since 1917, and it's strange that nothing can kill the wish to make films. Because, from an economic point of view, the French film industry is crumbling. I'm not an economist, but I believe that the main problem stems from the price of seats. It hasn't kept up with the rate of inflation. The real cost of a seat in a French cinema is about ninety francs. But if it were that expensive people wouldn't go to the cinema. So people try to find ways of making low-budget films, and everyone waits for the blockbuster.

"Let's not forget François Truffaut's *Le Dernier Métro*. I remember that even at the end of shooting, he felt sure that he had made the least commercial film of his entire career. And suddenly it became a huge success. So each time one makes a film one mustn't forget that it could be different this time, and it could be a success with the public, even when one least expects it. Thank God producers think the same way. That's why they take the risk."

Throughout our conversation, Resnais tried to give the

impression that he was a hired craftsman of film rather than an artist. I asked him whether he made films for any other reason than to please the public and earn his living. For I felt convinced that these needs were not the source of Alain Resnais's work.

He admitted that he did love making films, and in particular, working on the set. But he did not like talking about having a "vocation" or delving into the reasons why he made films: "Some of the questions you ask are very complicated. You bring into question the whole history of art. And I have no idea why some human beings have the capacity to materialize their dreams. And why some people buy them and absorb them, and thank them for having done a work of art by giving them money. I find it a passionately interesting question, but, for the moment it's an enigma. But I often think that, from a practical point of view, art has a function. For it is often very difficult for people to communicate with each other, and thanks to books and paintings and films, you can communicate with people more quickly than you can in life. Thanks to certain insights that an artist gives one, you can gain understanding, and you can love or hate a person more rapidly than you can when you meet people in ordinary life."

With a sense of relief, Resnais told me of his next film, which will be scripted by the Czech novelist Milan Kundera, who has been living in Paris since 1975. Of course Kundera is a friend, and Resnais will give him a great deal of freedom. Resnais says that the film will be a comedy. ❖

I t is strange to hear Alain Robbe-Grillet saying that theories are irrelevant to the making of films. Strange also that this adamantly noncommercial director should be more than willing to discuss his latest project *Le Jeu avec le feu* in exclusively commercial terms, manifesting great delight at his first opportunity to direct and script a large-budget feature film with a star cast including Trintignant, Noiret, and Anicée Alvina.

Despite self-imposed periods of abstinence before the com-

pletion of a film, Robbe-Grillet is well known for the bouts of theorizing that follow. *Glissements progressifs du plaisir (Progressive Slidings of Pleasure)* exemplified the pattern: the very successful showing of the film in Paris coincided with the *publication* of a new kind of *ciné-roman* which was originally aimed at film students, but surprised the author by its large-scale popularity. The *ciné-roman* provides a running commentary on the scenario and offers a possible "reading" of the film. In his preface Robbe-Grillet writes his own "Apology," anticipating the criticisms of his public, and explains that the rather provocative cinematic images are not the product of his fantasy world, but of society's, and that he only uses pornography because it is part of the vocabulary of the culture in which he lives. But while he is happy to use the so-called collective fantasy world of his culture, he disdains the conventions that the average audience expects of a film. "Of course my film does not have a plot. . . ."

In the same way that he championed the "New Novel" in the 1950's, he is now the proponent of a corresponding movement in films. Narrative structure, character, and "ideas" are dispensed with; the image alone remains. But surely the image cannot exist on a purely visual level?

"The camera records surfaces and the 'meaning' of the images does not interest me. I do not use symbolism in my films."

But the images Robbe-Grillet uses are highly charged: invariably, naked women enact the clichéd rites of the blue movie; whips, chains, crosses and blood are the inevitable props; the non-narrative story is based on a police inquiry into the murder of a young girl who shared a flat with the heroine Alice (Anicée Alvina) before her death. Alice is accused of the murder and is kept in a pure white prison run by lesbian nuns. Apart from the white walls, the images are by no means neutral. Does Robbe-Grillet really believe that these images can be taken on a purely visual level? Is he attempting to titillate his audience?

"My films are not erotically stimulating. There is a complete difference between my film and a pornographic film. They aim to excite the audience. I intend to deprive these images of excitement and hope to reveal their banality."

Alain Robbe-Grillet seems to be attempting the impossibly difficult task of incorporating a critique of his film within the

Despite self-imposed periods of abstinence before the completion of a film, Alain Robbe-Grillet is well known for the bouts of theorizing that follow.

film. The conflict between the creator and the critic is exemplified in *Glissements*. He realizes that many critics dismiss his "ironic" treatment of eroticism as mere pornography and hark back to the less explicit sexuality of *L'Année dernière à Marienbad* when he was under the wing of Alain Resnais.

"Alain Resnais is an essentially traditional film director. Unless he has someone like myself or Marguerite Duras to work with he slips back into making conventional movies like *Stavisky*. I proposed the idea of *Marienbad* to Resnais and he was prepared to work with me because he knows that he needs to be pulled up by his scriptwriter." Robbe-Grillet evidently does not need a scriptwriter. Since 1963 he has scripted and directed six films. He seems to be unwilling to enter into close collaboration with either director or scriptwriter. "I would describe my relationship with Resnais as the rape of Resnais by Robbe-Grillet."

Robbe-Grillet considers the transition from writing to directing films as the natural development for a *nouveau romancier*. In his famous novel *La Jalousie* his "point of view" is that of a camera. He describes objects and surfaces and does not develop plot or character in the novel. The eroticism is more controlled and subtle; the reality of the cinematic image tends to destroy the austerity that he achieved so admirably with words.

However, Robbe-Grillet has not deserted the literary world. He is currently an editor at the publishing house, Les Editions de Minuit, where he is free to exercise his critical faculties. I met him in his office surrounded by a pile of books that he had to read in the one afternoon that he takes off from working on *Le Jeu avec le feu!* He pushed an article into my hand and said as a word of warning, "The critics just don't understand my films . . . sometimes I feel they want to misunderstand."

Alain Robbe-Grillet has to contend with his own critical faculties, so he is wary of the dangers of criticism. Even his manner betrays the conflicting aspects of his personality: he explains his point with the precision and insistence of a professor dealing with a rather dull pupil, and at times treats you to an ebullient chuckle that suits his strapping physique and his enthusiastic, energetic personality. Although certain critics might not understand his films, the public seems to appreciate them. "I never make films for a particular audience, and when I

started directing I felt my films did not cater to any existing public. But I seem to have created one myself." ❖

Three times in his career, Louis Malle has worked from an impossible proposition: the first was in *Zazie dans le Métro* (1960) when he attempted to translate the exclusively verbal games of Queneau into cinematic images; the second was in *Black Moon*, where he strove to retain the authentic, primary vision of dreams and the contradictory logic of his unconscious without submitting it to interpretation or adopting a visual language shared by the public. Malle's third impossible proposition was to attempt to make an American comedy, *Crackers*, when he moved to the United States. I met him as he was preparing to leave Paris to live in America.

Malle came to the States partly out of a sense of disillusionment with Parisian life and culture. And he looked to the States for his subject matter. *Pretty Baby*, the first film he made when he moved to the States, still shows the sensibility and personality of a brilliant but definitely French director. The editing is slow, and Malle chose a location, New Orleans, that is marked by a French tradition. His next film, *Atlantic City*, was another story about corruption, but this time it was the drug trade and the underworld of drug dealers and strays and waifs. *Crackers* shows what can happen to a director when he loses sight of his cultural roots. It was a film that attempted to convey American humor. And sense of humor is a cultural peculiarity.

"I work in the opposite way to most film directors. Often, they elaborate on a variation of a classical theme. I take my starting point as an unacceptable, impossible, and shocking idea and try to render it acceptable. In *Black Moon* I was dealing with a dream that was no longer a dream, and I tried to communicate it. But I think I went too far, too quickly. I should have graduated to it slowly and warned the public."

Malle sees *Black Moon* as an accelerated culmination of a theme he has explored in almost all his previous films: in

"Each time I come to a turning point in my life, in work or personally, I make irrational decisions," said Louis Malle, as he prepared to leave Paris to live in the States.

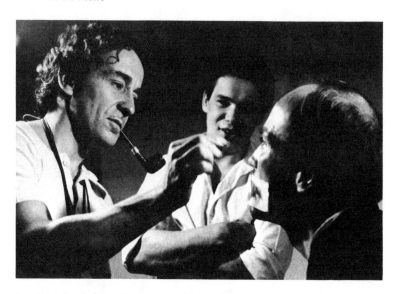

Louis Malle (left) with actor Jean Blaise, during the shooting of *Lacombe Lucien*. In this film he was interested in exploring society's vacation from law and order during the Occupation.

Lacombe Lucien he was fascinated by society's vacation from law and reason during the Occupation; in *Les Amants*, by a woman's ditching of her conscience and society's precepts; in *Black Moon*, by the dismantling of his own conscious and rational faculties:

"In life, people behave incredibly irrationally. But in so-called realism, people eliminate the irrational. Myself, each time I come to a turning point in my life, either in work or personally, I make irrational decisions. People want fiction to be more 'real' than life which means they want to eliminate the illogical. But it is precisely this which interests me. When I'd worked out what was of interest in *Lacombe Lucien*, I decided to push the idea further. *Black Moon* involved taking a risk. If I hadn't done it then I would never have done it, for a film has to coincide with a certain moment in life."

But *Lacombe Lucien* was an easier film to accept because the director maintained a reassuring control over his disturbing

material. The public is hostile and anguished by *Black Moon* for the universe that Malle presents is outside his control, and deliberately so.

"I tried to allow the flood of images to take over without giving them a symbolic or allegorical meaning. On the contrary, when I felt I was becoming too symbolic I tried to eliminate the tendency. Therefore," said Malle pausing, and rather surprised by his own words, "it must have come from very deep within me. Psychoanalytical interpretation is too simplistic and attempts to decompose and make a dictionary of things which are opaque. The unconscious resists analysis by definition."

In order to remain faithful to the source of his inspiration, Malle refused to taint it with his conscious, explanatory powers: "It was important to escape from a logical narrative structure and coherent psychology. Of course, the public likes the lack of surprise. But I wanted to find another coherence and logic. I was often tempted to return to a chain of cause and effect and to use a priori thinking, but I resisted in order to discover a more interrogative, open form. In *Black Moon*, the people surprised themselves, had no control over their actions and neither did the author."

Black Moon is a more intransigent and developed statement of another dominant characteristic of Malle's films: "I do not film my life, but there is, indisputably, a strong correspondence between my life and my films. My films are like distorting mirrors, but the reflection changes what it reflects. *Black Moon* was born out of a static period when I was locked in my room, in the middle of the countryside. It was like a closed circuit because I filmed it in my own house and used elements of my life. By installing myself in the film and by extrapolating from my own experience, I felt I was nearing the truth . . . it was a cry of fear and anguish; it had a lot to do with my own traumas and hang-ups. I had the impression I was living the scenario rather than writing it. I used my dreams and my waking life. The first sequence of *Black Moon* was created out of a dream I had.

"Making films can be a job. For some directors, being on a set is the most satisfying moment of their life. For me, making a film is not enough. I need difficulties, a challenge, a constraint

to overcome. A film is a way of getting rid of an interrogation. The interpenetration between my life and work is extensive: I even choose actors because I want to get to know them, and like them. They have a place in my life during and after a film."

In *Le feu follet* (1963), a film about the days preceding the hero's suicide, Malle was exposing another intimate state of mind. "I was filled with panic at the thought of presenting it to the public and almost tried to prevent it from being shown. It felt like placing myself naked on the screen. But films are only made to communicate to others and I had no right to feel like this."

And herein lies the problem of *Black Moon*: how can Malle expose fragments from his unconscious and communicate them to his audience, when, by his definition, they lie outside a shared verbal or visual language? Can he expect an audience to cauterize their reason, and enter, vulnerable and disoriented, into the world of *Black Moon*? He would have us enter this world without the equipment to face it or exorcize it. Malle, it seems, was aware of this problem:

"Myth is, in each society, the collective unconscious, the inexplicable that we share. We try to contain and control it in a system of thought that one calls archaic, but is, in my view, much closer to nature. Instead of analyzing this material abstractly, we use images and narratives which are tools for exorcizing and understanding. My ambition, which I didn't completely achieve, was to go to this most inexplicable material within me and share it with others."

Myth, however, offers an alternative coherence, whereas *Black Moon* denies such simplification and pattern. Malle admits that the problem of the film is that it cannot be communicated to the unconverted. "It can only speak to those who are already supple, who have none of the rigid mental structures imposed by society. People don't like the film because I dispensed with the apparatus of logic that made my previous films function. I make them return to childhood or exile them from the film. And, in fact, children react wonderfully to the film. It is a familiar world for them, less surprising than the world of adults. *Black Moon* represents the universe before the onset of puberty

and describes the fear of entering into an adult world. Someone said it was an initiatory fairy story."

Malle's maturity and success as a film director has led him to push his almost acceptable obsessions to their "logical" conclusion and to stand by them in an adolescent and courageous manner. In our conversation, he was however willing to abandon the monologue that is considered acceptable in artistic work, and to submit his intimate and deeply felt ideas to examination and perhaps to distortion. ❖

"**K**leist's short story, *Die Marquise Von O . . .* (you've read it, I suppose), is dry, precise and concise. Kleist never wastes words," says Eric Rohmer with a febrile enthusiasm. He could be describing himself. The director of *Les Contes Moraux* and numerous educational television series does not pause for breath. *Die Marquise Von O . . .* is merely the first stage in his quest for the past. It will form part of a series of six or more films entitled *Les Contes Historiques*.

Rohmer, having set up the tape recorder himself, continued to conduct the interview. He neither solicits nor suffers any prompting and heads straight to the point: "It's the past in itself which interests me. I make no attempt to modernize. I want to make people appreciate the past and the art of the past. We have inherited a great tradition and must not lose it through laziness. Nowadays, it is true, one must make a great effort because the educational system is less aware of the past. But I am aware that our modern epoch has no *exact* notion of the past."

I managed to ask Rohmer how he intended to capture the exact nature of an epoch he had never experienced. "I have changed almost nothing of the text. That's why I'm filming it in Germany and using German actors. And the exact dialogue of the text will be spoken in the film. *Die Marquise Von O . . .* attracted me because it was neither a novel, short story, nor

play. The book is written as a script. That is to say, there is very little description, except for the visual account of the characters' gestures and positions."

Rohmer continued to talk of his fidelity to the past, stressing his painstaking attention to costume and setting. But as he revealed his method of research, contradictions began to emerge: his perspective shifted from a fidelity to fact towards an accuracy to fiction. "I don't want to show the past as if I were a camera that existed during the epoch and entered into the life of the people. I draw my inspiration from the painting and music which were not the reality of the times. I particularly use the paintings as models of human gesture. I try to capture the declamatory nature of Fuseli without the parodic, ridiculous side. And I'm interested in the lighting, but do not wish to imitate it. History books would teach me nothing. I'm not intending to be an historian. It's not a question of seeing the epoch more accurately than its people, but of trying to use the cinema to evoke the past in a more concrete, alive manner."

But once Rohmer has left behind historical accuracy as a touchstone, how can he claim to present an undistorted image of the past? And, in particular, how would he define the difference between his approach and that of the fashionable "Mode Rétro"? "These nostalgic versions of the past are an admission of our epoch that it cannot re-create. It is not a positive move. It's a sign of our impotence in the face of the past. But people prefer the 'ersatz' past, the folklore of the past. It's rather like people buying plastic wells. Not only do they choose a useless facet of the past, but they also deform it. I am attempting to rediscover an epoch that has perhaps been distorted by tradition."

It was perhaps unwise to ask the dedicated professor of the past why his subject is so important to a modern audience if he makes no attempt to relate it to the present. Unconvinced by my simple question, Rohmer paused for the first time. "But surely you feel the reason," he said rather plaintively. Then he sighed and in a resigned tone continued, "I'll explain why the past is important in modern terms, if that's what you want.

"You know that linguists employ the term 'synchronic' and 'diachronic' to distinguish between an historical, evolutionary

study and the study of a moment in time? People say that the 'diachronic' has been dealt with and it is time to study 'synchrony.' Recently, I did a program on architecture in which I made the point that one must reintroduce 'diachronics' into modern architecture. What makes a city alive is that it is 'diachronic,' that it has been formed by the passage of time, that there are traces of various epochs. Architects must try to re-create that element of diversity which is created by history. We have such a rich past that we must take advantage of it. It's not only the job of the cinema."

But two contradictions still perplexed me: How can Rohmer refrain from making his film relevant to a modern audience and yet persist in proclaiming that the past is crucial to the modern epoch? Why is he obsessed by the wish to copy *Die Marquise von O . . .* faithfully when he professes to create his own work of art? My doubts were elegantly dismissed by a metaphor:

"Certain paintings are covered by dust and gloss that hide the painting. There are modern techniques of cleaning which reveal the true colors of the original. A painting which one found faded becomes bright and 'modern.' I want to clean the dust from *Die Marquise Von O . . .* by means of the cinema. The process of cleansing will make it relevant and will reanimate and re-create." ❖

On the completion of his twentieth film, *La Merveilleuse Visite*, forty years after his début in the cinema, Marcel Carné persists in presenting himself as a deliberately provocative outsider. "I have always been swimming against the tide; now I have chosen to make a film that owes nothing to eroticism and violence; I have chosen the sort of fantastic and whimsical story that does not go down well in France. And I refused to use stars, knowing that they can sell almost any film."

His refusal to conform to prevailing fashion has led to

repeated rebuffs: even *Les Enfants du paradis*, starring Jean-Louis Barrault, was refused at the 1946 Cannes Film Festival. *La Merveilleuse Visite* was refused thirty years later and had to be shown at Antibes. Carné resents the hostility of the French public and critics, yet he deliberately chose to make a film that would not appeal to their tastes; he feels more hopeful about the English public and said, "If the film is shown in London I would love to introduce myself and talk to an English audience about their reactions."

Carné's film is ostensibly based on an English source, a novel by H. G. Wells about an angel visiting a village in Cornwall. In actual fact, he eradicated most of the novel; not only has he changed the setting from Cornwall to Brittany, but he has substituted for Wells's free-thinking attitudes a bland religiosity and, for his reforming zeal, a disgruntled resignation. Carné dismisses Wells's attitudes as "sentimental socialism" and says that the sole idea he retrieved from the novel was that of the angel visiting earth; Carné transforms him into a golden-haired hippie, dressed only in white trousers decorated by a red heart. He lands himself in difficulties because he is untainted by the ways of the world.

"The film is a search for purity and innocence at a moment in time when we are wallowing in pornography and violence. I chose the idea of the angel because it is a powerful visual symbol of purity. I am not trying to say that purity does not exist in a human being. But in my view an innocent person is one who has not been sullied by society, and it is practically impossible to remain innocent when one is participating in ordinary life."

In the film Carné's views are more clearcut: it is only the unreal and fantastic which are pure. Everyday experience is seen as a demeaning compromise. Youth and childhood are spared Carné's most virulent criticism. But the conclusion is that true innocence cannot be attained by a socialized, civilized being.

Carné criticizes French directors for dealing with the sordid aspects of everyday life: "I think French directors ought to be more ambitious in their choice of subject. They should treat more elevated, general subjects, instead of resorting to the usual themes of adultery, human relationships, the trials of everyday reality."

Carné's absolute distinction between good and evil, his rejec-

tion of any form of compromise, and his escape into fantasy give the film a naïve, almost adolescent quality. His absolute, uncompromising attitudes pervade his behavior. He seems to evoke similar attitudes in others: "People either love or hate my films; there seems to be no middle reaction. The Parisian critics dislike whatever I do."

But Carné is somewhat proud of the running battle he maintains with the critics, for it reinforces his image as the artist-pariah—an image that might be harder to sustain after the recent dinner that Valéry Giscard d'Estaing gave in his honor. Nor does he look the part. He is rotund, with twinkling eyes, and a voice that resonates with avuncular jocularity. We both agreed that he does take pains to achieve his seemingly enforced role as outsider. "Perhaps it's a form of masochism," he said smiling, "but it amuses me to make difficulties for myself."

❖

Jean Eustache won popular acclaim and the admiration of the critics at the 1973 Cannes Film Festival with *The Mother and the Whore*, a film that has none of the ingredients of a popular success. For years his progress had been followed by the younger generation of French film directors who continue to see him as both pioneer and mentor. And for years he had been content to make experimental shorts; then in 1971 he made a two-hour film, *Northern Zero*, which has never been shown. *The Mother and the Whore*, because of its length, its verbal, nondramatic and troubling quality, was not a film that courted popular approval.

Eustache remains hostile towards and critical of his achievement, and is unmoved by the public's appreciation. His constant self-deprecation exists alongside a self-confidence and certainty; he would not have been able to sustain a solitary and unrecognized career if he had not believed in his work. Talking to Eustache is as disturbing as watching his films. He expresses strong views and very willfully maintains that he knows nothing.

He is pernickety and belligerent when questioned, as if he wished to undermine the conventions of the interview.

"If I knew exactly what I wanted to say in a film it would not be interesting. And I would be dealing with ideas that everyone already knows. I find I begin to get interested when I am unable to name something, when I cannot define. I never understand what I am doing when I am actually making a film and afterwards my interpretations vary radically. In any case, the difficulties of making a film are so great that one does not have the ability to think of the meaning of the images. One only has the energy to search for the right image. When I was younger I read Flaubert's letters and could not understand why he found writing so painful, why he was always searching for the exact word. After making some films I begin to understand."

Jean Eustache's insistence on the importance of discovering a film through the process of making it might lead one to infer that he does not prepare his films but just allows them to happen. That this is not the case is confirmed by the team he works with. "On the set, everything was worked out in advance, every gesture was measured to the centimeter," said Martin Loeb, the hero of *Mes Petites Amoureuses*. Centonze, Eustache's assistant, said: "People often say that film directors are demanding people. Eustache is just that. Everyone in the crew felt Eustache's determination to drive the film in the direction he wanted it to go." Eustache dismisses the notions of *cinéma-vérité* and improvisation. "*Cinéma* and *vérité* are separate. There is no such thing as *cinéma-vérité*. The so-called reality on the screen bears little relation to life. Film is not photography. In a film, life is completely digested even when the film relies heavily on documentation. Realism is merely an aesthetic choice, a convention. But I don't really understand these sort of classifications. I'll end up saying something, but I will be deceiving myself."

Eustache is adamant that *The Mother and the Whore* is not a social document portraying a certain intellectual milieu. The setting is immaterial. The film, it will be remembered, centers on the predicament of the hero, Alexandre (played by Jean-Pierre Léaud), who has lost touch with life and sees in words the only hope of a return. Most of the scenes take place in

houses and cafés, and the drama is not in the action but in the dialogue and monologues. By emphasizing the verbal at the expense of the visual, Eustache seems to have sacrificed some of the possibilities of the medium to reinforce his theme. At the time he made the film, he says that he too felt life slipping by, although he was aware of the "vertiginous" nature of life.

"The main reason why I have never liked *The Mother and the Whore* was because I felt provoked and attacked when I made it. I had always wanted to make the film that was to become *Mes Petites Amoureuses* but I couldn't raise the money for it. I chose to make *The Mother and the Whore* because it only required a minimal budget of 700,000 francs. The fury with which I made the film was assimilated into its structure and theme: the length was provocative and the title, and I portrayed beautiful young people who were desperate because time was passing them by. They could find no explanation for their predicament."

Ironically, after many frustrating years he obtained the necessary 2,500,000 franc budget for *Mes Petites Amoureuses* on the strength of the success of *The Mother and the Whore*. "It tells the story of a boy of thirteen who begins to discover the world outside himself. He abandons irreversibly the golden age of his early years spent in the village with his friends, and becomes a person who has everything to learn, who perceives the burdensome limitations of regular work and escapes into his first sexual encounters. In the end he discovers that he is alone."

Eustache says the differences between the two films are superficial and that it is "the mask of appearances that might prevent one seeing the similarities." Both films explore a desperation and incomprehension that Eustache felt at different stages in his life. He says his childhood was anguished and that he does not suffer from any nostalgic or romantic notions about it. In both films there is a central male character who is alone. Alexandre is aware of his isolation and tries to seek contact with the world through words; Daniel, the thirteen-year-old, is at the stage of discovering his solitude. Eustache describes himself in similar terms. "I think filmmakers are aberrant misfits. They are useless and should not exist. They exist in contradiction to their surroundings. Only when they have an audience does their

To communicate with Jean Eustache demands a willingness to learn his private language. His conversational tactics are aimed at forcing the other person to share his hyperbolic doubt.

position become legitimate. I think this problem of our isolation and uselessness should be brought up indirectly in the films we make."

Although Eustache never wooed the public and believes that "it's not one's job to educate the public or pander to them," he is obsessed by the manner in which the public might or should react. After all, he admits that the only justification of an otherwise useless activity is provided by the audience.

"Literature and films have had a profound effect on the way I live my life. Because this is the case with me, I assume that it can happen to others. A filmmaker is not a philosopher or a politician. Nor does a film offer a 'poetic' opinion. But if it works, it can transform people's lives profoundly. The smallest disturbance a film can cause is already something to be reckoned with. In fact, I have found myself most influenced by works

that disturb me and that I hated at the time. I am totally against people reacting 'emotionally' to a film. By that I mean that I don't want people to identify with the characters and share their emotions. Nor do I think that it matters whether people believe they have understood a film. Understanding is a spurious notion and is useless. A film should address itself to reflection and leave us cold. Reflection is what happens within the audience when the film has imprinted itself on them and becomes part of them, when they think they have forgotten it. When everything on the surface has been analyzed and understood, reflection is what is left. One must live with a film."

To communicate with Eustache demands a willingness to learn his private language. His definition of the word "disturbance" did clear my mind in one respect: "for me it implies that one is forced into a position of doubting everything, that one's principles and ideas are turned upside down." It is not that Eustache does not have strong views but rather that he is ashamed of having them. To say "I don't really know" at the end of each statement seems to allow him to believe that he has no prejudices or fixed ideas. His conversational tactics are often aimed at forcing the other person to share his hyperbolic doubt. "One must not rest upon one's principles. Most of my life has been spent in trying to rid myself of the notions I already believed in when I was a child. I feel impelled to doubt everything even though it prevents tranquillity and makes me feel disturbed and uncomfortable."

Jean Eustache was born in 1938. He committed suicide on the night of 5 November 1981. After *Mes petites amoureuses* (1974) he made several films: *Une sale histoire* (1978), *La Rosière de pessac* (1979), *Le Jardin des délices de Jérôme Bosch* (1980) for a television series, and *Les photos d'Alix* (also for television). Eustache had been working on some projects that he intended to film. The screenplay for *La Ville S'allume* had been deposited at the Centre National du Cinema (CNC), and he intended to use Michael Lonsdale and Jean-Pierre Sentier for the main roles. He was also making a video film about himself.

I was surprised to hear Parisians suggesting that he had committed suicide because he had been unable to find financing

for his film. Many spoke of him as a victim of the film industry. I asked Bertrand Tavernier if Eustache had, in reality, abandoned hope of making films, and had thus killed himself.

"No. Because Jean Eustache was very ill at ease with himself. He drank a lot. He had many reasons for committing suicide. Eustache was able to make films. He even had propositions from Gaumont because he was a director who was admired and supported by the critics. And when the critics like you in France, you can express yourself. Perhaps somewhere inside he had a crisis of creative impotence. Perhaps he had momentary difficulties getting finance, but I don't really believe that he couldn't make films. You can always find people in television and even producers who will finance your projects. Through snobbishness. But Eustache's films had talent, over and above snob appeal. And he had an enormous appeal with *The Mother and the Whore.*"

The tragedy of Eustache appeared to preoccupy Tavernier, for he continued to talk at length about the young deceased director without any further prompting. "The real problem was that Eustache had difficulty writing up certain stories. Perhaps because he chose to write about his personal dramas, and at a certain point he exhausted the material of his own life. Or perhaps because he wanted to make certain kinds of films, and people wanted to push him in a different direction. But it wasn't because he couldn't find financing for his films. Eustache had always been marked by death. As I said, he was a depressive, like many alcoholics.

"And there were many people, and at least two or three of his girlfriends, who killed themselves—there were people in Eustache's entourage who killed themselves without anyone mentioning it. So he was someone who provoked death, and who lived a tormented life. He used to tape-record all his conversations with girlfriends, all the rows, and then he'd use them for his dialogues in his films. There were women who recognized themselves in a film of his and killed themselves. And so it wasn't his relationship to the industry that was the key factor. It was also his relationship to his films."

As Tavernier spoke, he revealed his own acceptance of the vicissitudes of being a film director. "You know, I don't think

one can subscribe to the notion of the misunderstood artist. There are many people who make a film every eight years and don't commit suicide. The industry can be at times pitiless and detestable, but wouldn't it be better to take a job at Renault? The anguish that one goes through as a creator is really a luxury. And the pain is also balanced by extraordinary joy. One has to take responsibility. I feel very mistrustful of the idea that when someone dies he must be a victim of society. Because I feel everyone is responsible for what he does. And, you know, people destroy themselves first. Jean Eustache wasn't killed by the French film industry in the same way that Marilyn Monroe wasn't killed by Hollywood. But it's sad, really sad, that he died, because he had enormous talent." ❖

B ertrand Tavernier, who has directed such varied films as *Death Watch* and *A Sunday in the Country*, chooses to explore diverse subjects partly because he is afraid of his natural tendency to return to the same themes and characters. On the set, Tavernier has caught himself repeating certain sequences from previous films. But he feels that despite his decision to explore different epochs and varied worlds, his central theme remains the same:

"Most of the characters that interest me are people who are preoccupied by the problems of communicating, and they are always people in crisis. On some level they are always creative people. Whether it be the Regent in *La Fête Commence* or Nathalie Baye in *Une Semaine de vacances*, Harvey Keitel in *Death Watch*, or even Michel Piccoli in *Les Enfants Gâtés*. The Regent of France was a musician, because he listened to music during the film. He was an intellectual, a writer, and he was dealing with the problem of power, like the central character of *Coup de Tourchon*, who was dealing with corruption. I know that all these films have something in common, because at certain points it became a standard joke with the crew. They would say, 'Here we go again. We're doing the same sequence again that we did in his

last film.' It's true that, superficially, I like changing with each film, because I like exploring new worlds. But even in my choice of epochs, I have always chosen the moments when something was coming to an end, whether it was after '68 in *L'Horloger de St. Paul*, or 1912 in *Un Dimanche à la Campagne*."

Quite recently, Tavernier decided that he would not contradict his desire to return to the same theme. "I had great difficulty in letting go of the people in *A Sunday in the Country*. And I didn't want to leave them for anything. They stayed with me for a long time, and they're still with me. I wanted to remain in their atmosphere, and you know, that changed a lot of things for me: It changed the way I thought about directing. Suddenly, I found I could allow myself to retain certain things in the scenario that I wrote, which I would never have dared retain before *A Sunday in the Country*."

Tavernier realizes that he has always, on some level, made films that describe his own creative process. He is not interested in making films about himself, in a documentary sense, but rather in exploring the relationships that surface in his imagination. "I have the impression that I always identify myself very strongly with most of my characters, and that they are, to some extent, allegorical images of a film director. Frequently, the main characters are my doubles. When I make a film, I always experience conflict between the central character and the secondary roles. I have very bizarre relationships with my secondary characters. Often, I feel that I am using them to reply to the doubts of the central character. Because one of the main characteristics of my central character is doubt, and a certain kind of questioning, and anxiety. Some of his questions are answered by the other characters, and another kind of question is resolved by the film itself, by the way it is shot. And another kind of question is answered and responded to by the public. I always want to leave a place for the spectator, and I know that some questions can only find a response in the audience."

Tavernier believes that it is his responsibility as director to respond to the questions of his central character and also bring reassurance and answers to his actors. "One uses different methods for each person, but I feel that actors are often fragile, and that they demand some kind of protection from a director.

There are thousands of ways of giving them what they ask for. Sometimes it's enough to create a good atmosphere on the set, so they feel wanted and needed, and that you have trust in them. It's so important that they should feel they can try anything. That you never censor them. And I try to extend this same feeling to the technicians—in fact, to everyone who works on a film of mine. And then you have to create in your team a desire to surprise you. I've seen films where people just do their job. But they don't try to astonish the director because they don't have human contact with him. And without human contact you can't make demands and people never transcend themselves."

Tavernier adapts himself to the particular needs of each actor and does not have any habitual style of directing. "Harvey Keitel needed to have a deep understanding of what he was doing. He asked lots of questions about motivation. But I think some of it was just a need to be reassured. With Phillipe Noiret it was completely different. He needs two or three guidelines. With Romy Schneider, all I needed was to mention a piece of music. I'd say, "I want you to act it like that passage of Mahler. I want you to find that melody for me.' And she would know exactly what I meant, and she'd do it. Harvey would have asked me, 'Why not Beethoven. Why Mahler?' I think that's also to do with a difference of acting traditions. Jean Vilar was used to acting the French classics and he had a very analytical understanding of everything. He understood what I wanted, immediately."

Tavernier's sensitivity to nuances of emotion is perhaps the most startling quality of his work. He often manages to capture movement of an emotion that is not in itself dramatic. In *A Sunday in the Country*, there are moments when Ducreux, the painter, sits alone in his studio and reflects. Nothing is said and he makes few movements, and yet one senses his silent emotions. His daughter, Sabine Azéma, is an energetic, explosively cheerful young woman, and yet Tavernier, without any helpful hints from the dialogue, makes us aware of her underlying pain.

I asked him whether film lends itself easily to the expression of such delicate nuances of emotion for he has a novelist's ability to describe the inner life of characters. "I feel that film can

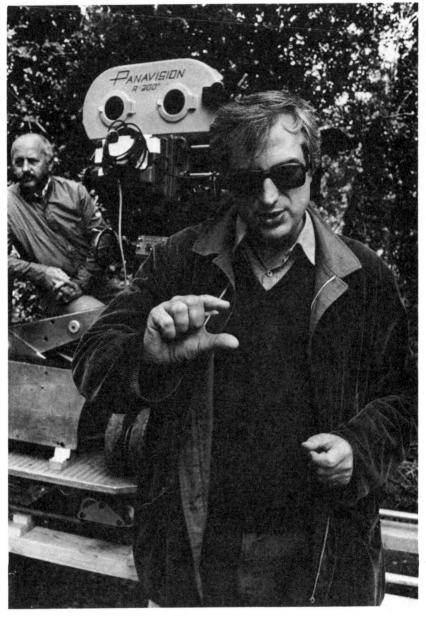

"Frequently the main characters in my films are my doubles," said director Bertrand Tavernier.

explore emotion in great depth. All the directors, like Renoir and Lubitsch, whom I admire, have explored feelings. And I don't just mean that film can do what the novel does. I'm not just talking about the dialogues. For there are moments when the way you place the camera and the way you edit sequences can suggest emotions that are as deep as anything that Stendhal or Balzac could create. So you see I don't think the cinema has any limits. I've heard writers say that film is incapable of doing this or that. It's not true. And nor is the way you achieve certain moments a matter of technique. The way you move from one angle to another can change the whole meaning of a scene. It's like saying that Stendhal's sentences were a question of grammar."

Since Tavernier's eye is focused on the emotions of his characters, so his camera and his script trace the story of feelings. "I've been wanting to go in a more emotional direction. And I want now to completely suppress the notion of intrigue, in the sense of a dramatic twist. These coup de théâtres irritate me. I kept some in the first part of *Death Watch* and I regret it. I want the story to spring from the emotions of my characters, and for these emotions to arise out of the inner self of a character. I don't want emotions to come from some accident dreamt up by a screenwriter. For I believe that one can express very pure emotions in film.

"My favorite films, like *La Règle du Jeu* and *La Grande Illusion*, are those where dramatic ironies are minimal, and when they happen they are organic to the material. They are true surprises that ask real questions. And in modern American cinema there are directors like John Huston who base the rhythm of their film on the rhythm of their characters. With an actor like Gary Cooper you couldn't impose a rhythm on him. He brought along his own music. And you mustn't confuse rhythm with speed. And film can move slowly and still have a rhythm and a speed. It's really a question of music."

Tavernier tries to orchestrate the melodies of his characters' emotions, and his next film will be about this part of himself. He has chosen to make another "emotional" film. "Like *A Sunday in the Country*. It's about the deep friendship, almost the love between two men, from very different cultures: about a black

tenor saxophonist and a young Frenchman. And I've set it in Paris in 1959, which for me was one of the most creative periods for jazz. I want to make a film about the anguish and passions of a jazz musician. But there will also be a strong story of friendship which even people who don't know jazz will be able to understand. In the same way as in *A Sunday in the Country*, people could understand the film without knowing anything about being a painter."

Tavernier wants his films to be accessible to the public. He talks about critics with disdain, and would not be content with an audience of intellectuals. He lives in Paris but often finds the atmosphere suffocating. And though this next film is set in Paris, he will shoot most of it in Lyon, his hometown. During our conversation he was often on the defensive, and though I do not feel and did not suggest that he was a conventional director, he told me that many critics do not describe him as "avant-garde."

"Critics always try to categorize people, and contrast them. They say that one director is traditional, and another is avant garde. And then, twenty years later, you see that the supposedly traditional director is still an important force and the avant garde one is old-fashioned. The film industry is large enough to harbor all kinds of directors, and there should be a law against critics who say one kind of cinema is superior to the other. As for me, there are moments when I envy what Godard does. But there's no reason for me to feel inferior to Godard. I lost that complex a long time ago. I think I'd be incapable of making his kind of films. I don't think Godard would have the discipline I have to make my kind of films. I don't think that there's one genre of cinema that is superior to another, or that one genre of film renders another kind of film obsolete."

Decisive Women

Marguerite Duras
Delphine Seyrig
Roger Vadim
Monique Wittig
Françoise Giroud

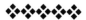

"In *India Song* I pose, in principle, the sovereignty of Woman. I hope I have not demonstrated it or made a didactic film," says Marguerite Duras as if to silence those who reproach her for a cerebral or theoretical approach. For Duras, such an approach belongs to the masculine world, and she wishes to define the distinction between male and female and to place herself firmly in the latter category.

"When I write or film I have the feeling that I silence the virile voice, the cultural voice within me. I am never as female as when I write," she says in a stylized manner, worthy of her heroine. "It's not true to say that my films are created by intelligence. They are made in a state of passionate crisis. Normally in about fifteen days.

"Afterwards, intelligence intervenes, in the montage and editing. But during the shooting and before, I am in an extraordinary emotional state. In the beginning I maintained a distance from my films. But now that the technical side poses no problems, it does not mask the crisis."

In *India Song*, Duras calls on Delphine Seyrig to represent her notion of Woman: Anne-Marie Stretter, France's Ambassadress in Calcutta, who speaks little, moves like a tigress, and is "infinitely desirable." Duras explains: "She represents the sovereignty of Woman's body. She is the only person in the film who pronounces the word 'intelligence.' She has an intelligence of India and of the oppression. She and the Vice Consul, who is a virginal man, almost androgynous. I say that they are mad. The Vice Consul because he wakes up each morning and sees the world for the first time. The injustice and horror of his life

is intolerable. He remains true to his madness and Anne-Marie to hers: her corporeal knowledge of the world which I call intelligence."

I questioned Duras on her choice of the word "mad" in this context. "Yes. You are right to question me. I do not give recognition to the term 'mad'. I use the masculine world's language so they will understand me. It is a form of accusation."

Talking to Marguerite Duras one feels that one has been female without being aware of it. She ushers one into an undiscovered sovereign world of women which defies male participation. "The knowledge that Anne-Marie Stretter has is completely female. A man could never have it. I could describe this female quality as a kind of constant identification. I say somewhere that she *is* Calcutta. Woman is open to everything. She is constantly listening. She has no specific place. Men have lost this corporeal knowledge. They are everywhere at the same time, dispersed—in their heads, in a rhetorical practice of life.

"It is the millennial silence of woman which makes this osmosis with life possible. It is a liquid state which flows on the same level as life. Almost like a child's perceptions."

While Duras extols and perhaps creates certain specifically female qualities, I wondered if her films would get made if she followed these precepts too faithfully. The wielding of power through words, the direction of a film crew, all require what Duras chooses to term masculine. Although she claims that her ideas are not born of intelligence, she certainly demonstrates an analytical capacity when communicating them in words and images.

Duras stresses the importance of Stretter's womanliness, but the central theme of the film—and of our conversation—was her death and its implications. Stretter's story is recounted about forty years after it happened. Instead of attempting to reconstruct a "livable" narrative, Duras presents the lacuna and disintegration that death and passing time imposed. "It was only possible to make the film because the woman's story had been stopped by death. One could not write her history if she were living. For writing or filming are always in the past. Narration cannot refer to the immediate present."

Our sole link with Anne-Marie Stretter's past is through

"I am never as female as when I write," said Marguerite Duras. "When I write or film I have the feeling that I silence the virile, the cultural voice within me."

memory. The fragmented, elusive narrative of *India Song* mirrors the distortions and fictions created by remembrance. The film is not a monument immune to time. It reenacts the erosion caused by passing time. Duras refers to it as the "place of death and doubt."

"The photography of death is there on the screen. The settings are also important: Anne-Marie appears by what I call the 'altar'—a piano with a bowl of roses and an old photograph, in a rectangle surrounded by mirrors. The mirrors cast further doubt on all that happens. There are also the ruins where no one enters, which are emptied forever by time. The sucking in of everything by death. Here the narrative voices speak in the past tense."

Such careful details characterize the film and suggest the work of a conscious, analytical intelligence, even though the source and effect are emotional. But Duras continues to play her anti-intellectual role: "I cannot tolerate any philosophy about death. My awareness of death simply makes me feel that I must occupy my time according to my desires."

If Duras's films and books occupy her time adequately, it is strange that she should conclude "I hope women will never talk as much as men, and never on the same level." Fortunately, Marguerite Duras is the last person to be taken in by her own rhetoric. ❖

D elphine Seyrig made her name by incarnating, as she puts it, "a sophisticated, inaccessible woman, a dream who is not the true ideal because she doesn't do the washing up." The qualities that Alain Resnais brought out in *Last Year in Marienbad* have stood her in good stead. But Seyrig has become increasingly disenchanted with her screen image.

Her figure shrouded in layers of peasant skirts and her face pale and evanescent without makeup, it is only her curled auburn hair, feline movements, and husky female voice that identify her with her screen image. Outside her spacious living

room one can hear the laughter and chatter of the women who participate in her feminist activities. She launches into an explanation of feminism which, when she discovered it, was a catalyst that gave her the confidence to express all that she had intuited and bottled up:

"It starts off when you're a little girl. You are almost born angry. You notice the difference between little boys and girls. At school, you learn that everything has been created and invented by men. I knew I had to smile, be mischievous and pretty. People had a low opinion of my intelligence. When I tried to speak about things that were important to me I was told it was nonsense. So I became superficial in order to please. I saw a choice before me, although I couldn't formulate it: to rebel right from the start, or to say to myself, 'In order to survive I must become what others want me to be. Otherwise I will be crushed. It's evident that people aren't interested in *me*, so to be recognized I will exist for others. In myself I am nothing.' I chose the latter course and succeeded in giving the image that men wanted, always with a nagging feeling of disquiet."

Seyrig feels that her role as an actress exemplifies all that is destructive in the relationship of women to men. "Actresses represent clearly what men want, and yet they also reveal the anguish of fulfilling this role, for the public know about the problems of our personal life. But we also oppress women by offering them an image which is impossible to live up to. We set up envy. But that, again, is typical of man's attempt to sow discord among women."

Seyrig discusses the frustrations and constraints of being an actress and sees a direct comparison with the situation of women in general. "When I wanted to become an actress I thought I would have the chance to express myself. What did I do? I ended up learning texts by heart. After many years, I realized that I had never expressed myself. I had only expressed what would make me acceptable. But, on stage, I tried to get through to women, and I know they understood me, from their letters. Unlike men, they have a magical, indirect way of telling you their reactions. It is never explicit or explained. And I communicated with them in an indirect, underhand way. It was like

the Resistance movement, a sort of underground. What you say has to come through surreptitiously because you're working from set texts by men. That form of communication is particular to women."

Because of her firm belief that film acting is essentially dominated by male film directors, she is starting to work with women directors, like Marguerite Duras and Chantal Ackerman.

"I was always bewitched by successful women and tried to fit into the mould. I still try to fit in. Some women liberate themselves completely. But the games and roles are so ancient and complex that I can't find a satisfactory alternative. At the moment, I am wondering if one has to become masculine in order to give up being what men want. I'm sure there will be a way of being neither masculine nor feminine. But I don't have my own image of myself. And I don't expect to achieve authenticity and heterogenity before I die. Old age does tend to facilitate authority in women, but for an actress it is very difficult. I'd prefer to be a coquette than an authoritarian replica of a man. Some career women are like transvestites. They accept and participate in male society and government. I fear all structure, authority and power-wielding. I am frightened that women will become men.

"And I'm not interested in explaining it to men. They make no effort to understand our problems and they find it amusing. Obviously, people are not going to give up their privileges with joy. I don't care if men are deaf and blind to our movement. I've exhausted myself trying to persuade them, but I now prefer talking to women. Men can only change within themselves. We can only state and define our position, but we can't discuss the rights and wrongs of the issue with them." ❖

Françoise Giroud's installation as France's first Secretary of State for Women was perhaps a sign that fundamental attitudes were changing in the mid-seventies. Nearly every

director, talented or otherwise, female or male, had his or her say about the New Woman. But the New Year issue of *Paris-Match* summed up the previous year as "l'année de la femme," and its pictorial contents revealed just what aspects of women they were celebrating: a full frontal of Brigitte Bardot at forty, Emmanuelle's breasts on the cover, and a center-page spread of 10 naked victims taken from Borowczyk's *Contes immoraux*. A new erotic film emporium, the Alpha-Elysées, had just opened. The doyen of this kind of erotic "feminism," Roger Vadim, was concerned that his monopoly might be ending.

When I met him in 1975, he was, understandably, bored with the image he created for himself. He feels that he has lost sight of what he wants to do by fulfilling the demands of producers, distributors, and stars. In the twenty years since he directed his first film, *And God Created Woman* with Brigitte Bardot, he has known only too well how to sell himself, his wives, and thereby his films. He sees himself as someone who has been typecast for too long.

"It was very difficult to liberate myself from commercial success. When you've made a successful film, producers want to repeat the formula," he says, talking in a mixture of French and English (although he has a perfect command of the latter).

At forty-six, he had just made the first film for which he was willing to take full responsibility. *La Jeune Fille Assassinée* is, according to Vadim, an exploration of the problems of the new freedom that women have today. He has scripted, directed, and produced it and also stars in it. Its heroine, Charlotte, played by a new actress, Sirpa Lane, is "young, beautiful, and brilliant and feels that she can do whatever she likes." But Vadim shows that it isn't that simple: she ends up brutally murdered.

"Nowadays women are in a difficult position," he says. "They are made to believe that they can do anything. They can: but what they don't realize is that it's dangerous." Vadim feels that he talks from personal experience, having seen both his seventeen-year-old daughter and his former wife, Jane Fonda, bewitched by the notion of absolute freedom. "Jane Fonda felt she was being turned into a sex symbol and fought so hard to achieve her freedom that she doesn't make movies." He was

forgetting that at the time of our interview, she had co-directed *Vietnam Journey*, and of course he did not know that her many careers would flourish after she left him.

Vadim is perhaps best known for his unfailing sense of publicity and his talent for exploiting his personal life. His succession of wives and mistresses—Bardot, Annette Stroyberg, Catherine Deneuve, Fonda—have always given his films a spurious fascination. But the sort of publicity he once welcomed is what he now fears, particularly when his new film, which has been causing a sensation in Paris, reaches Britain.

"At the moment the English market for foreign films is diminishing. Often the only way to sell a film with subtitles is to present it as a pornographic movie. I can see the distributors picking on the erotic scenes and selling it on that basis. I don't want that to happen because it will distort my conception of the film; so I'm going to supervise its distribution in England and America. Often the publicity surrounding a film determines the way people look at it.

"I enjoy beauty and so do other people," says Vadim. "I don't see why one should feel bound to film ugly people. But I have often been accused of portraying women as sex objects and this is unfair. In my films and private life I have always wanted women to be free, and not only sexually.

"Treating people as adults has its difficulties because quite a lot of adults are stupid and vulgar and so you get stupid and vulgar movies. But the good aspect is that directors who have something to say can do so without taboos. A few years ago one of the scenes in *La Jeune Fille Assassinée*—in which a man makes love to a woman he has killed—would never have been accepted, but I had to include it to make my point."

The film marks a new freedom for Vadim. "One of the most important factors in filming is time. If you don't finish a movie in time producers think you're not a real director. But projects should germinate and develop as one is filming. Because I was my own master, I took three weeks off before shooting two key scenes. If the film is bad, it is my own fault.

"Films cannot be made for a future audience. The life of the movie is short. It must be released quickly because what it has to say is linked directly to what is going on in the present."

It would be easy to consider Vadim affected and superficial if one was not immediately aware of the dynamism and energy that is so carefully channelled into his performance as he stalks the room in his spacious flat in a fashionable part of Paris's Left Bank.

"I prefer to make films that do not propagate the latest 'ism' of the day," he says. "And I don't want to present my ideas as definitive answers. Nowadays, people don't listen to you unless you're aggressive. In this sense I am not very fashionable at the moment. But I have always found it difficult not to be influenced by current fashions. In the end, one often feels if everyone is doing something, it must be right. But I'm beginning to listen to myself. For me, freedom is being able to say I'm not going to make a movie about social problems." ❖

M onique Wittig, the small, dark-eyed Joan of Arc of the lesbian community, perched on her chair, and in a voice which gradually lost its defensive tone, said, "I could not bear to write anything obscene about a woman's body. Until now men have held the monopoly in describing a woman's body, but their vocabulary is tainted by their attitudes. I felt it was time for women to start writing about their own bodies. In *The Lesbian Body* I tried to use a fresh and untainted vocabulary."

Far from being regarded as pornographic, Wittig's book has been acclaimed by French critics as a masterpiece. Her novel *L'Opoponax* won the Prix de Médicis in 1964 and, with *Les Guérillères* (1969), was championed by Marguerite Duras and Claude Simon in France and by Mary McCarthy and Edna O'Brien in England and America. Freed from the sensationalism and persecution that surround lesbianism in France (one thinks of Violette Leduc and Albertine Sarrazin), her book may well receive a more sober and just appraisal in Britain.

"The critics say that the book is beautifully written, but that's not really my main concern. *The Lesbian Body* is the only book I have written with such passion and personal commitment.

Though the subject is very much a part of me, I didn't write it for myself. I wrote it for lesbians, on behalf of lesbians. I could never have written it if the ground hadn't been prepared by the Women's Liberation Movement, and if I hadn't written it, someone else would have."

Monique Wittig's mission to publicize and make acceptable lesbianism has become something of a crusade. She talks of world-wide persecution, citing numerous examples, and wishes to enlist all women in her battle. Whether a woman is lesbian or not, she is a woman, and for Monique Wittig that is all that counts.

"All women suffer from the same oppression, whether they be lesbian or not, and we should be united in our fight against the male phallocracy," she said. "I think that lesbians can inject new blood into the Women's Liberation Movement (MLF) and give it fresh impetus. In France, however, there is a division and conflict and this results in the formation of numerous splinter groups. In the beginning, the lesbians of MLF left to form a group called Le Phare. But soon male homosexuals invaded it to a point at which women were only a very small minority. So we left the men to it and created a new group which in turn dispersed because a lot of people found it too radical.

"In the MLF itself there are two main currents: the psychoanalytic and Marxist, and the feminist group to which I now belong. But there's a general feeling of confusion and a lack of unity, partly because lesbians are too frightened to come out into the open and join us and partly because they feel that they are not real women—they are made to feel this by others, and so they are unwilling to participate in movements that are not solely concerned with lesbianism.

"Politics is another divisive factor: one group was abandoned because the Trotskyists took over. Out of this confusion 'Choisir' and 'MLAC' were created. The latter concerns itself mainly with the problem of abortion. Though men dominate the group, it nevertheless serves a function by providing an organization that does not frighten off provincial housewives. But I would like to see an international organization. Then we might eventually be able to do something for the really backward countries like

India and South America. We need to communicate our ideas to others through films, painting, and literature. But we have no cultural tradition, whereas male homosexuals have felt free to write about their problems. In my book I made reference to the Sapphic and Amazon traditions because these are the only roots that we have."

Although Monique Wittig might not consider Albertine Sarrazin and Violette Leduc as champions of the lesbian cause, these two writers have provided a living literary tradition for younger novelists. The isolation that Monique Wittig feels in relation to a hostile society and a "nonexistent" lesbian tradition is symbolized in *The Lesbian Body* by islands that were the homes of matriarchal cultures. But the writer's alienation from society also springs from a conscious and deliberate withdrawal.

The Lesbian Body combines the warlike fervor of the Amazon and the poetic strength of a Sappho: prose and mythical undercurrents merge with an intense polemic to create a new kind of irony. For where the Swift of *A Modest Proposal* uses ferocious satire, Monique Wittig uses poetry. *The Lesbian Body* can be compared with *The Female Eunuch* and *Sexual Politics* but it also stands in its own right as a work of fiction.

"I would like to write a purely polemical work because I feel that the question of lesbianism needs to be explored as much as possible," she said. "But I chose to write 'fiction' for a number of reasons: to describe how one can live as lesbian in our society involves one's imagination. At the moment, it is particularly impossible to live happily as a lesbian, but fiction allows one to describe a new world where lesbianism can exist. If I wrote a discursive work I would be forced to describe the misery and pain of reality. In fiction my vision and my hope become immediately alive."

To describe her vision, Monique Wittig is obliged to use the language of her present, which she finds hostile to her purposes: "Language has a magical relationship with reality. It creates our experience and goes beyond it. Although we are imprisoned by language we must attempt to escape. The French language is grammatically and semantically saturated by the sexual dominance of men. Take, for example, the fact that in plural agreements the masculine always predominates over the femi-

nine. When I was faced with the prospect of describing a woman's body in the language of men I could not do it. Instead, I used medical terms that are freed from any male connotations. Although I could not create a new vocabulary, I think that the words became new through existing in a totally different context. I 'divided' all personal and possessive pronouns (Je, m/a), because I wanted to create a separate expression for the female subject. I find it physiologically impossible to use the same personal pronoun to describe a man and a woman. Problems arise when men translate my work. Their attitudes are obvious in a variety of ways: for instance, in *Les Guérillères* the male translator wrote 'The trees were erect' instead of 'The trees were upright.' He also translated 'le sexe' as 'genitals' instead of 'the sex.' And I believe that in English this word refers mainly to the male, or to the whole reproductive system of the female. From now on, I would like all my books to be translated by lesbians." One can only wonder which dictionary provided Wittig with such definitions.

Why then is Wittig's book entitled *The Lesbian Body?* Does the title suggest that a woman as sexual-object can exist just as easily in homosexual relationships? "I see my book as a body, a concrete entity, something that exists in space. At regular intervals throughout the book I interposed facing double-pages, printed in large capitals, of lists of all the parts of the body. I wanted the new reality of woman's body to run through the texture of the book." "Corps" also means type face: it is the body, the visual and material presence of the letter. The exploitation of different "corps" is by no means new, and one wonders whether she could not have manipulated language to do the job itself without resorting to typographical devices, for their effect on some readers is doubtful.

"*The Lesbian Body* is more concrete and substantial than anything I have written. It is full, crammed with passion. The oblique strokes that separate the letters in personal pronouns and the facing double-pages provided a breathing space for me and perhaps for the reader."

In saying this, Wittig is voicing an attitude towards language that was shared by many of the younger writers in France in

the seventies who stressed the materiality of language and viewed words as "substantial" forms.

Wittig's isolation becomes increasingly less convincing when one sees her in the context of Parisian literary life: her attitude towards language and her belief that her books are not "litera-ture," but statements, link her to the adherents of "la littérature engagée" and the writer-linguists of *Tel Quel* who carry her views even further.

Her situation and work become more relevant in a larger, extra-literary context, for her battle against the status quo is shared by all writers and thinkers who have minds of their own.

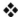

F rançoise Giroud became the first Secretary of State for Women in 1974. This post was created by President Valéry Giscard d'Estaing, and he chose a woman who had never voiced the extremist feminist views that became increasingly prevalent after May '68. Feminist movements were often associated with the Left in France, and yet it was de Gaulle's Liberation government in 1945 that first gave women the vote. And it was Giscard who made a concerted effort to pass the abortion laws, permitting women to have legal abortions. Françoise Giroud, however, was not the instigator of the new abortion laws, nor was she particularly supportive of Simone Veil, the Minister of Health at the time, who fought to have them passed. Giroud was not against the new laws, but she was uncertain that even the Communists would vote for the bill. Her unwillingness to fight for what she believed was an impossible cause reveals her intensely pragmatic nature.

When I met her, in her apartment on the Right Bank in Paris, I asked her why she had steered clear of feminist ideologies. She gave a smile that reminded me of the radiant, seductive expressions of the French anchor women (speakerines). It was an expression designed for the camera; but it was also a rather

vulnerable and friendly expression of someone attempting to please.

"I'm allergic to ideologies, in general. I'm interested in observing them and trying to understand why they arise, but I'm profoundly skeptical. I'm incapable of adhering to an ideology. I believe that the MLF [Women's Liberation Movement] in France was the extreme culmination of a very powerful movement throughout the world. And it did have its roots in history. Feminism is a very ancient movement, but perhaps, for the first time, it has really achieved something. In France, in the nineteenth century there was a great deal of feminist activity. In England, they managed to gain the vote, but the movement failed in France. But actually, having the vote is really not the key. There are only two essential elements that can change women's role in society: birth control and women's participation in the economy."

Giroud gave a rather schematic historical analysis of women's changing roles in society and went on to explain how she decided to change certain laws that were created under Napoleon, which no longer reflected current attitudes in France. She did not wish to change the existing order, but merely to update the legal code.

"The Napoleonic Code is quite extraordinary. You know, Napoleon was a really macho man. He was a Corsican (if I said that in a newspaper I'd be slaughtered), but nevertheless, it's true. He was Italian and he despised women. You have to understand that in France women have lived under two curses—the Napoleonic laws and Proudhon, who was the father of trade unionism. He was a misogynist and a very sick individual . . . he was pathological in his attitude towards women. He's the one who said that a woman could either choose to be a courtesan or a housewife! So, you see the working classes in France were infected with Proudhon's misogyny. I'd say that the working classes are more profoundly misogynist than the bourgeoisie. And it's still the case. And the Napoleonic code didn't give women the right to have a bank account without their husband's authorization, and they were not allowed to travel without their husband's permission . . . the whole code was filled with the

Françoise Giroud, Secretary of State for Women, at a reception for the painter Sonia Delaunay, who had just received the Légion d'Honneur (1975) from Mme Giroud.

most unimaginable legal provisions. So, I obviously had to change all that."

Giroud believes that while the working classes have traditionally been repressive of women, the bourgeoisie and the aristocracy are not. She told me that the seventeenth-century woman was treated as an equal, but when I asked her to give an example of this egalitarianism, she referred solely to the privileged woman.

"After the French Revolution the attitude towards women changed. Women played a very important role in the eighteenth century. For instance Mademoiselle de Lespinasse—in fact, all the salons where the Revolution was concocted—Madame du Châtelet, who was Voltaire's mistress, was a fantastic, cultivated woman. They were very free in their behavior . . . for the eighteenth century was the time for *libertins*. They had all kinds

of affairs . . . and the notion of the family as we know it now, of fidelity in marriage, is a relatively recent notion in France. It only became fashionable in the late eighteenth century.

"But in the eighteenth century the life style of women was much more evolved. Couples would live in large town houses and Madame's quarters would be on one side and Monsieur's would be separate. So, there was no intention of husband and wife being faithful. The idea of fidelity was considered ridiculous. Marriage was quite simply the union of two inheritances or two great names. It was not thought of as an association of two people who loved each other."

The notion of fidelity within marriage was a Napoleonic invention, and, according to Giroud, it is repressive of women:

"The obligations of fidelity, virtuousness, and the imprisonment of women within their domestic duties were introduced by Napoleon. The laws he created were severe and hostile towards women: he wanted to put them under surveillance. But France is not a puritanical country. It may be a rather prim society but it's not puritanical. So the Napoleonic laws did not really correspond to the country's attitude. Nowadays things have really changed. There's a real sharing of domestic chores. It's not up to the women to take care of the housework. I think the French have really succeeded in this area. In general, I'd say that there has been a successful feminist revolution in France.

"I also think that most women did not become aggressive towards men. They knew how to bring them gently towards a new attitude. And there has always been a certain kind of respect . . . well, perhaps it's too large a word. A certain kind of consideration for women. A Frenchman would not find it enjoyable to have lunch with his men friends. If a woman wasn't at the table, it wouldn't be much fun for him, would it? And the notion of a men's club, such as it exists in England, is completely alien to the French mentality.

"I've had many struggles in my life, but I've never had to struggle against men. In fact, I'd say that men have always helped me. They've always had confidence in me. I don't think relationships between men and women are as simple as the feminists say. It's also becoming apparent that men need to be

protected and cared for, as well as women. I actually believe that women are, in general, very strong. At least all the women I've met and certainly the French. I've always been struck by women's strength. Colette once coined a phrase which I believe to be true. Instead of saying someone's made of iron, she said someone's made of woman, implying that woman is strong. Women have more tenacity and perseverance than most men. When a woman decides to do something, no one can resist. It's quite extraordinary, but it's true that a woman always achieves something once she's decided to do it."

It is certainly true that Giroud has shown persistence and determination in her work, and she has also managed to work harmoniously with men: in 1953 she founded *L'Express* (the weekly magazine that was to become the blueprint for *Le Point* and *Le Nouvel Observateur*) together with Jean-Jacques Servan-Schreiber. She ran the magazine until 1974, when she became the Secretary of State for Women from 1974 to 1976. She then served as Secretary of State for Culture under Raymond Barre's first government.

She has written numerous books, including a novel called *Le Bon Plaisir*, which was recently made into a film starring Catherine Deneuve. The heroine is a woman who has had a child with the President of the Republic. She is in many ways an extremely independent and strong-willed woman. And yet her strength consists in enduring the rather unrewarding role of mistress to a sympathetically portrayed President.

Giroud told me that she did indeed intend that the man appear sympathetic and that she was not critical of his behavior towards his mistress. "I've seen many men in my life who were involved in government, including Presidents of the Republic, and those who would like to be President, and the central character in the novel is an archetype that has always fascinated me. I actually find it quite ridiculous, this desire for power that men have. But men who have power aren't ridiculous, at least some of them aren't. For careerists, with an eye on the main chance, never succeed in politics. It's only those who are sincerely convinced that without them the world would be a different place . . . those are the ones who succeed. It's quite marvellous,

in a way, this conviction that some men have. It's true ambition, the feeling that their existence will transform the world. But it's a little bit infantile."

While Giroud is tenderly accepting of man's desire for power, she feels that women are, in reality, the more powerful of the sexes. But women have learnt to manipulate behind the scenes. Giroud is not judgmental of women who try to achieve power indirectly, through seduction. "I believe that women have always known that they are strong . . . in certain areas. But they have used their strength to seduce, to convince, and to manipulate . . . they have not used their strength overtly. Men are a lot less crafty than women . . . women can dissimulate . . . you can see it in the way they use makeup and style their hair and their way of dressing. A woman's life is a constant dissimulation."

But a woman's interest in dressing up and making up could be a wish to accentuate and heighten her own beauty. I told Giroud that I did not agree with her view that women are naturally more seductive or crafty than men. I certainly did not feel that a woman's interest in her own appearance was a sign of her capacity for dissimulation.

Giroud was adamant that seduction has been a woman's profession, and she went on to explain how feminism has changed women's behavior, and has led French women to use their strength overtly: "Women have always had confidence in their capacity to seduce. It was their domain. And feminism changed all that: women no longer existed in the eyes of men. Since, for centuries, women only existed through men . . . so they conquered the world through men. Seducing a man meant gaining a social position, money; in short, a woman's existence depended on her capacity to seduce.

"But there's a certain age that a woman reaches when she can no longer seduce. You can be charming, agreeable, intelligent, and kind, but there's an age when you're no longer physically seductive. I believe that the feminist revolt coincided with the increased life expectancy of women. Just think that a century ago the average life expectancy was thirty-five or forty years. Women had many children and often the children would die at birth. So at the age when they finished having children, they had about ten years left to live. Nowadays, it's completely

different. Women have a lot of life ahead of them when they reach forty. So they begin to enter into politics, or they take a more active part in society, and now there's a kind of second life for women after the age of forty."

But Giroud's analysis of the feminist revolt is based on a misconception: that the majority of women in France are either single or unhappily married. For why would a woman wish to seduce a man and base her life on seduction if she has a fulfilling relationship?

"It's biological," says Giroud. "It's a very natural game. And men also make an effort to seduce. It's normal. There are many ways of seducing. You can do it intellectually, as well. Obviously, one doesn't spend all day doing that. But at a certain age, one is no longer an object of desire. And also one can tire of the game of seduction. There's a certain point when women want to be recognized as human beings. But there's a tragic side to this new development, and you should really go to the Soviet Union to see how terrible it can be when men and women are indifferent to each other. For in Russia, the women run the country. They earn their own living so they're not dependent on men, and they have no time for men. So the men drink enormously and there's a kind of separation of the sexes, and an enormous solitude. I'm actually thinking of Moscow, not of the whole of Russia."

Giroud has never preached aggressive feminism, and her moderate views prevail. Extremists, like Hélène Cixous (who wanted to change the French language, because it was anti-feminist), did gain attention in the seventies. But their popularity was short-lived, and the moderates, like Giroud, represent the attitude of the majority of French women.

According to Olivier Todd, the moderates have reason to be satisfied since they have won some major battles. And the extremists are no longer to be taken seriously by the majority, for their goals were always too far-fetched. "The main ideas of feminism are at least theoretically accepted. And nobody would dare to go publicly against them. In practice, though, it's slightly different. In advertising or universities or even in journalism, women still find it harder to climb up than men. But these days, since feminism has been associated with the Left, like a lot of

Left Wing positions, it's suffering a setback. And many women who were extremists are now singing the reconciliation of the sexes and the ideal of monogamous love, and so on, and doing quite well."

Todd points out that the views that Simone de Beauvoir expressed in *The Second Sex*, which were considered revolutionary at the time, are now taken for granted and fully accepted. "When Simone de Beauvoir appeared for several weeks on French TV on a kind of illustrated version of *The Second Sex*, which was absolutely awful, she seemed like a school mistress trying to slam into open doors. There was slight embarrassment, even in Left Wing circles: do we really need her to tell us that virginity is not a must at marriage? That taking the pill is reasonable. They had everyone under the sun appearing, from Kate Millett to Indira Gandhi. Someone pointed out that this TV series was full of minister's wives and establishment people. And it's a sign that feminism is absolutely acknowledged and it's been accepted. But feminism is not in the forefront as it was in the seventies.

"Still, one has to remember that we're talking about urban areas. Feminists still have a lot of work to do in the countryside, I can tell you that. And, on the whole, I think it's better to have feminism with its mistakes, than machismo with its crimes, because that's what we've had in France. And, in France, we're nowhere near a Ferraro candidacy. Not on your life. We've only had two political characters that are women: Simone Veil and Françoise Giroud. And Giroud was more a journalist than a politician. I mean her political career was a disaster. It really was. She was Secretary of State, that's all. She was never a full-blown minister.

"I remember, I did an interview with her and I asked her a question: 'You were not a full minister were you?' and she crossed that question out before we published the interview in *L'Express*. We had to be polite. But no, she's much more important as a journalist. After all, she was responsible for the first news magazine in France. And she was the soul of *L'Express*. We all owe her something.

"Jean Daniel [the editor-in-chief of the *Nouvel Observateur*] owes her a lot, though he employs her now. And I learnt a

great deal about journalism through Daniel, and indirectly through Giroud. She's not a politician, and certainly not a typical politician for she knows that on some issues she can be on the Right and sometimes on the Left. That's another thing, that's very important in France; this paranoid polarization into Right and Left. Giroud doesn't suffer from that and she has a sense of humor."

But Giroud feels that her writing and political activities spring from the same source. When I asked her how she managed to combine politics and journalism and novels, she tried to explain that these activities were not as disparate as I suggested:

"Obviously, I do attempt a lot of different things, but, essentially, all these activities consist in speaking to the public . . . for instance, I could never do anything related to commerce. I couldn't own a shop. I don't have that sense of things. But I do have a sense of the public. I have a feel for communicating with the public. I also hope to influence public opinion. That's my true profession. I attempt to communicate something, whether it's an opinion, a state of mind, or a vision of life. And that desire to communicate can find many manifestations: When I was Minister for Women, I told myself that I had to make the French understand what was happening to women. O.K. How would I do this? What tone would I take? What arguments would I use? On television . . . it's the same with written journalism. It's knowing how to be heard by as many people as possible."

Giroud carefully distinguishes between communication and art. The use of words to communicate an idea to a large audience is not necessarily the guiding force behind a novelist's work. Many writers, in fact, would be loathe to use their work to serve an idea. Giroud feels that her novels hold a special place in her work, and that she is overtaken by a mysterious urge to write, which has nothing to do with a wish to communicate to a large audience:

"In most of my writing, and my activities, I have never tried to reach out to a small, sophisticated public. That's for art . . . and art is not made for the masses. In fact, an artist's creation can't be used to reach a public . . . it's normal that it touches a few people and slowly gains a larger audience. But when it

comes to communication, you can never aim low. You have to reach the maximum number of people. But a novel is more like the sea. . . . "

Giroud rarely ventures into the world of fiction. She prefers to do journalism at the moment, writing a television review for *Le Nouvel Observateur* each week, and a book review for the Geneva-based paper, *L'Illustré*. She gives the impression of withdrawing a little from public life, and though she says that she wants to withdraw even further, to write more books, one senses that Giroud is a social animal and that she misses the political arena:

"I'd like to find time to do some more work on a book in the next few months. . . . I will try to protect my time . . . but it's difficult in Paris . . . even though that café society is over. . . . I have the feeling that people spend much more time in their homes. . . . Perhaps it's just that I'm growing older . . . I go out a lot less than I used to. But I do sense that people, in general, tend to go home and watch television. Of course, there are still the Parisian lunches . . . Lipp is a place where one still has lunch. And then there's a new way of socializing: people project films in their homes. So you have fifty people over to your home, and then there's drinks or a buffet dinner. . . . It's a new way of entertaining.

"Perhaps we've withdrawn because we had a very cold winter, and the French aren't used to cold winters. So no one wanted to go out. And, when you do go out to dinner, people make much less fuss. In fact, the Parisians care much less about appearances than they used to. The French bourgeoisie devoted themselves to appearances. When they entertained everything had to be perfect. Nowadays, people take pleasure for themselves, not to impress others. So they spend more money on holidays, and travel. And it is absurd to spend your life impressing people. I've also noticed that French women spend less money on clothes than they used to."

Giroud talks of her fellow countrymen dispassionately. She analyzes their habits, and their history, as an observer. When I asked her whether she shared the views that she attributes to others, she would try to divert me from eliciting her own personal response. She protects her obvious vulnerability and

acute sensitivity by maintaining a silence about herself. But she
has no intellectual arrogance and she has never used ideologies
to win over her public or soothe her own doubts. She has
retained her vulnerability and a moving desire to make contact
with others. But Giroud feels that the atmosphere in Paris is
not inviting. And I did agree with her when she said that the
Parisians had become increasingly irritable and discontented
over the last few years.

"I sense that the French are becoming very bad tempered.
And it's unpleasant to have to deal with it. There's no real
reason for being dissatisfied for France is still a wonderful place
to live. But the French don't like their future, and that's why
they're unpleasant. I'm talking collectively, not about myself. I
think that the most disquieting thing that's happened is that the
death of Marxism has left an empty space. And I'm not referring
to the working-class Communists who vote for practical reasons.
I'm thinking of a whole class of intellectuals who were drunk
on Communism. They weren't underprivileged, so Communism
was more like a religion for them. They lived it like a religion.

"I suppose it's part of man's nature to need a religion. And
it's that need in mankind that I find most dangerous. For the
moment, in France, there are no religions, in the sense of an
ideology that you live as a religion. And it's not by chance that
the most powerful Communist parties always took root in
Catholic countries. There's no Protestant country where Com-
munism has really been an overwhelming force."

Giroud believes that the intellectuals in Paris are undergoing
a severe crisis of confidence, partly because of the loss of their
Communist fervor, and partly because they are no longer able
to pose as critics and rebels of the society. Mitterrand's attempt
to woo the intellectuals and to include them in his government
was not a success. While Régis Debray and Jacques Attali
accepted his offer to work within the socialist government, the
majority of intellectuals refused. And even the poets who
complained for years of receiving no subsidies from the gov-
ernment, are now complaining about the problems of receiving
too much government support.

"You see, the Parisian intellectuals are made to be in opposition
to the government. Intellectuals don't want to be on the side of

MAGNUM/Jean Gaumy

Françoise Giroud (shown above with President Valéry Giscard d'Estaing) is tenderly accepting of man's desire for power: "I've seen many men in my life who were involved in government, including Presidents of the Republic, and those who would like to be President, and the central character in my novel, *Le Bon Plaisir*, is an archetype that has always fascinated me."

the establishment. It won't work for them. So they feel very ill-at-ease because they don't want to be against a socialist government, and yet, they don't want to be for it. So they maintain a silence. And, in any case, there aren't that many great intellectuals left in France."

Giroud believes that the French have a tremendous respect for the small intellectual elite that is centered in Paris. But this does not mean that the French, as a majority, are more literate or well informed than the average British or American. "There is a very ancient French tradition which is this respect for a small class of people who are very cultivated, and are often very

highly developed, intellectually. And I'm not talking about intelligent people, because being intelligent is not the same as being intellectual. These intellectuals created the illusion for the rest of the world that France is made up of cultivated people who read a lot. And it's not true. People read much less . . . newspapers and books. But they still have the feeling that they belong to a cultured nation."

The French enjoy their intelligentsia, and writers like Marguerite Duras and philosophers like Roland Barthes have been best sellers. And the longstanding success of Bernard Pivot's literary talk show, *Apostrophes*, shows that the French do pay attention to their writers and philosophers and poets.

Giroud is more enthusiastic about the state of the French film industry. She has participated in over fifty-five films as an assistant director, screenwriter, and continuity girl. She worked full-time in the film industry until she became a journalist, and she still continues to write screenplays. "The French cinema is the only and the last exciting European cinema. And it exists thanks to the government. That's to say, the government has always given a lot of financial support to the film industry. And the cinemas in France are really very modern. They're clean, they have comfortable chairs, which is very important. The French really have made an intelligent effort to keep the film industry alive. And I've enjoyed working in films. I suppose one enjoys what one is good at. Even French television can do some remarkable things. It's a real mixture of extreme vulgarity and artistry. But the power at the moment is in the hands of those who work in television."

Giroud feels that television is also at the root of the increasing Americanization of French society. While many complain about the "imperialism" of American culture, Giroud accepts the inevitable, with equanimity.

"The media are mainly responsible for the infiltration of American ways of living into our daily life. It's quite startling . . . the way American culture is establishing itself in France. The other day, I got into a taxi, coming from the airport, and I didn't hear one French song. They were all American rock songs. It's true that American cultural products are filling the world. It's a fact. You can't fight it."

Giroud assesses this issue with her characteristic ability to face the facts. With a certain humility, she realizes that she is powerless to change the status quo. She feels that her task and ambition is merely to communicate her impressions: "I find it ridiculous when people even go so far as suggesting that America should not be allowed to sell their cassettes in France! I think it shows no understanding of history to talk like that. It's natural that certain cultures dominate at certain times in history. It's like a river. For a while Europe dominated the world, together with America, and now, Europe's power is waning . . . it's an historical phenomenon that you can feel sad about, or you can be pleased about it . . . it really doesn't matter what you feel. All you can do is state the facts."

The Invasion of the Modernist Philosophers

Poets of the Hexagon
Edmond Jabès
Philippe Adrien
Jean-Paul Sartre
Jean-Paul Aron

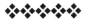

The six major poetry publishing houses in Paris form a hexagon that is just as delimited as the *héxagone* of France herself. Within this self-contained and concentrated world exist smaller worlds, each speaking a different poetic language. For although they are only a brisk five-minute walk away from each other they might as well be as far away as the publishing house of Fata Morgana in Montpellier for all the real contact that exists between them. Or so they would have us believe: the fact that French poets diverge so radically does not mean that their *point de départ* is not shared. Signs of a common ancestry are becoming more apparent: it is to be found, paradoxically, in surrealism. The young, radically experimental poets of the Mercure de France proclaim their independence from their surrealist ancestors. These rebellious children tell us that they have exorcised the "demon of analogy" that possessed the surrealists. They say that they have resisted the temptation to use metaphor, simile, and symbol. But they have to admit that some of their mentors, Artaud, Bataille, and Roussel, were born and bred of the surrealist movement and they too worship the same god: the Word.

Not surprisingly, a new form of "Rétro" is hitting a large cross-section of the reading public: the republication of long out-of-print works by minor surrealists such as René Crevel, and the publication of previously uncollected texts of Albert-Birot and Ribemont-Dessaignes, attract inordinate attention: the *colloquia* on Artaud and Bataille have been published in one of the best-known intellectual paperback series—*10/18*; young French publishers are earning their living by publishing reprints of the

most influential surrealist reviews; and new assessments of surrealism and individual surrealists flood the bookshops.

In the elegant seventeenth-century hôtel that houses one of the oldest established publishing houses, the Mercure de France, you wouldn't expect to find the most radically experimental and controversial poetry: that of a group calling themselves the neo-puritans, Jacques Garelli, Jean Daive, Anne-Marie Albiach, and the late Roger Giroux. For these writers, the subject matter of their work is language: "poetry" is not a word they would have you use. Ironically, it was Rimbaud and Lautréamont, the forerunners of surrealism, who had first launched an all-out attack on the traditional themes and the rhetoric of poetry. Language was no longer to be regarded as a means of expressing lyrical emotion. It was gradually becoming a means of examining its own problematic status. Ponge expressed a similar attitude twenty years ago in *Tel Quel* when he wrote: *"La poésie, merde pour ce mot."*

However, one can escape from radicalism and polemics in the publishing house of the Librairie Saint-Germain-des-Prés and enter the more comfortable world of popular anthologies like Jean Breton's *Poésie Un Franc* series (50,000 copies each issue), which nostalgically keeps its original title while costing three francs. Pierre Seghers has been in the anthology business much longer but is more up-to-date and has even employed the pop singer Georges Brassens to sing the merits of his most recent compilation on television and in the local cinema. Bernard Delvaille, a poet and translator who works for Seghers, recently edited a widely acclaimed anthology of work by young French poets, *La Nouvelle Poésie française*. All the texts were taken from little magazines and the most recent experimental volumes, an idea that Delvaille says he got from Michael Horovitz's *Children of Albion.*

In the more sedate atmosphere of Flammarion you are unexpectedly plunged back into surrealism, with the recent re-publication of Crevel and the continuing publication of Reverdy's complete works. Their latest "discovery," Cholodenko, is a mixture of beat poet and surrealist and the combination succeeded in getting his last book banned. One cannot criticize him

for using his libido as his subject; but Cholodenko's libido seems to be doing the writing as well, and the result is uncontrolled and immediately accessible hysteria. It is a relief to return to the poets of the Mercure de France.

Jean Daive, editor of *Fragment*, perhaps best exemplifies the aspirations of many of the Mercure group. Like Anne-Marie Albiach, the first translator of Zukofsky, Daive's texts are heavily influenced by postwar American poetry. He has translated Robert Creeley as well as Celan. His most important book, *Décimale blanche*, was translated by Cid Corman and formed a whole issue of *Origin*. The quarrel with surrealism becomes more apparent as we read texts that would deny both the central role of image and metaphor in "poetry" and the generative power of the unconscious. Free association and automatic writing are replaced by a self-conscious preoccupation with the activity of writing and the structure of language.

One of the very rare links between the publishing houses is provided by Edmond Jabès, a Gallimard author, who has helped many of the younger Mercure de France poets in their work. Jabès has lived in France since 1957 and has written several volumes since the publication of his collected poems in 1959. They form one book in which the texts are incidental to a story that is never told but only commented upon. The subject of this story is both ambiguous and elusive. Jabès might seem at times to be writing about separated lovers, the interaction of man–woman–stillborn child, the suffering of the Jewish people, the human condition, or the process of poetic creation. In fact, the true subject of the book *is* the process of writing, discontinuous and always unfinished. It turns on itself and describes its own birth and the inevitable death of both author and book. These texts are impossible to classify. They have the texture of poetry, but are mostly prose. It is difficult to calculate how long it will be before this radical "poetry" is fully accepted by the reading public. It took the French forty years to understand both Crevel's prose-poetry and the significance of his suicide; even longer for them to understand that Vaché and Rigaud, like Crevel, were the victims of "writing." The rebellious children of surrealism continue to speak in their works of that same savage god. As

Edmond Jabès says in *Elya*, "We will die a bartered death at the feet of our words."

To an outsider, the self-annointed intelligentsia of the Parisian literary scene seems tribal in its partisan aggressivity. There are certain passwords and turns of phrase that mark out the members and exclude the uninitiated. It seems, on reading *Change* or *Tel Quel*, that you can create literature by repeating ad infinitum some magical formula: "faire éclater le livre," "le lieu de l'écriture," "la rupture," etc. The intelligentsia rely on unintelligibility and hermeticism to gain an audience.

The central problem is that the questioning of the pioneers has become a complacent catechism. You have to be anguished to be a writer. Once you have learnt the terminology, there is nothing to stop you. But the disciples of Blanchot, Bataille, and Jabès have, for the most part, camouflaged the insights of their masters by a parrot-like fidelity. Bataille died in 1962; Blanchot refuses to make any public appearances or to explain himself, but Jabès is still in action.

Jabès was born in Cairo, but came to Paris to study literature for a few years. There he met many of the surrealists and published poetry inspired by them. At this time he was the precocious enfant gâté of the fashionable literary world. It was under the tutelage of Max Jacob that he began to develop his own voice. He tells a rather quaint story of the time when Jacob tore up his manuscripts and told him that he was too influenced by him. A lesson for the Jabèsian followers? In 1937 he got married, but it was only twenty years later that he developed a clear idea of his personal and individual contribution as a writer. This coincided with his enforced exile from Egypt and his sudden awareness that he was a Jew.

For Jabès, the notion of being a Jew is inseparable from his awareness of being a writer. But one should not confuse his writing with traditional religious thought, just because there happen to be some rabbis in the story. Jabès works within a

world without God. Nor is the notion of the Jew sectarian or exclusive. In Jabès's view the Jew is exemplary of the minority, the exile from society and the immigrant. He is the person without a homeland and without a language that coincides with his abode.

To build his homeland Jabès has only the building-blocks of words. And he uses them as such in a literal way, decomposing and reorganizing them, creating patterns and associations that one had never imagined. But the word is not the living world it refers to. And Jabès experiences his masonry as a descent into a shadow world close to death. Herein lies the double bind and the paradox: without his book, Jabès is without a language or a land. With his book, he is obliged to come face to face with the shadow world of words.

It is easier to say what Jabès's Proustian series or "unified" books are not. You can cross out the novel, the short story, the aphorism, notebook, or intimate journal. By virtue of their concentration and ambiguity of meaning and the sheer beauty of language you could opt for poetry as a classification. But here we come to the perpetrators of this avant-garde: the negativity, the impossibility of the task that the writer assumes. Mallarmé believed that everything in his life should have culminated in a book, and he never wrote it. Similarly, Jabès is aiming in each book to create the ideal book, and the reason he keeps on writing is precisely because he never achieves his aim. So each book is an unfinished, doomed failure.

The series which has been "completed" is called the *Livre des Questions*. It is a surprisingly direct title. Jabès writes as if Descartes had not done a volte-face on doubt, as if there will never be a way of answering a question: "In the dialogue that I pursue, the reply is abolished; but, sometimes, the question is the explosion of a reply." (*Livre des Questions* III, 42).

The questions that Jabès asks are the kind that keep children awake at night, but that most people get fed up asking. What is the meaning of suffering? What is death? What is language? What does the absence of God imply? But this suicidal doubt is strangely bracing. While Pascal attempted to show the grandeur of man with God and his misery without Him, Jabès strives to reveal man's dignity deprived of a savior. Jabès does

not indulge in a philosophical or mimetic consideration of disintegration and solitude. We find none of the popular social realism of the breakdown of values and the outcome. Nor does he explain away the problems with psychological theories. Admittedly, his writing could be considered cerebral, but he does not resort to current ideologies to help him out of the fix. Many might say that his imagery and context is rather too biblical and evades a confrontation with contemporary society. But when he talks about the desert he is talking from his own experience, and when he returns to the theme of exile one must remember that he was uprooted from a satisfying and perhaps passionate attachment to Egypt.

Paradoxically, Jabès undermines already disintegrating values and the few standards that remain, and reinstates man in a dignified and noble role. This springs partly from the beauty of the language and his infinite attention to detail. Though he knows he will never find the answers, he continues to battle with the questions. I asked Jabès how he would explain his books to an uninitiated reader.

"Well, I began writing poems and articles, but I never considered myself to be a writer. These texts were published by Gallimard in 1959 under the title *Je bâtis ma Demeure* and were recently re-edited. In the postscript, Guglielmi tries to show how the seven-volume *Livre des Questions* is implicit in my early work, because I am already asking questions about the nature of words. For the last decade it has become very fashionable in Paris. But, in my case, it was an interrogation and not a theory, and I suppose it must be the most ancient example of so-called modernism. In fact, the *Livre des Questions* was born out of my disrupting separation from Egypt.

"It is the first book in the series, and it is a kind of story [*récit*] which is never directly narrated. It is revealed in bits and pieces. It seems as if I am speaking to characters I have known for a long time and am asking them questions about their life. For instance, many Jews know certain stories, like this one, without needing to have the details filled in. Similarly, with the story I tell. It does not need to be related. It's about two adolescents who are deported called Sarah and Yukel. But they have both lost their reason when they are released. Yukel is lost in Paris

without Sarah and one day when he sees some insulting graffiti about the Jews he gives up and commits suicide. Certain questions posed by rabbis are centered on this story. It is an example of 'le livre éclaté,' which is now in vogue."

I asked Jabès what it meant to "explode" a book.

"First, you have different voices: characters, an absent narrator, anonymous voices, and rabbis who talk in the present and outside time. Many people mistook the form for aphorisms, but they are fragmented conversations, which are questions and are questioned themselves. The dialogue never has an answer. But the question form permits contradiction and ambiguity. Without all these voices you could not have such conversations. If I used 'I' I could not say so many things at the same time. The people in the book efface me and speak in my place. In the first three books (*Le Livre des Questions*, *Le Livre de Yukel*, and *Le retour au Livre*), I make reference to the history of the Jews, the waiting for the Messiah or the ideal book, but always in relation to writing. Then there is a new series of three books, *Yaël*, *Elya*, and *Aely*, which is a sequence to the previous interrogation and makes one see them in a new light. Here we see the writer face to face with the Word. Yaël is a woman who deceives the man she is living with, and he tries to kill her because he is in search of truthful dialogue and never achieves it with her. She represents the Word. But when he kills Yaël he no longer has the Word or a loved one and moves towards silence. Yaël has a stillborn child called Elya which symbolizes silence. And thanks to this dead child, or silence, the writer retrieves the Word. For, without silence, there would be no intelligible sounds. The pauses between sounds create words and distinguish language from noise. Yaël refuses to accept the death of her child and invents an imaginary life for her child. This is followed by the sixth book, *Aely*. For Yaël hesitated between giving the name of Elya and Aely to her dead child, and she chose the former. Aely is the book of a doubly dead child because he was not even given a name by his mother.

"It is like a death within death. Unthinkable and unimaginable. I think that we live with an awareness of death and can imagine it. But there is a death behind ordinary death which has no name. Obviously, it is difficult to talk about. But I see it as a

pair of eyes, a look which is indifferent to everything, detached from life and which has never come into contact wtih life. We have a word for ordinary death, but this particular death is outside language and is very anguishing.

"Then, there is *El* or *Le Dernier Livre*. The title figures as a dot on the cover. It refers to the final dot at the end of the book, but is also taken from the Kabbala, which says that God uses a dot to manifest himself. But I found that this final dot represented a new beginning. There are throughout the books obsessional words: DIEU, JUIF, OEIL, LIBRE, LOI, NOM. I try to show the way a book functions, and how the parts articulate."

Jabès's writing seems to center on an interrogation about the nature of writing. And I wondered whether we would be coming closer to the subject of his work if we talked about his actual experience of writing. I asked Jabès why anguish is necessary and inevitable to his writing.

"Faced with the Word, I am always anguished. For it is the tool by which the writer expresses himself. But, in reality, it is impossible for the writer to control the words and, finally, even if one is attentive to what one wants to say, one ends up 'being said' rather than 'saying.' It is a source of anguish to be bound to something which should help you express yourself and ends up expressing you. The world of writing [*écriture*] no longer belongs to you and you battle against it."

But the experience of being possessed and led by one's material is also a source of pleasure for a writer. I was not convinced by Jabès theoretical explanation and asked him if there were other reasons for his anguish.

"With me, the need to make a book is an obsession. But the edifice that you try to create disintegrates. One ends up emptied and almost nonexistent. I think writing can lead to suicide. For one continually finds oneself face to face with oneself, as if one had not said anything. For me, the actual act of talking is like the opening of a wound. The lips open and what will come out? Writing forces you to close your mouth, to be silent and to confront something which wants to exist in place of you and at your expense."

"Why do you go on at this point?" I asked.

"Well this point is the beginning of the reflection on language. The interrogation in my books is born out of that anguish. I had to find out why I allowed myself to be overwhelmed by this passion. This particular question is confused with the other questions in the book and develops alongside them."

I told Jabès that I believed one started a book with the aim, among others, to create something. Is it not that, in his particular case, he has a Midas touch, which destroys what he creates? Or does he believe this Midas touch is common to all writers?

"No, it's not that. When one starts writing one is in possession of one's forces and believes that one can write anything and everything. But something else happens after what I call the Avant-Livre. That's to say, a book will be created which is not the one you intended, which will work against all the other books you have written, as if it were making a path through a crowd. It imposes, and all the other books one has written will be rejected by the new book and, by entering into relationship with the new book, will find themselves changed. It's an adventure. I'm not talking about a novel where writers make preliminary plans. My book drags me along and creates its own interrogation. And that interrogation questions me. You find yourself faced with a machine which will function, fed by all you put into it—your obsessions and fantasies will come into play—but they can come into play directly, or they can question themselves. In my books the latter happens and the question is always spoken by a living man. There is always a concrete fact that sparks off the interrogation. An everyday detail can often lead me back to relive the past."

I asked Jabès whether his "questions" are felt, rather than being a kind of intellectual inventory that he automatically applies to everything.

"But of course. Everything participates in writing, especially the body. One's body mimics the death implicit in writing. I have asthma crises which are linked to my writing. When I write, I often have the impression that I cannot catch my breath. This is why the sentences have an aphoristic form. I try to create spaces in between the words in which to breathe. I try to find a rhythm in words which will carry me along."

Since Jabès's experience of writing a book seems so distressing,

I asked him whether he would like to escape from writing now that he has completed the seven volumes, which is the task he set himself. Why did he go on to write his forthcoming book, *Le Livre des ressemblances*?

"Well, I knew I hadn't completed anything when I came to write the dust cover. If one could talk definitively one would be talking like God and that would mean death. While writing one lives in a world of one kind of death, but it is questioned and one can, at least, try to name it."

I asked Jabès whether his fear of "talking like God" sprang from a religious fear of transgression or hubris.

"Yes, that comes into it. But, I must add in answer to your previous question, that writing involves a great pleasure, an extraordinary eroticism. The words couple, hold each other, fall in love. To write definitively (without questioning) or to stop writing would involve stopping that game. There would be no anguish, but there would be no life. The fact that the books question each other means that they retain movement. And in any case, my books could never be complete or definitive because the reader recreates a new book out of his reading which contradicts the book itself. It prevents the book from becoming immobile and fixed. Without death there would be immobility. Without death, no questioning. Let me explain. If you say, 'This is a vase,' it's over. But death allows you to ask, 'Is this a vase?'— you put into doubt that which exists. In reality, death is always ready to intervene, to tell us that all existing things are not there. This happens at all levels. In a revolution, one questions the existing society, in order to destroy it. Without that question one could not destroy.

"So death is creative?" I asked.

"Yes. One starts off by naming things and one *creates* them. Without a name, they do not exist. But that is the problem. The name fixes and immobilizes things. You give everything a status which is fixed. But inside that status there is a game. You say to yourself, "Perhaps it's not really a vase, or not exactly a vase," and your eyes work on it and you touch it and question its status. A question makes everything move and play, but it springs from a desire to destroy that which is given, and accepted as the status quo."

"It seems very paradoxical. You believe that you create and yet destroy things by naming them. By doubting, you bring their existence into question, but you also relieve them of their deathly immobility," I said.

"Yes, exactly. That's why I find Jewish mysticism so extraordinary. They gave God a name that cannot be pronounced."

"You mean He is outside man's capacity to destroy or create? In a way, you sound very religious when you talk like this."

"No," replied Jabès. "I only *use* Jewish mystics. I divert their texts from their original intended significance. There is a modernity in Jewish thought which I find incredible. But practicing Jews don't see it in this light."

I asked Jabès whether he considered himself a Jew.

"Yes. Being Jewish is not situated in religious practice or belief, in my view. It is situated in a book, in the homeland of the book. The Jew only had the book in which to be free, and when one is a writer one cannot be unmoved by a people who have lived the situation of a writer for thousands of years. The true Jew is a rebel. He often exiles himself from the Jews. For instance, the Prophets upset people by questioning traditional Jewish thought. A Jew cannot be Jewish if he does not question. All Jewish thought is based on endless commentary and discussion that is often contradictory. If a new question is asked which contradicts Jewish thought, it is still Jewish."

"But what is the point of writing for a world from which you feel exiled? Surely a book must have some relationship to society and life? You said earlier on that that you were your own reader. It seems that you would wish to dispense with the outside world completely. And since all writing is there to be communicated this seems a suicidal enterprise. Can you explain what you mean?" I asked.

"We are all readers of the book. But a reader is the master of the book and if there is a reality in writing it lies within the reader. The author disappears and is emptied. In the second book of the series the narrator dies at the beginning to show that I am not master of the work."

"But are you a privileged reader?" I asked Jabès.

"Not at all. I respect differing opinions and can only speak of them as a fellow reader, since I could easily misunderstand the

book myself. But the situation of myself and you as you read is that you are confronted by the whole and can flick through. I am faced by the empty white pages which is where it all happens."

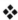

The Marquis de Sade's economic and political texts are being brought to light by current research. These texts have been more severely censored in the past than his erotic texts. When it came to placing Sade in the context of his age a strange austerity and paring down came into play in Philippe Adrien's *Sade dans le dix-huitième siècle: L'Oeil de la tête*. A solitary Volaire appeared to fill us in on the Enlightenment view of Nature and God. The French revolution of 1793 was cursorily summed up by three rather docile members of the Committee.

Adrien chose to concentrate on the clichéd and increasingly less subversive writings on sexuality and religion, and the political implications of Sade's writings were perturbingly glossed over. He failed to show that there is a frightening logic running through all Sade's thoughts and that his views on sexuality are extensions of his political works.

Adrien's dramatization of writers like George Bataille made him one of the choice exhibits of the avant-garde. Parisian theater goers were awaiting his *Sade* with excitement.

It seemed that Adrien's pilgrimage into the systematically destructive works of Sade had turned his head: the play was a sprawling, anarchic enactment of debauchery.

But it becomes apparent that Adrien's interpretation sprang from a fashionable complicity with the author. Sade has exerted a fascination and influence over many intellectuals and it was Camus who, thirty years ago, summed up the dangers: "Sade died in order to fire the imagination of a privileged milieu and literary cafés. But that is not all. His success in our epoch can be explained by a dream which he has in common with contemporary sensibility: the demand for total liberty and the dehumanization carried out coldly by the intellect."

Adrien's production is exemplary of this high-handed belief

in impulse and licence which is justified by a rigorous but inhuman logic. Marxist interpretations of Sade are casually inserted into the frolic. In the program you are told that anything obscure or incomprehensible is a semiological "signe" to be deciphered. Structuralism is production. ❖

S artre was the first to admit that he had become land-locked in a classical cultural tradition. Structuralism dominated the French intellectual climate, and Sartre was as provocatively in disagreement with Lévi-Strauss and Lacan as he was with de Gaulle, Castro, and Camus, at various points in time. The younger generation espoused new ideologies, reserving a place for Sartre in their education, but rarely their debates.

Sartre's participation in Maoist groups, his frequent appearance in their demonstrations, and his conclusion that "one must abandon one's role as intellectual to put oneself at the service of the masses," did not convince the public of his youthfulness or relevance. They tended to feel that he was playing the clown.

It is, therefore, all the more surprising that a three-and-a-half hour film, *Sartre par lui-même*, should have shown to packed houses in Paris. Expecially when director Alexandre Astruc decided to leave camera angles to chance, and the questions to himself and a supporting cast from the review *Les Temps Modernes*. The action of the film is limited to a few attempts at musical chairs and the occasional lighting up of a cigarette.

Sartre, flanked by a petulant Simone de Beauvoir, had little choice but to take responsibility for the film: he added the humor by lampooning himself, provided the drama, by disagreeing with Madame de Beauvoir, and almost managed to crystallize the material for a resolutely *cinéma-vérité* film. His sense of the moment, his awareness of the dictates of a filmed interview, revealed, in miniature, his outstanding capacity to live within the flux of time. And this impression was clarified by a chronological history of the part he played in major events.

It became evident that Sartre's rejection of the structuralist

Sartre and Simone de Beauvoir having lunch in Paris. "The younger generation have espoused new ideologies, reserving a place for Sartre in their education, but rarely in their debates."

fad did not stem from a withdrawal from contemporary society into a private ideological haven. It was rather that he rejected a philosophy substituting timeless patterns for the particularities and idiosyncrasies of events. And although Sartre changed position many times, there was an underlying consistency in his method of arriving at a conviction: every attitude was submitted to ruthless reappraisal. He spared neither his own attitudes nor those of his age. The only time Sartre allowed his voice to speak for a fashion was during the Existentialist boom that he himself created. ❖

W hen Sartre died, the French mourned the loss of a genius. When Malraux died, he was proclaimed a hero of French culture and those who had villified him during his lifetime remained silent. But when Barthes, Lacan, and Foucault died, they were buried uneasily, though they had influenced the sixties and seventies more directly than had either Sartre or Malraux. This ungracious reaction on the part of the critics towards their *maîtres à penser* was particularly ironical, for their style of writing bore witness to the fact that structuralism, in its many forms, had been fully integrated into the French intellectual's vocabulary.

The demise of structuralism was celebrated in a book by Jean-Paul Aron, *Les Modernes*. Aron summarizes the main "intellectual events" from 1945 to 1984, and highlights the sterility and dishonesty of the modernist philosophers. The book was published in1984, by which time these philosophers were dead and unable to reply to Aron's criticisms. Barthes had died on the 26th of March 1980 at the age of sixty-four. He was knocked down by a laundry van as he was leaving a luncheon with François Mitterrand, Jack Lang, the Minister of Culture, and some other notable Parisians. He had stated, in interviews and to friends, that he was beginning to doubt his system of thought. He wanted to write less analytical, more lyrical books. He wanted to take time off from Parisian literary life and spend more time wasting time. He was obviously in need of lying fallow and would, no doubt, have come up with a new kind of book. Already, in *Fragments d'un Discours Amoureux* (1977) and *La Chambre Claire* (1980) he had begun to infuse his work with lyrical, unexplained material. He would take the reader swiftly from an idea to a personal experience and back again to a theory. His life was just part of the puzzle, and his attitude towards his own life was playful and witty. He made his name in 1953 with *Le Degré Zéro de l'Ecriture*, in which he celebrates

Camus's simple, clear writing style, and points to the terrible problems that rhetoric poses for a French writer.

There followed a number of semiological texts, *Eléments de Sémiologie*, *Système de la Mode*, and *L'Empire des Signes*. Then in 1975 he accepted an offer to write a book about himself called *Barthes par lui-même*. So, by the mid-seventies Barthes had experience writing autobiography and criticism. He was now faced with the challenge of synthesizing his differing talents, and he succeeded, in a highly original way, with *Fragments d'un Discours Amoureux*. But he was looking for a more novelistic form of expression, where his life and ideas would be transformed. It was at this point that he died.

When the critics say that Barthes was disillusioned with structuralism, they are quite accurate. But when they assert that he had become a prisoner of his own system of thought, they overlook the fact that Barthes was going beyond pure structuralism even before it had become internationally fashionable.

But Barthes is no longer fashionable, and Jean-Paul Aron's *Les Modernes* happened to coincide with the Parisians' desire to disown their structuralist past. During our conversation, at the Brasserie Lipp on the Boulevard St. Germain, Aron went so far as to suggest that Barthes' sterile philosophy had contributed to his death. "I have to be careful when I say this, but nevertheless, I have the feeling that Barthes was very ill at ease with himself towards the end of his life, and that he had enclosed himself in a dead-end system. He was perhaps trying to come up with new solutions, but as I say in my book, *Les Modernes*, it's hard to change your identity when you've made your name doing one thing. And Barthes had made his name with structuralism. O.K. you will say to me. But what does that have to do with Barthes' death? Well, I don't want to attempt mediocre psychoanalyzing in a brasserie, but I would hazard to say that Barthes was lacking in creative energy, and that he was in a kind of despair. And that was what prevented him from recovering from the accident. Often, you need a certain kind of energy to fight back and live after an accident. And Barthes did not have it. It's obviously only a hypothesis but it is not that far-fetched."

Aron feels that structuralism is antithetical to creativity. And

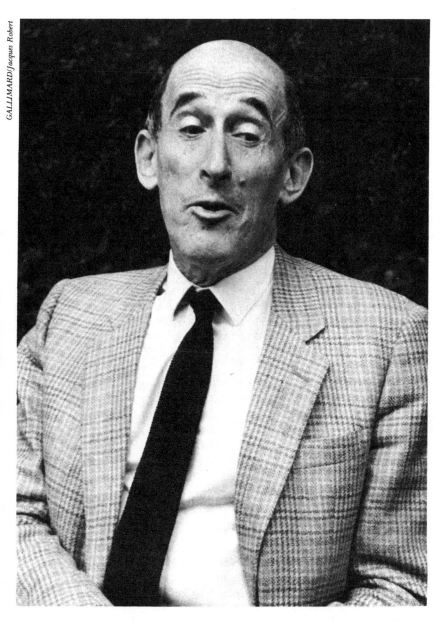

Jean-Paul Aron summarized the main cultural events in Paris from 1945 to 1984, in *Les Modernes*, and highlighted the sterility and dishonesty of the modernist philosophers.

he bemoans the effect that it had on writers and poets during the last twenty years. For it was not only psychoanalysts like Lacan and philosophers like Foucault who integrated it into their work, but also poets and novelists who wrote with the intention of remaining faithful to the theories of the structuralist gurus. "I believe that the cultural models that have become fashionable in France have asphyxiated the production of works of art and literature, and I denounce it in my book. But I think it's ridiculous to affirm that a painting is merely a 'language.' And that a novel should be an arrangement of objects that professors can then criticize and dissect, as in the novels of Alain Robbe-Grillet . . . these artistic productions have nothing to do with real art."

Aron feels that his compatriots have always been fashion-conscious and fickle, particularly in Parisian circles, but more recently their search for novelty has invaded art and literature. "I am not against modernity, and I know that each epoch produces its own new truth. But I am against these impostures of modernity, that's to say, these 'new' systems of thought, which become like commodities. People think that America suffers from this search for novelty, but it's becoming a real problem in France. And people say that America produces literary works like commodities. But it's true of France. At the moment we have new products, or books, that glut the market, each one destroying the validity of the previous 'new' book. This vertiginous production of books has nothing to do with modernity.

"It's certain that it's no coincidence that American universities in particular have been fascinated by these French models of thought, and particularly structuralism and semiotics. Nowadays, thank goodness, the French have no time for all that, and the only place where structuralism is taken seriously is in American universities, and a little in English universities."

Aron has travelled a great deal in the United States, and he continues to give lecture tours. He is not referring to Americans in general, but to the academics, when he says, "When the Americans stumbled on semiology, and strucutralism, they were delighted, for it offered them a method of thinking which dispensed with the need to live or feel. They were reassured to find a discipline that affirmed that language had an existence

of its own, independent from life. I also think that Americans are wary of delving into their feelings, and structuralism gave them the opportunity to opt out."

Aron defines structuralism as a technique for avoiding feeling: "People take to these systems of thought when they want to avoid living, meaning, and feelings. There's this curious taste for objectivity. I'm not sure if that's the right word to express it, but what I mean is that people are under the illusion that you can transcribe a so-called objective view of the world . . . so you don't have to actually experience life. English in any case would be a better language to express my thoughts in this area, for you have a much richer vocabulary than the French for expressing words like 'ressentir' and 'le vécu.' People like Robbe-Grillet, too, are radical enemies of feeling, and his books did well because he reflected the fashions of the epoch."

But Robbe-Grillet cannot be categorized alongside Barthes, nor can the followers and imitators and dissectors of structuralism be confused with the founding fathers. For Robbe-Grillet did hold the view that meaning was extraneous to literature. But Barthes never shared these views. In 1984, Robbe-Grillet published an autobiography, *Le Miroir qui revient*, which had the critics up in arms. How could a writer who had banished characters from the novel write about himself? How could he write a readable, perfectly accessible book when he believed that meaning was a peculiarity of old-fashioned novels? *Le Monde* lamented: "How can the champion of a literature without conscience or meaning begin to write about his own life and his ancestors after thirty years of asceticism? One has to admit that his followers have been wasting their time."

At first it seems strange that Robbe-Grillet's followers would be dismayed to learn that he had written a book contradicting his past theories. But when one learns that Robbe-Grillet is an established editor at Les Editions de Minuit, as well as a writer, one can see that his changing tastes are decisive for certain authors. One of the problems inherent in Parisian literary life is that many writers are also editors and critics. The fact that writers like Robbe-Grillet and Bernard-Henri Lévy (who runs a collection at Grasset) have the opportunity to publish their friends and review their enemies' books, gives Parisian literary

life its passionate intensity. And the action still takes place in cafés. Places like the bar at the Hôtel du Pont Royal and Lipp (where Aron and I decided to meet) have their regular clientele of editors and writers, some of whom are known to appear at precise hours.

Aron had suggested we meet at Lipp, on the Boulevard St. Germain, which is one of his favorite meeting places. He described himself, over the telephone, so I would recognize him: "I always wear a scarf. I'm a little balding. And if you ask the maître d'hôtel, he knows me. They all know me at Lipp." Not only did the waiters know Aron, but a young man caught his attention and asked if he would sign a copy of *Les Modernes*, which he happened to be reading. The young man congratulated Aron on his book. Aron gave him the dates of his next lecture and proceeded to tell me that this kind of chance meeting was the way things happened in Paris. The young man had probably been awaiting his arrival.

"It's so hard to explain to American students, in fact to people who haven't lived in Paris," said Aron, "but places like Lipp are cultural institutions. It's a specifically Parisian phenomenon. You see these places have such a historical weight. There are cafés that have been here since the seventeenth century. The proof is that there we are in Lipp. And the reason these places are so important is that the French don't socialize that much. And when they do, they prefer to see their friends outside their homes. There are numerous kinds of spaces where people meet . . . in the corridors of publishing houses, and magazines and reviews. People bump into each other by chance and they exchange information.

"There are several privileged places, like the Closerie des Lilas, and the Bar du Pont Royal, and to a lesser extent, La Coupole. The Coupole is much less important than it was before the war, when the painters like Modigliani and Soutine and Giacometti met there. Sometimes even Jean Genet would come along with Giacometti, although Genet did not like socializing in public. Oh, for certain, La Coupole is of less importance now. But you mustn't eliminate it. Then there's Balzar. In the evening it tends to be the place for painters and writers. And, of course, Lipp. There are also restaurants . . . under the Second Empire

and during the beginning of the First Republic there were so many restaurants. And there were the famous dinners Flaubert and the Goncourt Brothers and Saint-Beuve and Zola attended. And Edmond de Goncourt would write down everything they said during dinner.

"So you can see that these actual meetings in restaurants created a kind of literature—as with the Goncourts. The magnetism of these cafés is quite incredible. Even the American exiled writers, who were much less equipped to deal with Parisian literary debate, would meet up regularly at cafés. As you know, the American writers are not used to this kind of life, and they would never have met up in cafés if they had been living in the States. I'm thinking of 1925, when Hemingway, Scott Fitzgerald, and Miller would meet up at the Closerie des Lilas and Harry's Bar. They would actually play the Parisian game among themselves. You have to admit that it's extraordinary, the power of these places."

Before the publication of *Les Modernes*, Aron would also participate in the literary lunches given regularly by the *Nouvel Observateur*. The majority of newspaper and magazines, including *Le Monde*, also gave regular lunch parties. "I wrote for *Le Nouvel Observateur* for a long time. But when *Les Modernes* was published they sacked me, out of fury. I remained courteous towards them, even though the editor, Jean-Daniel, wrote me an insulting letter about my book. You see, each week they write a piece praising Lévi-Strauss and Barthes."

As Aron talked about his book, which took him ten years to write, one had the impression that he was writing from his own convictions. Though the publication of *Les Modernes* coincided with a general weariness with the modernist philosophers, he had not written it to please. On the contrary, his book had resulted in the loss of his job at *Le Nouvel Observateur*. I asked him how he had maintained a distance from the literary fashions over the years:

"Oh, that's very kind of you to ask me this question, because it gives me a chance to talk about my own intellectual itinerary and my personality. And since you are asking me to talk about myself, I am forced to return to my bibliography. Thirty years ago, in 1955, I was young, but I was old enough to think for

myself. I was a young teacher at a lycée. It was then that I first came into contact with these models of thought that I denounce in my book. At that time, Proust and Joyce were mainly used for structuralist criticism. My immediate reaction was to laugh, when I saw what the professors were doing with these authors. After all, there are extraordinary things in Proust and Joyce, and they were being forgotten. All that had feeling and humanity was eliminated as they analyzed it away. I think I had a sense of distance later on because I felt marginal. I felt that the culture was asphyxiating me and that it was not mine."

While structuralist literary criticism is still taught in French universities, and certain newspapers like *Le Nouvel Observateur* continue to praise Barthes and his disciples, Aron feels that their work has passed into history, and has nothing to do with the actual preoccupations of writers and philosophers. But structuralism was a way of life. It was a private club, and a way of interpreting life. The absence of structuralism has left a void. I asked Aron whether he was heartened by this freedom from ideologies:

"Well, perhaps you are right in suggesting that it is a good thing. But this absence of ideologies in France at the moment is also a sign of a lack of values. Not that I wish to confuse a sense of values with ideologies. But I feel that there is an emptiness at the moment. And I don't think it's confined to France. People are obsessed by a need for security, in France and in the rest of Europe, and they don't understand that a society has to take risks.

"But there are two levels to any culture: there's the superficial, obvious level, and another level which is in the process of being created. The universities and critics write about the solidified culture, and they read Barthes and Lévi-Strauss. But there is also the underground culture.

"The French have this habit of praising the established culture. There's an attitude of deference and admiration here which makes people completely lose their critical capacities. I think that the French certainly have a lot to learn from the British in this respect. For in England they do retain a sense of judgment. In France, this adulation that's showered on the fashionable writers is an ancient tradition. As in the case of Foucault, they

continued to praise him, even though his last books were the least original things he had ever written. But he was famous, and he was ill, and so they would say nothing against him.

"He did have a great talent as an historian, and he used structuralism as his tool. His books are perfectly made, but they are actually without originality. And I think that Foucault, like Barthes, was plagued by his own lack of creativity and vitality. And his loss of vitality might have been linked to his premature death. I realize that I am taking a risk by making statements like this. But one can take a look at the facts. Since his book, *Surveiller et Punir*, which he wrote ten years before his death, he had written hardly anything.

"Of course, there was that small tome on history called *La Volonté de Savoir*, but he actually spent seven or eight years preparing a book that was in no way an important book. *Surveiller et Punir* was a very important book, but after that he wrote conventional things and I don't think he had much conviction in what he was doing. And Althusser is in a mental home after killing his wife in a fit of madness. It might seem shocking to you that I would say this, but you yourself pointed out that Barthes, Foucault, and Lacan all died within a short space of time. Now that I come to think of it, I should have devoted more space to this coincidence in my book."

Foucault died on the 25th of June, 1984, at the age of fifty-seven. And the critics did indeed treat him more graciously on his death than either Lacan or Barthes. Though Aron feels that he wrote very little after *Surveiller et Punir*, which was published in 1975, he did in fact write several books, including three volumes on the history of sexuality: *La Volonté de Savoir* (1976), *L'Usage des Plaisirs* (1984), and *Le Souci de Soi* (1984).

But it is true that Foucault had lost his enthusiasm for his work. In an interview which he gave just before his death, to *Le Monde*, he says that he "nearly died of boredom, writing these books; they resembled my previous work too closely." Foucault had also withdrawn from his previous activism. His writings on prisons had been accompanied by practical action to improve prison conditions in France and to publicize abuses. In the mid-seventies, the group he had founded, the GIP, to deal with these issues in a practical way, was dissolved. During the last

ten years of his life, he seemed to doubt the validity of his practical work and his writings.

In the eighties, the pernicious nature of structuralism became most apparent when it was applied to psychoanalysis. Though critics still dispute whether Lacan's system was bona fide structuralism, it is evident that he tried to apply structuralism to the study of the unconscious. On his death, on the 9th of September, 1981, many psychoanalysts and writers spoke out against Lacan's theories. In *Le Monde*, the psychoanalyst Colette Chiland stated that Lacan was merely playing with words. He had created a theory of psychoanalysis which omitted making any mention of the patient. Psychoanalysis was no longer a method of giving emotional support or understanding to a patient. It had become a self-sufficient study, whose subject matter was psychoanalysis. This same narcissistic and escapist mentality had also infiltrated the literary world: The subject matter of writing was writing itself. The attention and massive publicity that were given to these various dogmas created the illusion that France had nothing to offer except its *maîtres à penser*. When the masters died, and the ideologies were refuted, many critics, both abroad and in France, pointed to a creative decline in France. The structuralist coteries may have given the critics a great deal to write about, but one cannot confuse structuralism with a creative flowering.

It is a heartening sign that no new coterie dogmas have been fabricated in the eighties, for it paves the way for a more open-minded and less rigid approach to literature. Even Aron's pessimistic view of French culture has become attenuated: "For the last thirty years I had the feeling of living in a cultural desert in Paris. But now I think there's a murmuring, underground culture that is in the process of germinating in France . . . it's imperceptible at the moment . . . but I sense that something is being born."

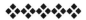

Freedom Fighters

Olivier Todd
Yves Montand
Bernard-Henri Lévy

"I think that Sartre, like many intellectuals, should have spent more time writing and less time standing on a crate in front of Billancourt, harrying the workers. There's no reason why intellectuals should be competent, particularly literary intellectuals, to deal with politics," said Olivier Todd, whose perceptions of France were shaped quite early on by two opposing traditions. He read Moral Sciences at Cambridge and was profoundly influenced by British philosophers like Ayer. Then Jean-Paul Sartre took Todd under his wing and encouraged him to write. But Todd did not find Sartre's philosophy convincing: the Sartrian viewpoint was not even considered a philosophy by the Cambridge school.

"I had a dose, even an overdose, of what I would call elementary logical positivism. In fact, I still remember the first book that was thrust into my hands by my tutor, which was *Language, Truth, and Logic* by Ayer. I think it took me twenty-five years to recover. Wittgenstein wasn't there when I was at Cambridge. But nevertheless it did me a lot of good. And you can imagine that when I met Sartre it destabilized me."

Nevertheless, Sartre became like a father to him. Todd describes their ambivalent but predominantly affectionate relationship in *Un Fils rebelle*, which he wrote after Sartre's death in April 1980. But he says that it took him until recently to see Sartre in perspective. As one talks to Todd and considers the development of his journalism and novels, Sartre's influence is at times hard to decipher, for Todd never accepted Sartre's opinions unquestioningly, and he never shared Sartre's belief in Marxist theory.

"One thing that this trip to England made sure of, was that I could never become a Marxist. And you know the importance of Marxism in France. I didn't trust words the way the French do. I mean a lot of writers in France get totally carried away by words, whether it's Malraux or Bernard-Henri Lévy. They may come to the right conclusions but they get drunk on words. Sentences have a poetical beauty. But the verification principle just doesn't apply."

Sartre published Todd's first poems and tried to steer him towards writing novels. "The first novel that I wrote was actually patronized by Sartre. He published excerpts of it. It wasn't a novel, really. It was a chronicle of a soldier's life in North Africa. The language was very important, because I wanted to show how soldiers behaved and talked. It's set in Morocco, where my batallion was stationed. And my second book was rather bad, *La Traversée de la Manche.* It's a semi-imaginary, autobiographical novel about my relationship with my mother, England, and my grandmother. And then I had ten years in which I didn't write a single book. I went into journalism. Sartre kept telling me that I had gone into journalism because it was a good excuse not to write novels."

Now, Todd admits that Sartre was not entirely wrong. But, at the time, he behaved like a rebellious son, and many of his decisions were simply reactions, based on doing the opposite of what Sartre suggested to him. Journalism became the focus of Todd's writing, and he took a job at *Le Nouvel Observateur*, the Left Wing weekly. Todd has always been wary of writers who express a political bias—as did Sartre—and he thought that his Cambridge training had saved him from the dangers of politically biased reporting.

As a reporter in Vietnam for eight years, he was convinced that he was reporting "the facts." Then, in 1973, he realized that he had been blinded by the Left Wing bias of his paper, and that he had been defending unknowingly "The Red fascists." Part of his feeling of disappointment in himself sprang from the realization that he had been practicing what he had criticized in Sartre's work.

"I did support Hanoi and the Vietcong for many years. In the *Nouvel Observateur* there are still some articles that I have

Sartre became like a father to Olivier Todd, who describes their ambivalent, but predominantly affectionate relationship in *Un Fils Rebelle (The Rebellious Son)*, which he wrote after Sartre's death in April 1980.

published that make me really blush. I changed my mind much too late. It's obvious that when I landed in Vietnam in February 1965 for the first time that I should have known what was actually going on. It took me from 1965 to 1973 to see the light. I mean, how slow can you be? When I came back and told the paper, 'Boys, we've made a mistake, these guys are Red fascists,' all hell broke loose at the *Nouvel Observateur*. When I meet them now they admit that I was right. But they took the beat away from me. And even now say that I was right too early! And that I should remember that certain truths must not be told too soon. It was also one of Sartre's ideas: it's the unformed fetus of the dialectic.

"Everything jelled in my mind when I walked unannounced with the *Newsweek* correspondent into a Vietcong zone. He spoke Vietnamese, and they didn't expect us, so they couldn't prepare a big show for us. And I suddenly realized that the NLF was exactly what the Vietcong expert in the States had said it was, that it was a branch of North Vietnamese political activism. And I came back and said so. They wouldn't let me write it in the paper, so I gave an interview and stated it. They wanted to fire me, and make me retract, and it went on for months and months. I'm not sorry I did it.

"But it shows one thing: that French journalists never say candidly that they've made a mistake. For some odd reason French journalists are supposed to be like theologians. They can't be wrong. And it's made worse when you are working with newspapers that have a huge ideological setup, and it's implicit in what everybody's writing in the newspaper. If a journalist contradicts the ideological stance, they won't take it."

Todd feels that the public has sensed the iron grip that many Left Wing papers exert on their journalists and that they are beginning to tire of reading pieces that act as Left Wing propaganda. "*Le Monde* is in trouble for a number of reasons, and it's not simply a financial problem. All their readership is leaving them, as is the case with all Left Wing newspapers in France. It's an absolute catastrophe at the moment. Even *Le Canard Enchaînée* went from 500,000 to 350,000 since May 1981. *Le Monde* has been responsible ever since 1945 for misinforming us about two countries: the U.S.S.R. and the United States. If

someone was lynched in Alabama it was entitled to the front page in *Le Monde*, but the famine and police repressions in Russia were mentioned in abstract terms, and they never gave us the price of potatoes in Vladivostock. They never gave us the facts."

I asked Todd what he thought of the phenomenon of *Libération*, the Left Wing newspaper which Sartre had helped to found. In its early stages, the daily had been conceived according to his ideals: *Libération* was a cooperative, and all the "workers" had shares of the profits. Sartre wanted the paper to be comprehensible to the average man, not the intellectuals, and the first pieces that appeared were written in a colloquial style. Sartre even wrote a number of pieces for the paper before he became ill. I had interviewed Serge July, the editor of *Libération*, a few days before talking with Todd, and learnt that he intended the paper to be free from a Left Wing bias. In fact, July hoped the paper expressed a variety of biases. July started off his journalistic career as an editor of a Marxist student paper, but he told me that his Marxist days were over. He also admitted that the cooperative structure of *Libération* was unworkable and had therefore to be abandoned. Though many of Sartre's original intentions have been lost, July is indebted to Sartre, and feels that he could never have founded the newspaper without Sartre's support.

Todd says *Libération* is a great success, "but its success means that it went from 25,000 copies a few years ago, to a little more than 100,000 copies. And the fact is that it's read by the socialist establishment. You see it, first thing in the morning, on the tube. It's the young "Enarques" [Ecole Nationale d'administration], it's in the ministerial cars. And that should make people wonder a bit, considering that it was intended for the workers. First, you have to remember that the standard of the French press is abysmally low. So, in the country of plains, hills look like mountains. And *Libération* is not that hot. It still has a considerable amount of vulgarity. It's the French slightly vulgar version of radical chic. But it is a step in the right direction from the old hard-core extreme, Maoist Left.

"But, in general, in France, journalism tends to be less factual than in England. Obviously, the hard and fast line between

what one calls news and opinion isn't that hard and fast, because the selection of facts is an opinion. And French journalists are, if not servile, excessively polite towards politicians. I think on the whole the relationship between politicians and the press is much better in the Anglo Saxon world, because they know they need each other, and they expect criticism from each other. In France, there's a kind of feudal relationship between the politician being interviewed and the journalist."

Todd needed to take regular breaks from the world of French journalism. He worked for the BBC, as an anchorman on Europa, and wrote for *Newsweek* from Paris. His meeting with Jean-François Revel in the fifties marked the beginning of a friendship and collaboration which culminated in Todd coediting *L'Express* with Revel. He had found a kindred spirit in French journalism. "Jean-François Revel and I got on like a house on fire even though we didn't agree politically, because he's the closest thing to a British empiricist that you can find in France."

When Todd was dismissed by Jimmy Goldsmith, the owner of *L'Express*, for publishing material that was unfavorable to Giscard just before the elections, Jean-François Revel resigned from the paper, probably out of solidarity with Todd.

One of the characteristics of Todd's political reporting is that he will not defend blindly either the Left or the Right. Though he defines himself as a socialist, he wrote a highly critical "letter" to Mitterrand in 1983, which was published under the title "Une Legère Gueule de Bois" ("A Slight Hangover").

But Todd's refusal to examine events from an ideological standpoint has made him feel estranged from the mainstream. For a while, he says, he felt French when in England, and English when in France. Recently, however, he notes that many other socialists are also beginning to doubt the ideological basis of their convictions.

"There's been a requestioning of the so-called fundamental opposition between so-called capitalism and so-called socialism. Today, Left Wingers in France find it hard to talk about 'capitalism' as a generality, because they now recognize that there are all kinds of capitalisms—in France, in Great Britain, in Social Democratic Scandinavia. And they also recognize that

there is generally one kind of communism, which is characterized by two things: the police state and total economic inefficiency. Now that we're in the eighties there are very few people left in France who are not aware of the total disaster that communism is, even within the Communist Party.

"The Left today in France has a nasty problem, which is how they can be on the Left without accepting capitalism with its faults and even its crimes, but with its incredible superiority over existing socialism. And this applies not just to the rich, but also to the underprivileged. For if you look at it very carefully, if you've been a staunch Left Winger, you have to admit that, for instance, workers and farmers in the United States are better off than workers and peasants in any Communist country."

The traditional anti-American stance of the French Left has also undergone a reappraisal, according to Todd. "When the Maoists went to China and then visited the United States, they never recovered. Some of them are even going too far. I have several Left Wing friends who are now more Reaganite than the Reaganites in the States. I know these people are special cases. But many French academics and journalists were given scholarships in the States, and they discovered an open society, and had to compare it to the Communist countries they'd seen. And they did.

"But you must put anti-Americanism in perspective—and over the last forty years, since 1945. First, there were many Communist anti-Americans during the golden days of the Communist Party when they had twenty-five percent of the vote. This communist attitude was latent, and came back in 1958, when de Gaulle came back into government. The Gaullists inherited de Gaulle's anti-Americanism. And then you must set it against the background of Vietnam which determined many French people's attitude toward America. I think we're also going through a revisionist attitude towards America's involvement in Vietnam."

Todd points out that the attitudes of the far Left and far Right have often overlapped, and that nowadays the Communist vote is being lost to the extreme Right, in particular to Le Pen, the Right Wing racist politician.

"Some Communists have gone to Le Pen, but that's very

normal. People forget that in Nazi Germany a lot of Communists went to Nazism and that a lot of ex-Nazis are now in the Communist apparatus. This only means that political life in France is not like it is in the House of Commons, with the Left on the one side and the Right on the other. In France, the extremes meet. Temperamentally, a Communist and a Nazi have more in common than an American conservative or a British conservative and a French socialist."

I asked Todd whether the popularity of Le Pen's racist stance was a sign that the French were becoming increasingly xenophobic or whether he represented a more serious fascist movement.

"Le Pen is a nasty character, and some of the people around him are even nastier than he is. It's absolutely true that he represents xenophobia and racism. But I don't think for a moment that his electorate is a bunch of Nazis and fascists. In my village in the South of France (where I have a country house), there are twenty-five percent of the electorate voting for Le Pen. I know some of these people. They are not neo-Nazis waiting for their brown shirts. They are just irritated by unemployment and a lack of security. In the last few years, the small bank in my village of nine hundred inhabitants was held up three times. The people feel that everyone is being murdered all over France, which of course is not true. It's perfectly true that in all Western industrialized countries the rate of petty crimes, not of blood crimes, has gone up. In France, it is difficult to walk at night in the Metro, though it's nothing like the New York subways yet. It's still an extremely civilized society with people killing each other less and less.

"Le Pen has drawn to him all the people who are discontented. Not only people from the lower classes. There are a lot of doctors who are supposed to be fairly well educated who are devoted to him. I think that the phenomenon of Le Pen becomes even more mysterious when you realize that he uses futile slogans and silly platitudes which are not true. He's convincing people that if three million African immigrants were sent back home there would be enough jobs for the French, which isn't true. The French cannot fulfill the tasks that many of these people do. But Le Pen presents a very complicated and subtle

Le Pen, the President of the *Front National*, and other members of the European Parliament protesting the French National Assembly's decision to integrate public and private schools. Says Olivier Todd: "Le Pen is a nasty character, and some of the people around him are even nastier than he is. He represents xenophobia and racism."

problem for France, and there's no point being an ostrich and saying that the problem doesn't exist, as the socialists have been trying to do for years."

Despite Le Pen's popularity, Todd feels that France is becoming less xenophobic than ever before. "If you look at the facts, you'll see that France, over the last century, has absorbed a colossal number of foreigners, from Poland, Italy, and Jews from various countries. Our record on political refugees is quite good, under Giscard and Mitterrand. No, xenophobia is not one of the French national characteristics at the moment."

While Todd is confident that Le Pen's supporters will not turn to violence, he is thankful to Sartre for saving the Left Wing extremists from espousing terrorism:

"It's an interesting aspect of France at the moment, that we don't have anyone singing the praises of the Baader-Meinhof

gang or the Red Brigade in Italy. And you have to give Sartre his due here. You have people like Sartre to thank for the rejection of terrorism as a solution. I think that Sartre was a total disaster politically, but he did speak out against terrorism. And so did people like Glucksmann. There was a point when the disorganized battalions of the ex-Left Wing after May 1968 wondered where they were going and terrorism was a temptation. But Sartre never gave into that temptation."

Throughout our conversation, Todd would find himself referring to his ambivalent relationship with Sartre. Todd's independence from his "adoptive" father is still an issue, and he seems to gain some kind of relief from criticizing Sartre's attitudes. And yet, one senses that Sartre's influence continues, and remains a touchstone for Todd. He tries to assess Sartre "objectively," but often forgets that he has strong emotions towards the man.

"I think that Sartre is in Purgatory. And though she makes hard TV efforts not to join him there, Simone de Beauvoir is there also. I think I can assess Sartre quite candidly now, if not objectively. I mean, that I can. Philosophically, he was a total disaster. But, his biggest disaster was his political commitments, apart from his defense of Israel, while at the same time defending the Palestinians. And also, in his attitude toward Biafra. I think I had something to do with this. Because I came back from Biafra and told him that it wasn't a simple issue, and I wrote some pieces that weren't mechanistic.

"But politically he was up the wrong street, until the very last weeks of his life when he published those curious interviews in the *Nouvel Observateur*, where he said that he had made a mistake in thinking that the French Communist Party embodied the French proletariat. I think he didn't have time to go even further and say that there was no reason why the proletariat should be the destiny of the world. Why should uneducated masses carry cultural thinking? It's idiotic. I think today that one should write a defense of the bourgeoisie. After all, the bourgeoisie was the class that carried culture, and it's ridiculous to attack it as some monolithic evil force. But, from a literary point of view, he's still very interesting. I like some of his novels

like *La Nausée* or plays like *Huis Clos*, or even that operatic machine, *Le Diable et Le Bon Dieu*, or *Kean*. But I think his attempt at modernism in *Les Chemins de La Liberté* was an unmitigated disaster."

Todd still finds himself reassessing Sartre rather regularly. His views have changed, yet again, a few years after the publication of *Un Fils Rebelle*: "I'm in a different mood now about Sartre's last period. Very different from when I wrote *Un Fils Rebelle*. I know that he was sick and ill and blind. That's true. But he did have his moment of lucidity. So, it's not fair to say that his last interviews were unacceptable because they question all that he wrote before. I can understand why he changed his mind. And it's quite possible that he went on thinking despite his last illness."

I asked Todd what he now felt towards Sartre as a person: "Well, as a man, I'm very fond of him. He was very kind to me, and got my first book published and things like that. And one cannot question Sartre's generosity, although one can question a lot of stands he took, may his soul rest in peace."

Todd's main criticism of Sartre is that he spent too much of his time dealing with political issues, and too little time writing his novels and plays. Recently, Todd has learnt the lesson that he preached to Sartre. He is devoting himself to a novel and has decided to put aside journalism in all its forms. For Todd was a journalist of his own life, and used the novel to "report" on his personal world. Many of his attempts at fiction do read like novels, and those who are unaware of the details of Todd's life might find it hard to tell that he is writing about himself. Todd's novel *L'Année du Crabe* is a riveting story about his search for his father whom he had never met. He tells how he eventually traced him and was at first disappointed with the man.

"Most of the novels that I've written have been semi-autobiographical. And *L'Année du Crabe* was almost ninety-nine percent true. Nobody was fooled by the fact that it was presented as a novel, and it hurt a lot of people. I wrote it after a series of crises and in a kind of daze. I'm not ashamed of it, but I'm a bit flabbergasted by it. Now, for the first time, I'm writing my first real novel. Or my last false novel in the sense that, though

it's in the first person, it has little to do with me and my actual life." ❖

"**C**an you imagine what they wrote in *Le Monde* about me?" asked Yves Montand, gesticulating with both hands, his voice a little hysterical. "They said . . . '*Montand rend hommage à la droite*' [*Montand pays homage to the Right*]. That's extraordinary. *Le Monde!* I told them, aren't you ashamed to say such a thing. I rang the editor . . . twice." Montand was convinced that he was perpetually misunderstood. He wanted me to understand that he was still a socialist, even though he did not always defend the socialists.

"I'm permanently attacked. In a most underhand manner, in an abominable way. Let me give you an example. To be a good Left Wing citizen, you have to be against Le Pen, for the Third World, and antiracist. Ah . . . ah . . . but you're overlooking all the problems that are much more serious, which would force you to question your political stance. An example: the French union wants to help the British miners, but, at the same time, they completely forget about the conditions in Silesia or Poland. Do you understand? If they spoke about Walesa and Poland they would be forced to reconsider what's going on in France and why they keep wanting 'the union of the Left', which is a union with Stalinist officials."

The union of the Left has always posed problems in France, for the Communists and socialists remain in basic disagreement over many issues, and the French Communist Party continues to have strong ties with Russia.

"The union of the Left becomes an obscene word. Do you understand? Even after Marchais [Leader of the Communist Party] gives them a slap in the face, they still want to be friends with him. It's not possible! And this is what I tell them, and instead of saying is he right or wrong, they just attack me. They say, so you're turning to the Right, you're not on our side . . . I've been fighting for two whole years with them on this issue."

Montand spoke as if he had never heard of the traditional polarization of Right and Left in France. He also seemed to be unaware that the socialist government has been reassessing its position for many years, and has accepted that old Left Wing theories have to be reformulated to the extent of admitting that nationalization was a mistake. Socialists are now encouraged to practice free enterprise. And the crimes of communist regimes are no longer defended by the majority of Left Wingers.

I asked Montand whether his roles in Costa-Gavras's films, such as *Z* and *The Confession*, or Resnais's *La Guerre est Finie*, had influenced his feelings about political issues, but Montand was not keen on talking about his acting career.

"Do you know what they do to me? . . . Excuse me for interrupting you. The honorable Left Wing people meet up in cafés and brasseries. What do they do? They sing *The International* and *Le Temps des Cerises* . . . as if they were still persecuted. It's not possible . . . excuse me . . . what did you ask me?"

I repeated my question, adding to my list Costa-Gavras's *State of Siege*, in which Montand plays an American government agent. He is captured by a terrorist group in Latin America and is killed after he has had time to think about his profession of supplying torture instruments to the military.

"Before *State of Siege* I made four films which were under the good flag. The right flag. They were *The Wages of Fear, La Guerre est Finie, Z*, and *The Confession*. Then, suddenly one day, I said, one has to admit that the suffering in the world isn't just due to capitalism. Some people say, why is he suddenly saying this now? Don't they realize I've been saying this for thirty years? But no one listens. Because it doesn't suit them to."

The publicity that surrounds Montand's every statement on politics is proof that many people do take notice of what he says. Montand's television appearances attracted a large following, particularly his program on economics, *Vive La Crise*, which was a rather astounding success. Montand has also appeared on American television, on the program *60 Minutes*. He has some advice for the American government:

"I tell them: United States, you must give the Latin American people the power to construct a democracy, even if it's only economic democracy. But, already there's democracy in Brazil

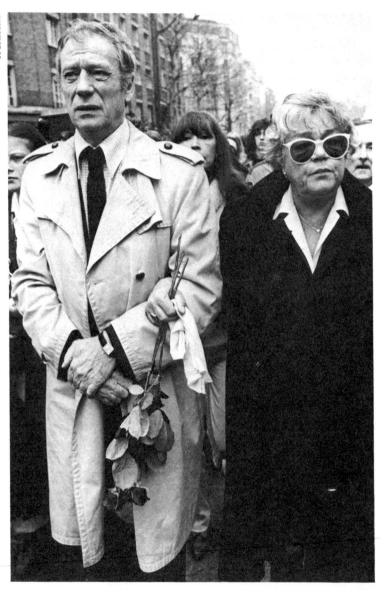

Yves Montand and his wife, the late Simone Signoret, accompanying Sartre's coffin to the cemetery at Montparnasse where he was temporarily buried on April 17, 1980. Over 50,000 people paid homage to Sartre. There was no official ceremony and no service.

. . . it's beginning . . . I'm still waiting for the same thing to happen in Afghanistan or Poland. I'm waiting for the Russians to say, 'O.K. You can vote freely.' You can't even compare what's going on in El Salvador with Afghanistan . . . it's dishonest to do so. I'm not saying one hundred percent Amen to the Reagan administration. But what's positive is that he's positive. I'm sorry. When I said, a year and a half ago, that Monsieur Reagan, I prefer him because he has some capable people around him and his track record is positive, that doesn't mean that I'm entirely in agreement with him, but I'd say sixty percent of what he does is positive. But you know what the Left Wing do? They continue to talk about the abominable Reagan . . . because they are upset . . . because it disturbs them. It's not fair. Do you understand?"

Montand leaned forward and stared at me rather menacingly. I was impressed by his ability to give a political speech in the privacy of his living room. But I was taken aback when he paused for breath and spoke to me directly. Until that moment I had the feeling that I was sitting in the front row of an auditorium, listening to a politician who was trying to get my vote. Montand continued, with full force, when I told him that I understood. He went on to tell me that Marxism does have a place in his political "philosophy."

"There are obviously power relationships in the world. You can't do anything about it. You will tell me that it is immoral, and I agree, but the fact is that people win wars, even in Costa Rica or Nicaragua, with guns. Now what do they do? They need the big brother Americans. So, they say 'Please, will you help me?' What is the North saying? In this case? 'No, we won't do it.' My reasoning is that even if a small country wins a revolution, they need help from the North, from America. So, they are obliged to have a revolution without guns. So the revolution has to take place with brains. That is why they have to think about Walesa and his friends. But the Marxist revolution is valid when a country needs a constitution. The only way to find a solution is the violent way."

Montand was sceptical that revolution can improve the lives of the underprivileged. "I don't believe that a change in society can change anything. You know, I remember about five years

ago there was a meeting of the union of filmmakers, and one film director said we need a socialist government for our personalities to blossom. Do you follow me? You have to have a personality for it to be able to flower . . . You don't seem to understand me . . . it's annoying."

"I have the impression that you said that a society . . ."

"No, Mademoiselle," said Montand, angrily interrupting. "Many people think that they will have no talent according to which government is in power. It's not the government or the political philosophy that gives you talent. You have to have it first. Or you don't have it. That's why life is cruel. Life is not roses. Life is hard; you can lose it at any moment, at any age. It's lucky if you make it to sixty-five. It's not a given. It's not owed to you. And that's what falsifies all issues. Also, people don't want to see what human beings really are. They don't want to see that we're animals. They always want to see the God in people. 'I'm God' . . . that's what they want."

Montand leapt from subject to subject, interspersing English nouns and French verbs. I pointed out that he had been unnecessarily bad tempered during the interview, for I had understood what he was saying, but I would have preferred to talk about his acting career and leave politics in abeyance for a while.

Montand's face crinkled into a look of shock and hurt.

Oh, no. I hope I wasn't unpleasant. Was I? No, let me explain why . . ."

Suddenly, Montand metamorphosed into a solicitous, soft-spoken man.

"You see . . . there are people who just give any old interview. But I can't. I give myself completely. I can't help it, and I can't do otherwise. It's a terrible weakness of mine. I admire very much le self-control Britannique [he said yet again in English and French]. No, I'm not joking. I would like to be very English. Sometimes it's irritating because it becomes pretentious. I admire the British sang froid, even when they kill without blood, but I don't like it when they enjoy themselves because then it becomes something repulsive."

And Montand amiably began talking about his acting: "When

you go on stage it's a mixture of plenty of things. It's egocentric, exhibitionistic, of course, but you also think am I connecting? You can't cheat in acting. If you do the audience feels it and cannot respond. I also think that we choose the acting profession in order to escape from real problems. It allows us to remain in childhood, but everyone is really big children. People always criticize actors or artists for the weaknesses and faults, without realizing that they are the reflection of the audience. You, the audience, are all actors. But people don't know that because they see us, and they don't see themselves. But you can't cheat. It's the same in politics and in love."

Montand explained that his views on love fit coherently with his view of politics. He believes that in both spheres man is guided primarily by an animal drive, and that to say otherwise is to lie to oneself.

"I could fall in love with a very ordinary girl tomorrow because of my age . . . you are never shielded from these feelings whatever your age . . . no one, not even women, and that's the biological, animal side. We are animals. We talk all the time with our intelligence. But then something happens. It's an animal reaction. Always, always, always, even in the real love affairs, when you are young there is a twinkle [in English]."

"It can lead to destruction. To self-destruction, if you take it to the limit. But it's because we're here to create another human being. And for no other reason. But we won't accept that. People won't accept the fact that we're on earth uniquely for procreation and for the continuation of the species. The rest is just cinema. Our reality is not particularly encouraging. It's not exciting. But it's the real reason we're here, like sheep or rats who reproduce. Millions of men and women die, and nobody moves. And I pretend to be a wonderful Christian man, and I pretend to be very, very integrity [Montand's English] Left Wing. It's always first me, me first."

But Montand was married to the late Simone Signoret for thirty-six years, and he was capable of learning from and respecting her political commitments. Montand has also stated that he benefited enormously from Piaf's mastery of singing during their affair. He has repeatedly fallen in love with women

who have strong personalities. I asked him whether his choice of women showed that he had experienced a kind of love that was not solely biological.

"Ah, that's possible. But these women were not only intelligent. If they had been just intelligent it would have been very boring. In any case there's a kind of intelligence I hate, and which bores me profoundly, which is academic intelligence. If it doesn't come from the heart, it doesn't interest me. Sartre had the intelligence that springs from the heart, and from culture, and from a knowledge of the world, even if he did make some mistakes. If people don't feel things, if a woman doesn't feel things, then I'm not interested in her. And I could fall in love tomorrow, more easily with a stupid woman, or a reasonably unintelligent one. Intelligence has nothing to do with falling in love."

Since I was still unsure whether Montand actually sees love as a primarily biological drive, I asked him if "love" was essential to his happiness. I learned that Montand does not necessarily associate happiness or fulfillment with "love."

"Of course, it's hard to live without love, but it's much worse to live without loving the work you do. I can't think of anything worse than not enjoying what you do every day. It's suicide. And it's not necessary to be an artist or a writer or a painter. You can be a butcher, and enjoy cutting up meat.

"I lived with Piaf for two years. And it was two fantastic years. But Piaf's temperament was different. Not for reasons of sex. It wasn't uniquely that. She always wanted to be destroyed by a separation, and find a new love, again, because she was always fabricating a new dream. But it took me many years to realize that. She needed to suffer, and when she suffered from a separation she would sing divinely, and when she fell in love again she sang divinely because she was in love. But you can't fall in love every two years . . . she was built like that. She had a terrible cruelty, like the majority of women."

And then we were back to politics:

"Man is an animal and woman is an animal, and when they have to fight for a bit of meat that has to last five days . . . that, the English knew a lot about that when they had rations . . . and with us it was much worse, during the Occupation. When

people are confronted with reality, then the fight for politics becomes secondary. But we talk about politics, when we have a good cognac and a good cigar in our hands."

Before I met Montand I had the distinct impression that his political stands were always based on human rights criteria. He had consistently criticized Right and Left Wing dictatorships and had made repeated stands against torture. He opposed the French governments in Algeria and their use of torture, and had criticized the Americans in Vietnam. He had spoken up against the Greek military dictatorship, and the American support of Pinochet in Chile. And he had also protested the Russian invasion of Afghanistan. Montand and Simone Signoret have made these stands together knowing that there would be repercussions. They were not allowed into the United States until 1959 because of their political statements.

I told him that I had always had the feeling that he approached issues from a primarily human rights point of view. I was mistaken.

"When you're forced to fight for your human rights in an authoritarian regime, all you think about is food. Unfortunately. We think about human rights when we are living in England or in France. And now, when people criticize Le Pen for his behavior in Algeria, during the war, and his involvement in the torture, it's true and I cannot approve. But I don't just judge him like that because I don't know how I would have felt if I were in the same circumstances. That's why I would like to quote a phrase of Monsieur Malraux's: 'There can be just wars, but there can never be a just army.' If you don't want torture, don't make war. What is this hypocrisy that people talk? You can kill a man twenty years old, but don't kill women and children. If I make war, I make war with all that implies . . . in abominations and torture."

I told Montand that I disagreed with his predominantly Marxist belief that economic rights come before human rights, and I pointed out that people have been known to prefer to die rather than capitulate and disavow their beliefs. Montand referred me back to the Occupation in France. "You are too young to remember, but when the war was over and Maréchal Pétain said 'The war is over' . . . not everybody wanted to be

part of the Resistance. But there were many groups of all kinds
of people, Left Wing, Right Wing, Catholic, etc., who resisted,
even though there were very few really active resistance workers.
Why? Because the majority of people were struggling for food,
for survival. When Pétain said the war was over, ninety-five
percent of the people were for it. Not only the working class
would not accept it. A lot of middle class people could not
accept the Occupation, and not only because de Gaulle was
there. Some took the boat to Spain or England. And the rest,
who did not leave, but who couldn't accept it, said 'O.K., the
war's over, but it's a shame for our country . . . we lost . . . it's
terrible.' And this happened to Left and Right. But they were
paralyzed because of the pact. So when the Liberation came,
people like that decided that they should judge the collaborators.
But they never actually were clear about who these collaborators
actually were. Many people continued to do business with the
Germans but they had to survive, and when the war was over
they were made to feel guilty. They felt: 'My God what have I
done?' But no one mentioned the fact that the workers at
Renault or the miners worked for the Nazi Army. They made
the trucks and tanks in the Renault factory for the Germans
. . . but no one judged people like me as collaborators because
we were the workers."

Montand had come full circle to his criticism of the self-
righteous statements of the Left. As I got up to go, he suddenly
became worried that he had perhaps explained himself too
quickly. He did not want me to misunderstand him, and he
even offered to correct the French transcript of our conversation.

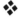

B ernard-Henri Lévy described himself to me, as we sat
in his office in the publishing house, Grasset, with a rather
ironical glint in his eyes. I had asked him whether the exasper-
ated, passionate tone in his books, like *L'Idéologie Française* and
La Barbarie à visage humain, was a tone he adopted, or whether
it sprang from his personality:

"I believe it stems from my personality . . . yes, I am sure it does . . . I am a mixture of nonchalance, and I have a taste for the good life, and easeful living, and pleasure on the one hand. And then, on the other hand, I am febrile, furious, frenetic, sectarian, brutal and violent."

"And violent?" I asked.

"Yes. I am violent. When I was a young man I would often get into fights. I was quite content to settle an argument with my fists, rather than by discussing the issue; I'm not tolerant, absolutely not. I think there's a contradiction in me, between the self that has a taste for easeful living, and the self that enjoys a fight. I have causes that I fight for with every ounce of determination."

Bernard-Henri Lévy became famous with the publication of *La Barbarie à visage humain* (1977), in which he attacked the ideology of Marxism. Given the number of Marxists and ex-Marxists in the French intellectual arena, it was not surprising the Lévy's book provoked a scandal. I asked Lévy why he thought his books were always the center of fierce debate:

"I think there are some irrational reasons, and some good reasons. I'll let you discover the irrational reasons for yourself. But I'll tell you about the professional reasons. I have always written books which show the political and intellectual establishment things which they don't wish to hear. In my first book, I wanted people to think about the fact that the idea of progress is reactionary; that Marxism is an establishment thought process, and that socialism is a dead ideology. So before thinking of conquering the Right, you first have to smash the Left and purge it of all its totalitarian aspects . . . which, of course, they had not yet done."

Lévy uses Solzhenitsyn's *The Gulag Archipelago* as the source and inspiration of *La Barbarie*. He explains why Solzhenitsyn had such a profound effect on his thinking. It was the manner in which Solzhenitsyn presented the facts that allowed Lévy to see that no political system of thought can justify or rationalize atrocities.

"I think that Solzhenitsyn's *Gulag Archipelago* had an enormous effect on me and my generation. First, because he is a great writer. No, for one reason . . . because he is a great writer. He

Dominique Nabokov

Bernard-Henri Lévy described himself to me as we sat in his office in the publishing house, Grasset: "I am febrile, furious, sectarian . . . brutal, and violent."

was the first person to speak about the camps without explaining them, without encompassing them in a rationale, without answering the question why (which all previous theoreticians before him had done). He showed them in their naked state.

"Until Solzhenitsyn, when people spoke about concentration camps they explained them so perfectly, they linked them so efficiently to their origins, and their causes, that the camps almost ended up, at the end of the argument, as being quite normal, natural effects of necessity. Obviously, one's mind could not agree with the fact of their existence, but the way in which the argument was structured made one understand so clearly the reasons for the camps . . . that they had grown out of the imperialistic encirclement, the backwardness of the Russian people, Lenin's logic . . . so that the scandalous, horrible, and nonsensical suddenly became integrated into a kind of common sense. The camps began to make sense, even when one was against them. When you read the *Archipelago*, you see how you do not find the slightest explanation of the camps, nor the slightest attempt to theorize.

"When I said in *La Barbarie* that Solzhenitsyn was the Dante of our times, I meant that he was the first person to look squarely at the horror, and face the completely nonsensical nature of the atrocities."

Lévy had dealt a blow to the French Communists and their uneasy union with the socialists, but some hailed him as a successor to Sartre, for Lévy, though he shared none of Sartre's beliefs, had the same capacity to galvanize readers, and present ideas that impassioned his readers. Lévy's brilliance and sense of irony came through, both in his writings and his television appearances and regular public debates. Then this *enfant terrible* of the intelligentsia produced a new book, and a new thesis, in *Le Testament de Dieu* (1979), which was almost whimsical in construction. Lévy's capacity for making an idea sound convincing had led him to rationalize his beliefs, which were a matter of faith, not of reason.

"In *Le Testament de Dieu* I said a second thing which the intellectuals did not want to hear, and which they found completely ludicrous, and which undermined them in their fundamental prejudices. I said that the Bible was a work of

resistance, that Judaism was the essence of modernism, and that we needed to draw from the wisdom of the Bible in order to fight the barbarities and atrocities of the contemporary world. Of course, that book implicitly attacked what I call 'the French ideology,' which became the subject of my next book."

When *L'Idéologie* was published in 1981, Lévy was fully established as an intellectual star. For some, he represented the fight against fascism in all its forms and for others, he was a scandalous troublemaker. Newspapers would often give three different reviews of the book, to show how divergent the reaction was. Lévy had stated and tried to prove that the French collaboration during the Occupation sprang from certain French national characteristics: xenophobia, racism, and of course, deeply entrenched anti-Semitism.

"The book was clearly scandalous for I demonstrated that France was Pétainist fifty years before Pétain, and that she is still Pétainist fifty years after Pétain; and you can see this Pétainist mentality all over the place in France . . . in a small county church as well as in the radical socialist luncheons, in a poem by Péguy, in a speech given by a member of the French Communist party, and evidently in the ideology of the National Revolution in 1940. When I demonstrated that transhistorical, metaphysical Pétainism, it obviously made the French intelligentsia mad with rage. There were petitions against me, from the director of *Le Monde*, *Les Editions du Seuil*, asking for . . . well, I'm not quite sure what they wanted to achieve with their petitions . . . perhaps that my book should be burned. You'll see it in the dossier that my secretary will give to you.

"And then there was my novel, which provoked very brutal reactions. Why? Because I simply told the story of what has happened in France over the last forty years, with that unbearable pretension that I have of telling history in my own particular style. And they couldn't bear that, either."

I asked Lévy if he had found it hard to make the transition from polemical writing to novels. For his "novel" *Le Diable en tête* is more like an allegory than a story, and the characters represent ideas, rather than having a life of their own.

"No, no. On the contrary. The novel and the essay are part

of a continuity . . . they are very similar and, what's more, my essays are already very personal, and they're written in the first person. They are essays which are erudite, but very personally committed pieces. My essays are in a sense novels."

Lévy had just pointed to the weakness in his novel, and his essays. For, in *Le Diable en tête*, he uses each character to prove a point, and never allows ambiguity, or the development of a viewpoint that would contradict his own authorial voice. In his essays, too, he diminishes the importance of his vigilant stand against fascism, by proposing the ludicrous notion that France is a fundamentally fascist country. Instead Lévy consistently eliminates any mention of the strong democratic and antifascist tradition in France, and seems to find it unimportant that France is not run by a dictatorship. If a complete outsider to France and her history were to read Lévy's book, he would come away with the impression that the French are a nation of xenophobic, racist fascists. I asked Lévy why he made no mention of the existing and historic tradition of democracy and tolerance in France.

"Yes. You're right. There are two opposing traditions. That of the Resistance and that of Vichy. But the two are having a battle at the moment. As always the French are always divided between the two. It's clear that there's been an extraordinary rise of neofascist ideology in France, and it's confronted by an incredible resistance."

Bernard-Henri Lévy explained that he had tried to present the opposing traditions in his novel, and he was not sure why many people had not understood his message. "The novel was about the interminable dialectic of fascism and anitfascism, and the way in which the ghosts of the war and the ghosts of fascism have continued to haunt the French for the last forty years. Some people took the option of going to the extreme Left because they were haunted by the ghosts of Stalinism and Nazism . . . and the redemption of all that is Jerusalem and Judaism. Not everyone understood my last point, even though it's crucial. Perhaps they didn't ever finish the book," he added rather nonchalantly.

I asked Lévy if his experience of writing the novel differed

in any way from writing nonfiction. Did the characters ever take control, and lead him to unpredictable ground, or was he always in control?

"No. I am the one who decides. And I decide what my characters will do in relation to the logic that I lend a character. And I am the one who decides to take that logic to its extreme limit. And I'm fully conscious of that logic. I would never let myself be carried away by a logic that would overwhelm me which belonged to my characters."

Bernard-Henri Lévy takes leave of Paris when he needs to write a book. He does not draw his inspiration from French literature, and he says that he does not write for a specifically French audience.

"I never write with the intention of talking to an audience . . . neither the French nor the Americans. And least of all the French. I believe that a writer speaks to no one . . . or perhaps to a faceless reader . . . but certainly not to the French. I feel very cosmopolitan. I feel just as comfortable in New York, Rome, Berlin, Barcelona . . . Actually, less in Berlin . . . but I love London and I go there a lot. But I am not a French writer."

"I am sorry, but I don't quite understand," I replied.

"I said I am not a French writer. The originality of my writing cannot be attributed to a French influence. I'm as influenced by Italian or American literature, German cinema."

"Then, do you feel like an outsider in France?"

"No. I enjoy living in France. It's the country I choose to live in, and it's a good life style. It's certainly a very civilized country when it comes to living well. And I have my own little village in Paris. I have my Paris, with my café and my restaurant. I go to the Récamier every lunchtime at twelve . . . and I have the same small village in every city I go to . . . I have one restaurant and one bistro and one bar. But, when I write I need to go into exile. I don't write in France. All my books have been written in hotels . . . in very beautiful hotels, actually. I like hotels, because as Proust says, a hotel is the only place where people will leave you alone. Half of my royalties are spent on hotels."

Lévy was delighting in his ability to keep a straight face while making far-fetched statements. It was obvious to both of us that he is a French writer, whose audience is in France, and primarily

among the Parisian intellectuals. His work is conversational, and constructed to provoke emotion in the reader. Lévy's playful attitude and his disdain for common sense makes him an entertaining person. But, in his work, his disdain for ordinary sense and balanced judgments becomes more worrying.

His passionate beliefs and command of rhetoric have led him to construct an alternative ideology. Once he had destroyed the Left Wing and the Far Right, he headed off into a new zone of dogma which now provided him with an answer to most questions. When I asked him whether he thought that anti-American feelings had subsided in France, he replied,

"Ah, you have a thesis on anti-Americanism in *L'Idéologie Française*. It's a Pétainist position, for two reasons. Firstly, because historically it was born with the extreme Right in France. It stemmed from the hatred of the English and of Anglo-Saxonness which one finds in Maurras, and in the extreme Right . . . in Drumont, the author of *La France Juive* (*Jewish France*). And then anti-Americanism continues with Drieu La Rochelle and the other Right Wing people in the thirties. It doesn't begin with the Left, but with the extreme Right. Now you might say to me that an idea can be spawned by the Right and move to the Left. But there's something very particular about Pétainist concepts . . . there's a hatred of abstract ideas, and a love of the earth. They hate the American people because they are people without roots, and a people who are not linked by belonging to the same race, but are linked by simply adhering to the same law. And the Pétainists hate that. The extreme Right is anti-American. And if the extreme Left is anti-American at times, it's only because of an unconscious fidelity to the Pétainist Right of the first half of the twentieth century."

I told Lévy that I had noticed, not a Pétainist hatred of America, but rather a fear that the American way of life and pop culture would overwhelm the French way of life.

"Yes. It's not certain that France will be successful in modernizing herself. What could happen is that she will become what Dostoevsky foresaw in *The Possessed*. That's to say, a museum of the world, a sort of archeological curiosity . . . a land of memories and cultures where the new masters of the world will come to relax as they look at the beautiful things in France, and

observe, with some disdain, the fossils that we will have become, us Europeans. What could occur is Hegel's idea of the aging of the spirit, if France doesn't manage to modernize."

When one listens to Lévy's picturesque ideas, and extravagant conclusions, one finds it hard to remember that he is an activist. For he believes that, as an intellectual, he has a duty to put his ideas into practice. On the day that I met him, he was preparing a talk for *S.O.S. Racisme*, a group that was formed to combat Le Pen, and he feels that his speeches and articles against racism give meaning to his writing:

"Sometimes I do wonder whether I'm making an effort for nothing, and on the other hand, I know that I am having some effect . . . as an intellectual. It's the intellectuals after all who helped to boycott the Olympic games in Moscow. It's the intellectuals, and I'm actually thinking of myself and the actions I've been involved in, who gave the Afghani resistance radio transmitters, that have a logistic and strategic importance on the territory. I also have the feeling that it's the intellectuals who are at the origin of the movement called *S.O.S. Racisme* which is holding a press conference tomorrow at the Lutetitia Hotel to which you are invited. So I believe that an intellectual does have a real function.

"But I'm not a rebel. I don't want to change society completely. I don't dream of a new kind of world. I don't want a fresh start. I don't want to reform mankind. In fact, I think that the fantasy of a revolution (which my character Benjamin holds to, in my novel) is one of the most terrible, totalitarian barbarous notions around. On the other hand, I am for a constant, obstinate, and practical resistance to the horrors and atrocities of mankind."

Though Lévy's ideas are always pushed to a logical or rhetorical extreme, it seems that he is merely being playful when he performs these feats of language. For he does not believe in taking extremist measures in practice: "I'm not an extremist. I'm sectarian. That means that I believe in a certain number of ideas, that seem to be important to me. They are values that seem to be decisive. And I believe in making a clear distinction between good and evil."

Lévy's sectarian stance, and his avowed intolerance towards ideas that contradict his own beliefs, give to his writings a

superficial and declamatory tone. But, his confidence and forcefulness makes him an effective activist and a successful media personality. His books are preliminaries to his personal appearances, and he devotes himself full time to his literary battles and his fight against facism and racism. When in Paris, he has no time to write. But this does not seem to perturb Lévy:

"I've chosen to live like this. I'm not a frustrated person. I've always desired what I do. Of course, the battle of ideas is tough . . . and literary battles are tough. But it's my life and it suits me."

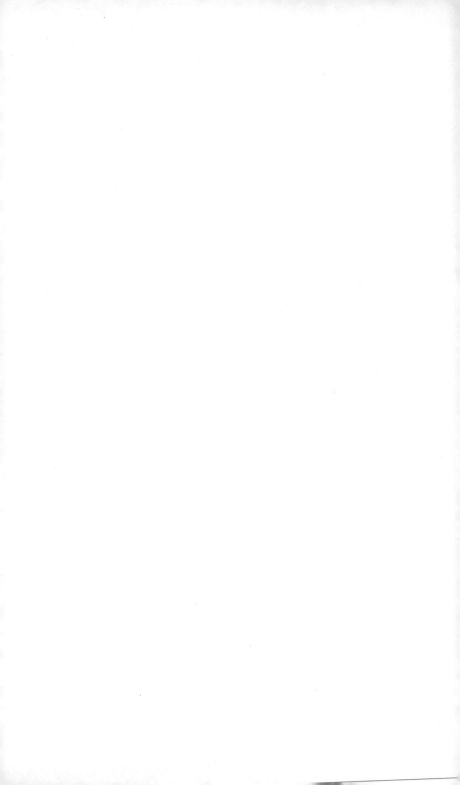

The Sovereignty
of the Writer

Françoise Sagan
Jean-François Revel
André Malraux
Régis Debray

"Intelligence is the capacity to be happy. And I define stupidity as unhappiness and depression. Truly intelligent people know how to be happy," said Françoise Sagan, as we sat, eating croque-monsieurs, in her sunlit home near the Boulevard Montparnasse. Since the publication of her first, best-selling book, *Bonjour Tristesse*, Sagan has continued to write novels that ignore intellectual fashions. She has no interest in the literature of ideas, and no pretensions to write political books. She is a novelist who at times writes plays and screenplays, but her first love is the novel:

"I never start off a novel with an idea, or a theme, or a wish to demonstrate something, or explain something. It always begins with an atmosphere or a rhythm, a particular tone, and characters . . . a very vague physical and moral silhouette of the people. A novel often begins with an image . . . like, for example a juke box with a disk meeting the needle. I began with that image once, which made me think of a person's cheek leaning against a hand. Then, there's a certain smell that can start me off on a book . . . the smell of the earth. Sometimes, even memories of a film I've seen."

Sagan does not decide, in advance, how the characters will behave. She allows them to surprise her and create their own lives: "It's easier to explain what actually happens if I give you a precise example. I wrote a book that takes place on a boat, during a cruise, and in my head, at the beginning there were fourteen people. Half were sympathetic characters and half of them were antipathetic. But by the end of the cruise, there were twelve sympathetic characters and only two antipathetic char-

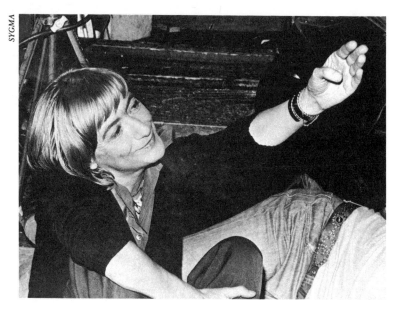

SYGMA

Françoise Sagan directing her first film, *Les yeux de Soie*.

acters. Because, when you write, suddenly the characters say something, or perhaps you think up something funny, and you lend that phrase to the antipathetic person. When you reread the paragraph, you realize that the person has become quite funny and therefore quite sympathetic. I know it's a rather bizarre explanation, but that's how it actually works.

"But at the beginning it's frightful. I always find that I hate everything I write. I throw everything in the wastepaper basket. It's horrible. But the moment one's taken off, after perhaps throwing seventy or eighty pages away (sometimes I've even gone through a hundred pages), then one gets to the other side. There's a kind of demarcation line which one knows one has crossed, instinctively. Then I begin to get emotionally and morally caught up with the people I'm inventing, and living with. But people around you, real people, sense it, and it can irritate them. It's quite normal that they get annoyed with you, because your whole life is revolving around the novel. You

really have to make an effort with your friends, but the writing moments when one is writing for oneself are delicious."

Sagan needs solitude and silence to write, so she chooses to work at night. "Paris is beautiful at the moment. It's superb. I love it in August most of all, because you can see it afresh, without the cars, and the crowds . . . the buildings and the fountains. I get up around noon, since I work late into the night, and I walk. I go here and there. I buy silly little things and clothes. I drive around in my car, and get home by seven. I don't work all the time, but when I'm writing a novel I work at night, and get about four or five hours sleep. I can't work in cafés. And I can't work with the telephone ringing."

Sagan needs solitude, but she also needs confirmation that she is not alone. Solitude is her basic fear, and it has become her subject matter. "The thing that interests me most, the most fascinating and the most terrible thing in life is solitude. And love (and ambition, which I have little direct experience of) remains the only way of combating solitude. That's why I write love stories, but you could just as easily call them stories of solitude."

But being alone need not necessarily imply loneliness. I told Sagan that I was unsure of what she meant by solitude.

"It's the feeling of not having a dog, a child, a man or a woman who takes an interest in you, and cares for you, and someone who can fill your solitude. People tell me that they love being alone, because one evening they'll stay at home and watch television and cancel a dinner. That's not real loneliness. Did you know that seventy-five percent of people who live in Paris live alone? Twenty-five percent are married. But the majority are alone."

I suggested that Sagan might be confusing independence with solitude, and I asked her whether she thought that the capacity to be alone was a prerequisite for love. "Yes. Naturally. There's a confusion between independence and solitude. When people say that they need to be loved, they often mean that they need to be seen. What people often miss most, when a love affair breaks up, is the fact that there is no one to watch them and take an interest in them as they brush their teeth, and walk in the door, and make their phone calls . . . that when they die

there'll be no echo left of their existence. That's the real horror. They feel that their actions don't have any weight unless someone is there. But that's not love. You can live in hatred with someone, and everything you do has an effect on them."

Sagan's notion of existing through the eyes of others, which she contrasts with truly loving another, is pure Sartre. I felt that Sagan was repeating his theory of being seen and existing for oneself (être-pour-soi [being-for-oneself] and être-pour-autrui [being-for-others]), and I wanted to find out how she had come to these conclusions herself. It was quite uncharacteristic for Sagan to use a theory as the basis for her novels. She told me how her attitude to love and solitude had evolved:

"When I was eighteen I had rather naive ideas about love. It took me about four or three years to understand that one can live together and separately at the same time. But it's difficult for me to explain it, because at the moment, I'm not in the right situation to do so. But I think that the need for love springs from the need to be seen. To see one's reflection in another's eyes. It's a proof of existence, seeing yourself reflected. But when I was eighteen I suddenly had so much success, and I saw my reflection in so many different places, and so many people had a precise idea of who I was, be it false or true, or pleasant or unpleasant . . . that I no longer had any desire to see myself reflected in others. I didn't search for myself in others. I wanted to find out about the other person. And from that moment, I tried to understand tne other, and wanted that person's happiness, and I learnt to really share. My success got rid of that show-off side that all adolescents have. I would try to pretend that I wasn't there, so that people would leave me alone and give me some peace. Do you see?"

I pointed out that early success does not necessarily teach people about love, and the capacity to share, nor has it been known to quench people's thirst for further triumphs.

"Yes, I think one starts off with a certain capital of affection. You start off rich or poor. One of Sartre's enormous contributions was to point out that the way a child is loved or not loved has an enormous influence on their behavior and way of loving in the future. When I was an adolescent, going through puberty, I remember that I thought of myself as being rather plain, like

little girls tend to. It wasn't a complex, it was quite normal. Then, suddenly at sixteen, I found a boy whom I liked and he liked me, and all my feelings of being plain were over. After that, all I can remember are books and books and books. . . ."

Sagan feels that she inherited her capacity to write and her capacity to love. "Writing is like a present that was given. I always loved literature. I always loved books even when I was little. And I began writing poems, which were very sentimental—you know how one writes when one's only fourteen—and then I wrote plays which were terribly boring, and terribly long, and then I began to write very small short stories. I'd send them to magazines and they sent them back. And then, I finally wrote *Bonjour Tristesse*. I had always dreamt of being published, of being a writer."

Sagan talks very quickly. She responds to questions with a momentary look of deep reflection, then looks straight at you as she rushes through her thoughts. She rarely disappears into a reverie or a monologue. And she does not lose herself in her thoughts. She constantly tried to find out my responses to all the issues we discussed, not as a way of avoiding being inter-viewed, but rather out of curiosity. She is extremely considerate, and though she had just come in from a dentist's appointment, it was hard to tell that she was in pain. Her liveliness radiates out of her very thin frame and gives her an ethereal quality. Yet her voice is deep and earthy.

"I don't try to give the impression of being different from what I am, but if I'm not in a good state, I try to take on the mannerisms of someone who is in a good mood through a wish to be polite. And quite outside social behavior, I don't want to give the impression that writing is a tragic and painful drama. People have seen so many images of me, that I don't know which one is accurate anymore. But I don't really care. My reflection doesn't matter to me any more."

Sagan has tried many ways of making herself feel happy. She has lived her life in the fast lane, and has often used risk to make herself feel more alive. But the sense of fulfillment that she drew from writing outweighed all other paths to excitement and pleasure: "It's true that I loved speed, nightclubs, alcohol—and I still do, to a certain extent—but at a certain phase in your

life you realize that way of living isn't right for you—but I did pass my days like that. Obviously, I wasn't stereotyped; I always wrote and I adored writing, alone at night. Those pleasures and whims were not the essence of my life . . . that fast life was not my center.

"From time to time, I have a crisis. For four years, I would travel, nonstop. That's gone completely, that need to travel. But I suddenly wanted to see things. I went to India, Mexico, New York, Venice. . . . But now I could spend three years in Paris without moving . . . although I love the countryside. I was born in the country and I know the seasons, and the smells. I love that. And I have a house where I was born, in the Lot, and I go there irregularly, and I have a house in Normandy, and I go there too. I love the poplars. I just sit underneath a tree and look at the wind moving the branches and I think of nothing. I'm not someone who goes to the country to walk or do lots of things."

Sagan now gives the impression of being more at peace within herself. But she still fears loneliness, and unhappiness that arises from solitude. She talks of loneliness as a part of herself, as a mood that defines her inner world. She can placate and soothe her loneliness with friends and activities and love, but it remains, in waiting. When this sadness overtakes her, she tends, however, to criticize herself.

"I feel very guilty when I'm unhappy. I say to myself: 'You're a real fool. You've got a divine life, and there you are feeling sorry for yourself. I get very cross with myself. And when I'm happy, I feel it's quite normal, and I feel innocent. There are people who feel that they have to pay for their happiness, so they punish themselves in advance, so as to avoid being punished by others, as they think they deserve to be punished. But those kind of feelings are alien to me. Perhaps I'm wrong, but I feel absolutely innocent when I'm happy."

"When a man loves you and you love him, you feel so rich with affection. You have such a supply of love, that it's very easy to be unfaithful. But if a man doesn't love you, or if he's making you unhappy, then you can't be unfaithful . . . because you're so unhappy and so trapped and so lost that you feel you have nothing to give and nothing to share. But try and explain that

to a man and he won't understand. I'm not a very jealous person. If someone I love goes off with another woman, briefly, I don't care at all. But if I see him laughing or enjoying himself with another woman it makes me anxious. It's because I'd be frightened of losing him. It's not that I feel that he belongs to me, that he's my possession, not at all. He's free, in my mind. But if he's taking a real interest in someone else, then I might be right in thinking that he'll leave me. I really don't care about brief affairs, because I'm not faithful, by nature. But I find it absolutely awful when people talk about their affairs. It becomes sadistic, under the pretext of sincerity.

"There are moments when I've been very alone. And I've had some unhappy relationships like everyone. But the very worst solitude is illness, and physical suffering. Then, one's completely alone. It's happened to me a few times—operations, accidents, and things like that. When one's facing death, one's completely alone. One doesn't think of one's children or parents. . . . Once I thought I was going to die. I was sure of it for about three hours. It was before an operation. They were sure I had some kind of cancer. So for three hours, I said, 'I will die, but I want to die because if they sew me up again, I'll spend three months dying, and it'll be atrocious.' It had a very strange effect on me. It was very mediocre. I kept saying, 'Well, it's happening . . . it's happening. . . .' I had the impression that I hadn't been given enough time . . . it had all gone too fast . . . and that it was inevitable . . . it's happening . . . now. . . . I wasn't exactly surprised . . . it seemed almost banal."

Sagan's lack of sympathy for her own dilemmas and moments of pain is matched by her deep compassion for others who find themselves in trouble. Her generosity and her willingness to put herself out for other people is well known in Paris. "It upsets me a lot to know that other people are unhappy. There are people who say, 'Oh, it's very sad, but you'll always find people in the world who are down and out.' But my feeling is, yes, it is sad and let's try to do something about it. Let's change it. We have to do something. And that's my primary and emotional definition of my kind of socialism. There are some very sick socialists who say, since there are people who drive cars, and people who have to go by foot, then everyone should have to

walk. No. I want to see everyone having a car. I think I can sum up my political ideas like that. It's a very simple viewpoint, I know."

Sagan believes that poverty creates another kind of solitude, but she has often lost large sums of money gambling and giving money away to help friends in trouble. She feels that to worry about her own security would be to abandon her innocence and her sense of fun. "I'm not very adult. I refuse to take serious things very seriously. Some people get so caught up in adult, serious matters like security and money and organization that they become old in their ordered existence. Finally, I think one's more intelligent at the age of thirteen than at forty. But money is important when you use it as a form of exchange for something you want. I'm convinced that lack of money increases people's unhappiness, particularly people who are unemployed. People who have a job go out in the morning and get on the train with other people, and have lunch with other people . . . and they go home to someone."

Sagan also fears that the modernization of France and the increasing use of technology will make people more lonely. Within the most banal aspects of daily life, she sees, with her novelist's eye, the threat of yet another loneliness. "I like using a travel agent. You telephone him, and you know him. You know the person who organizes your flights. I hate the idea of ringing up a switchboard where someone you don't know or a recorded message answers you. And the French are like that. We like to do things through people. And you know, people won't leave messages on answering machines in Paris. They hate that kind of thing, although I find that quite practical. But I find the automatic side of life very sinister. I love doing things through people."

Sagan sees her novels as a way of making contact with people, and she feels that her work has been popular because her books are not about ideas, but about people. "In Paris there was all that fuss about the nouveau roman [the new novel] and it was very boring. I think my books can be read by a lot of people because they can put themselves easily in the position of my characters. People identify with my characters. Anyone can identify with falling in love, after all. And then, I think I know

when to stop. You can never be sure when you're writing, of course, about the way you should cut short a development. But if you keep going on with an idea—through some kind of sense of honesty—if you like, it can get very boring. You have to be cavalier, and I often feel that my talent lies in cutting, instead of developing an idea to its limit.

"But, in any case, I have a very precise kind of talent. I can't change my tone. I have my own voice . . . so the coherence in my work is almost obligatory. I'm defined by my own limitations. If I were a genius, I could try out all kinds of subject matter, and change my personality, but I can't. I think there's also a coherence in my subject matter, this obsession with solitude and the fragility of human beings."

Recently, Sagan felt inspired to use her writing to undo the wrongs that had been inflicted on a close friend of hers, Jean-Paul Sartre. Her book, *Avec mon meilleur souvenir*, is a collection of portraits of people she has known and admired, and it includes a love letter to Sartre which she wrote before his death. Sartre was much abused in the press before he became a sacred literary figure on his death. Sagan's writing became an act of generosity: "I don't know if you saw the horrifying articles about Sartre? Well, the book began with Sartre. And then I wrote about other people I admire. Anyhow, Sartre's intimate friends began writing about him towards the end of his life, saying that he had become senile. They really said the most vicious things. They spoke of him as an old man . . . who spat into his plate . . . and rambled on meaninglessly . . . there were about five or six atrocious books in this vein. And since I had the opportunity to see him during the last years of his life—I'd have dinner with him every two weeks—I knew he wasn't as they described him. What they said, it infuriated me.

"So I decided to set the record straight. First, because I loved him a lot, and also I hated seeing that image of him. Then I showed what I'd written to someone and they said, 'It's really curious. You're the only writer I know who ever has anything good to say about other writers.' Then I thought about what he'd said, and I decided it would be interesting to write a book about the people I admire.

"I don't know much about Sartre's pure philosophical work,

because I'm not knowledgeable about philosophy. But his main idea, which was that everyone is responsible for his own actions, is an idea that I find to be just. There's a fashion at the moment in France for saying that if someone steps on your toes and insults you, it must be because they're so sensitive. No. That's ridiculous. The reason someone insults you is because they're coarse. Also Sartre believed that people are defined, their essence is defined, by their actions. There are no alibis. Sartre was a humanist. He was the last person to have confidence in humanity, because he had a very optimistic nature . . . and he was generous."

But Sagan feels the Sartre did not have much influence over his generation. She believes that Parisian intellectuals are fickle, and rather facile in their tastes. The current obsession with the dearth of ideologies, and the death of the *maîtres à penser* and *monstres sacrés*, is yet another charade in Sagan's opinion: "They're always having a *'remise en question'*, they're always deciding where they stand on issues . . . then, they decide not to make a stand, and they change their ideology. They say there aren't any more ideologies and that they'll start from scratch. The real action is in politics in France. The real question is whether you're on the Right or the Left . . . and people forget about other kinds of ideologies very rapidly.

"I've never been interested in ideologies, anyway. I don't have an intellectual theory. I believe that the only thing that will survive is the novel. It's Dostoevsky and Proust, not ideological works. Intellectualism doesn't interest me. The moment one has a small amount of intelligence, one can't become fixed on one ideology."

Sagan's confidence and forcefulness came through as she spoke of her love for the novel form and the strength of her chosen form. For much of our conversation, she had spoken quite openly of her sadness, her fear of solitude, and the moments when she found herself to be weak. Yet, as she spoke, she had not seemed vulnerable or weak. There is a down-to-earth resilence about Sagan.

"Intelligence consists in being unsure about everything. If you're intelligent, you can't adopt an ideological stance. You can't be right or wrong about ideas. Obviously, there are moral issues you can be right about, like being against torture. And

you can't join an ideological club, if you're intelligent, because everyone has a different kind of intelligence. But, in Paris, it's always been the same . . . now it's getting worse . . . this social, superficial intellectualism . . . with its literary prizes . . . and its literary fights . . . it's grotesque . . . but it's also the same spirit that brought about the French Revolution." ❖

"It's very important to perceive realities through the eyes of others . . . to listen to conversations in restaurants . . . to watch television in a foreign country. . . . I am in a good position to do this because of the life I have led, and I speak several languages, and that's an advantage," said Jean-François Revel, describing how he researches his books. He believes that it is impossible to come to a just conclusion about a political issue unless one has experienced not only the country in question, but also the way that other nations perceive an issue. Revel has a distaste for abstraction, and always immerses himself in an experience before he will draw a conclusion. He has written many books about the nature of democracy, and the threats to an open society, and he is one of the few French writers who has devoted himself to unmasking dogmas, without feeling the need to create an alternative system of belief.

"It doesn't matter how well informed you are. You cannot understand what's really going on in a country from abstract analysis. You have to read the press, where you'll find a certain kind of sensibility, and a particular way of expressing a problem. I'm not suggesting that everyone should speak four languages, but I have never understood how politicians in France and America can understand politics unless they speak another language. It was part of the education in Great Britain, in the eighteenth century. All the leaders and British diplomats had to speak another language. It's essential to see another point of view that is different from your own. You know, there are intellectuals who live in Paris the whole time. From listening to

them, you would imagine that only *Le Monde* and *Libération* existed in the world."

Revel has tried to see France in a larger context and has rigorously questioned his feelings about his native land. He feels he addresses his books to an international audience and says that his views about France are not colored by the fact that he is French. "I have always looked at France from a distance. As an example, when I wrote *Ni Marx, ni Jésus*, I was referring to a problem that concerned the States, among other countries. And you can't see the States clearly from the vantage point of France. *La Tentation totalitaire* was written for an American and European audience. Remember that in 1975, the year that I wrote *La Tentation totalitaire*, Mao Tse Tung was very fashionable, and people believed in the progressive nature of Chinese communism, and they believed in Eurocommunism. And as for *Comment les démocraties finissent*, I wrote it partly in France, in the States, in Latin America, because I think it is very important not to live in one country when you are writing a book like this. The chapter on Poland was written in the States, and you can tell because of the television programs and newspaper pieces that I quote. But that was not the only point of view I had on Poland. If you look at Poland from the vantage point of Venezuela, you can see that, for them, it is a less important issue."

Revel's opinions are expressed with a polemicist's conviction. But as we spoke I found it disconcerting that Revel prides himself on his opinions; I wondered whether he starts off with an opinion and then finds material to validate it, or whether he draws conclusions only after he has struggled to find a balanced viewpoint. On reading *Comment les démocraties finissent*, I had the impression that he was merely finding further ramifications and arguments to back up his anticommunist viewpoint, but he had not yet come up with any new subject matter. He had made an attempt to find a new area of study where he could reappraise his same cherished beliefs. Revel's repeated criticisms of Marxist ideology and different brands of communism, have led to a misunderstanding. He has often been thought of as being a Right Wing writer. But Revel's anticommunist writings spring from a commitment to socialism and a wish to keep socialism

healthy. He tried to point out to the French socialists the dangers of their association with the Communists. "I have always been and I still am a member of the anticommunist Left."

Revel does not confine his analysis to France. And he also gives warning to the West about the fragility of democracies. Nor does he feel that living in France has made him more sensitive to these issues. He speaks as a European. "I have always said that democracy is an abnormal political system. It's an exception. In Europe, people have found it difficult to maintain a democracy. But that is what I say at the beginning of my book, *Comment les démocraties finissent*. I also say that, nowadays, Western Europe is, for the majority, democratic. And I believe that these democracies are very profound and solid.

"So, as a Frenchman, I am more optimistic, and as a European, I am more optimistic than, let's say, my father could have been. For, if you were living in Europe in 1935, the situation of democracy was tragic. You had Nazi Germany, fascist Italy, Franco's regime was about to commence . . . and you had extreme Left and extreme Right political parties in France and Belgium. . . . When one is European one is much more sensitive to the fragility of democracies. For, apart from Great Britain and Sweden there have been hardly any countries that have not known a dictatorship in recent history. So, it's the first time since 1922 that there is no dictatorship in Europe. It's the first time this has happened for a long time."

Revel's confidence in the stability of current European democracies is not reflected in the tone of *Comment les démocraties finissent*. Revel, as in most of his books, adopts a polemical style. He warns, cajoles, persuades, and, at times, makes one shudder at the "West's baffled impotence in the face of insolent Soviet aggressiveness."* Revel, the diligent researcher, is an impassioned orator. Revel writes as if he is carried away by the force of his emotions. But he is not. Polemical writing is simply the form that he chooses.

"You will find this style of writing in Plato. Take for example the Protagoras, which is a very concise discussion of ideas and

*From *Comment les démocraties finissent*.

theoretical problems. I have also been nourished by André Breton's prose texts . . . or you could take Montaigne or Swift . . . I don't know . . . but, in general, I have been nourished by a type of literature that I call 'the literature of ideas' . . . de Toqueville, for example. . . . It's a form of literary art."

Revel believes that polemical writing, or the literature of ideas, is very similar, in its intentions and essence, to poetry and drama. He asked himself a question, and answered it: "What is literary art? It consists of . . . making certain subjects interesting to people who would not be interested in that subject, normally. When Voltaire wrote *Zadig*, which is a philosophical short story, he wanted to refute Leibniz's idea that we live in the best of all possible worlds. Right? So, he could have done this in a dogmatic theoretical form, and he would have had two thousand readers. But he actually had millions of readers because he used a form of artistic expression which is called 'the pamphlet.' It's a form that crystallizes an idea . . . it is rather like the art of writing a portrait. . . . One writes a polemical work, to a certain extent, as if one were writing a play. A comedy, rather than a tragedy. . . . But above all you have to be certain that your characters are authentic, that the dialogue is interesting, and that the situation works dramatically. . . ."

Revel agreed that he had devoted himself to polemical writing. But he was keen to define the term precisely. "The concept of what is actually polemical is very relative. Firstly, it's relative to the reader. It's also relative to a moment in time. Let me give you an example: Today, what Merleau-Ponty wrote and Sartre wrote have become commonplace. It is no longer polemical. Twenty years ago it was polemical. But that is of no importance. What is important is the quality of your arguments. I am often wary when people call me a polemicist, because there is the assumption that a polemicist substitutes a certain aggressive tone for valid arguments. I actually think that this kind of writing requires more solid arguments than other kinds of writing.

"It's a literary art . . . think of Voltaire, Diderot, Pascal, Swift. . . . It demands more seriousness and documentation than a dissertation. Because you are more open to attack. Let's take my personal case. People have often reproached me, and often

congratulated me, on the aggressive tone of my polemical writing. But no one ever said that my documentation was invalid. Let's take the case of Swift. He starts off with an absurd point of view and takes it to the limit. That's what I tried to do in 1981 in the first three or four chapters of my book, *La Grâce de l'Etat*, in which I criticize the government."

I asked Revel whether he was tempted to write fiction. He had already published a short story in *Pour L'Italie*, and a novel, *Histoire de Flore*.

"Not in the immediate future. I wrote *Histoire de Flore* when I was writing *Pourquoi des Philosophes*. I was still hesitating between writing fiction and essays. Then I found I was inspired by the essay. I think one is probably inspired to do that which one does successfully. *Histoire de Flore* was not an important book. It was an exercise, if you like. It was not a book that came from a deep inner need to write a novel. I did it to amuse myself, but it didn't come from within. It was the era when people felt that to be a writer, you had to be a novelist. It isn't true. Neither de Toqueville nor Montaigne were novelists."

The literature of ideas holds such an important place in France's past and present. "Philosophy" seems to find its way into poetry, drama and novels. And there are glorious examples of writers who have been able to create fully fledged novels and communicate their ideas, like Camus, Diderot, or Malraux. Revel has described how strong the temptation is for a French writer to write philosophical fiction. His decision to remain within the limits of the essay is an honest move.

"In reality, *Pourquoi des Philosophes* represented a much deeper inner voice. I gave myself to the writing of the book completely. On the level of what I really thought, and believed. I don't think one can decide to write fiction. You can never make an abstract decision to write any kind of book, whether it's an essay or a novel. When people ask me what I am going to write next, I tell them that the question has no meaning. If I could explain to you what I'm going to write, there would be no point in actually writing it. If I could explain it in a quarter of an hour, why would I bother to spend five years writing four hundred pages?"

In *Pourquoi des Philosophes*, Revel attacked the dishonesty and

muddled thinking of the current gurus, and, in particular, the structuralists. He did not offer the reader an alternative dogma, and did not propose himself as a candidate for becoming a new *maître à penser*, for he feels intense mistrust of doctrines that provide readymade answers, and rules of conduct or thought. Both Marxism and structuralism offer ways of thinking about an issue without needing to research the facts.

Revel prefers to research an issue and then present it as his passionate conviction. Though he uses techniques to convince the reader, he is careful to emphasize the individualistic nature of his ideas. And perhaps his decision to use an outraged and passionate tone stems from a wish to make it clear that he is presenting a biased though well-researched view. Though he wrote *Pourquoi des Philosophes* while structuralism was in fashion, he is not certain whether his book contributed to the demise of the Modernists.

"In 1957, I had already stated what Aron said in his book, *Les Modernes*. There was an entire chapter against Lacan. I wrote things against Foucault, against Barthes, against the facile use of linguistics, in particular. I wrote the book when they were still active and powerful. When I see that my friend, Jean-Paul Aron, writes a book like this now that they are all dead . . . I would say that Aron's book does not exert any influence . . . it's the product of an evolution. He is a mirror of the times. He didn't discover what he wrote, did he? But it's always the same. Now that Althusser, Lacan, Barthes, and Foucault are out of fashion, people denounce them.

"When I wrote my book, it created a scandal for me. It was a historic event. It was a best-seller and has been reprinted since. Jean-Paul Aron is a good man, whom I've known for a long time. But his book is the conformism of the day. It's very easy to criticize something when it's collapsed. I saw through the intellectual period of the last twenty or twenty-five years . . . and I've often been in a difficult position with regard to Sartre, too, and all those people . . . whom I sensed were not really avant-garde. I sensed something phony about them. So, I realize I sound vindictive. But I actually didn't prevent anything, because the phenomenon died of itself. That's one of the things that is discouraging about the battle of ideas. You

never actually manage to prevent anything, not even in politics. People tell you later on that you were right . . . Well, yes, but has one really saved people from a year of making mistakes? I suppose it wouldn't be too small an achievement, even one year saved . . . after all."

As Revel tried to assess the importance of his contribution, he vacillated between humility and self-importance. When I tried to find out how he assessed some of his political stands, such as his signing of the "Manifeste des Cent Vingt et Un," during the Algerian crisis, I asked him whether he had hesitated before signing, since he must have been aware of the repercussions of such a stand. He gave me a curious look of surprise and he started, rather like a soldier, straightening up and steeling himself for battle. He seemed to be saying that he would never hesitate over a question of principle. Then he proceeded to tell me precisely why the Manifesto was a valid document, and he never once referred to his own courage.

"But of course, it was dangerous. When I'd signed it, I was boycotted. I no longer had the right to talk on French radio. I was sanctioned by the Minister of Education, because I was a teacher at the time. But I've taken risks like this . . . you know when I wrote about the Marchais affair . . . I was physically threatened. . . . But that's not what counts.

"The question of signing the Manifesto was quite simple. Firstly I was persuaded that decolonization was a necessity during the postwar period. The Manifesto was a particular scandal. They would send over soldiers who were doing their military service. Normally, France was not at war, and Algeria was another French department. It was an operation to maintain law and order. And a government does not have the right to mobilize people who are not professional soldiers. They were civilians, and France was not openly at war with Algeria. In my mind, it was a complete imposture. So the Manifesto stated these soldiers' right to disobedience."

I reminded Revel of another of his firm stands on questions of principle. In 1981, when Jimmy Goldsmith sacked Olivier Todd from *L'Express* for publishing material that conflicted with his pro-Giscardian stance, Revel resigned his post as editor-in-chief. Revel said that he did not want to discuss this issue, since

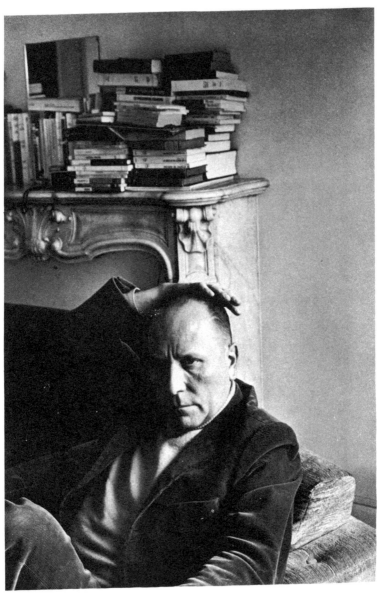

Says Jean-François Revel: "I saw through the intellectual period of the last twenty or twenty-five years; I've often been in a difficult position with regard to Sartre. I wrote things against Foucault . . . against Barthes. I sensed there was something phony about them."

he feared that his remarks could be interpreted as gossip and the actual significance of his fight with Jimmy Goldsmith would be diminished. Yet he returned to the incident later in our conversation and seemed to be relieved to talk about his feelings about his resignation.

"Firstly, my dream in life has not been to run a newspaper. I don't think it's the most important thing in my existence. During the three years that I ran *L'Express*, I was obviously unable to write my own books, because I was too busy. I would have been happy to make that sacrifice if I had been given freedom. And when I talk of freedom in this context, I don't mean the freedom to go against the owner. There have been many Left Wing attempts after May '68 to make out that an owner of a newspaper should have no part in what his newspaper says. I am not of that opinion. That's idiotic. But there is a middle ground.

"For example, let's take an editor of a book. You have a certain harmony. He can give you advice, and you can discuss issues with him; you see him from time to time. You talk to him about your projects . . . he makes suggestions. That's quite normal. But he doesn't intervene in everything you do every second of the day. I think that an owner of a newspaper should take the stance of an editor. But Goldsmith wanted to intervene the whole time. He had a dream. He wanted to have political power, which of course he doesn't have at all. And that's not the way to go about getting political power. I felt, personally, that it no longer interested me to continue working in these conditions.

"Goldsmith should have made himself editor-in-chief, but he couldn't because he didn't have the experience. He needed to surround himself with people like Raymond Aron, and me, and Olivier Todd. I'm not saying that all his ideas were mediocre. He is not a mediocre person, and we have remained on friendly terms. In my view, he should have created his own newspaper, and not bought one that already had a great reputation. I could see that he was using me as a facade, and behind the scenes he would send his henchmen to destabilize me.

"But I would like to relate this incident to a much larger problem . . . which is the problem of the press, in general. You

see, it's impossible to have a state-controlled press because that is totalitarian, by nature. There's no point dreaming of a press that's subsidized by public money. So, the only kind of press that is possible is a private press. That's the first reality. So one has to study, very carefully, how that press can best exist. And I find it passionately interesting subject matter, because part of my life is journalism.

"Let's take for example Jean-Jacques Servan-Schreiber. He was young in the fifties and sixties and had both the money to create a newspaper and at the same time the talent to run it, better than later on, when he wanted to get involved in politics, and that created an equivocal situation. At one point, he used *L'Express* for purely political ends to help him in his political career. . . . It created a problem, but he had more of a right to do it because he had created *L'Express*, and he was a talented journalist. And it's the same with Jean Daniel at *Le Nouvel Observateur* and Perdriel. They are all as tyrannical as Jimmy Goldsmith. The fact that he's a Right Wing millionaire doesn't mean that he's more tyrannical than the Left.

"The issue is not really about money. What I want to show with the Goldsmith affair is that it is part of a larger, general problem. The independence of the editorial staff on a newspaper is a worldwide problem, whether its Augstein with *Der Spiegel* in Germany. Whether it's Murdoch and Evans at *The Times* or Madame Graham at *Newsweek*. And the problem is never dealt with in a rational way."

Revel spoke at length about the Goldsmith issue, which he had at first flatly refused to discuss. I had not prompted him or even mentioned the issue after he asked me to respect his reticence. But he seemed delighted to discuss an issue which he has not yet written up. He spoke quickly, returning to points he had already made, constantly trying to home in on an idea and make it precise. He was impassioned, and yet he was able to assess the situation, not just from his own emotional point of view. He was quite clear about the fact that Goldsmith had irritated him, at times, quite profoundly. For Goldsmith had offered him the editorship of *L'Express* under false pretenses. He had promised him a certain freedom which he had no intention of giving him. But for Revel the issue transcends his

own situation: he sees himself as one of the many editors who have experienced this same problem; then, he becomes excited at the general implications of the issue; he researches similar incidents; he even tries to see the issue from the point of view of Goldsmith. Earlier in the interview, Revel had described how he goes about writing a book. As he spoke of the Goldsmith incident, I felt that I was witnessing the process that he describes. His method of transcending his personal perspective is to imagine a situation through another person's eyes. Revel then admitted that he will be using this incident in a book he is planning to write.

"Actually, the reason I wanted to avoid talking about *L'Express* is because I wanted to put it in my book. I would like to attempt an autobiographical book that is also a book about ideas. I will not simply give one a portrait of the people involved . . . as one might suppose . . . I will link the situation to more general ideas, and not leave events at a simply anecdotal level. One can't isolate an anecdote from its context. It's the context that gives it significance. And I do not want to write about it from a purely personal point of view."

❖

"I wanted to destroy the notion of autobiography. The part of oneself that allows one to say 'I' is profoundly irrational," said André Malraux, who had (just before our interview) published *Lazare*, fragments of the second volume of his *Antimémoires*. One day in the autumn of 1972 Malraux collapsed and was taken to the Salpétrière; two weeks later the doctors diagnosed sclerosis of the peripheral nerves of the brain. He came close to death and encountered "an I without-self; a life without identity."

He considers the fact that he was sitting alive and well, in his country house at Verrières-le-Buisson, as a resurrection. Although *Lazare* is inspired by his encounter with death and intermittently treats the personal experience, Malraux uses it

primarily as a basis for meditating upon dilemmas that transcend the individual.

Both in the book, and in our conversation he speaks of his personal experience with a wry dismissiveness. "When it happened, the first thing I felt was great surprise, and then a certain irony. I would never have thought that death was of such little importance. But I want to stress the fact that we must never forget that physical suffering is all-important. For someone who had suffered physical pain it would have been a completely different experience. It was an event, but it was scarcely suffering."

The particular form his illness took—helplessness, absence of pain, awareness—made him compare the experience to sleepwalking and led him to explore the nature of death from a very singular angle. At the moment when he thought he was about to face the mystery, he lost consciousness; but in the crucial weeks that followed he was in full possession of his faculties. He maintains an ambivalent attitude towards the conflict between consciousness and death.

"I wanted to get across the idea that we can free ourselves from fear of death by attaining the absolute certainty that death is something the mind cannot conceive of. My own death belongs, radically, to the unthinkable. Just as the East believes in reincarnation, so we believe, unconsciously, that we journey onwards in the corpse. What frightens us is that we believe that we will be nothing more than this corpse. And this is meaningless. Here we are the dupes of language. This is much more the case in French than in English. Because in English you can say 'I am dying,' but the French 'je suis mort' is comic. Of course, if you have faith, there is no anguish before death. It is the margin, the vacillating uncertainty of the agnostic, that creates anguish."

Malraux moves outward from his personal experience to consider contemporary civilization and draws a parallel between his situation and the outside world. "Western civilization has been dying since 1890 and yet we're still very much alive. We are the first civilization that has a sense of its own disintegration— because we have never known *decadence*. And why? Before us, dying civilizations would die. But we have become more pow-

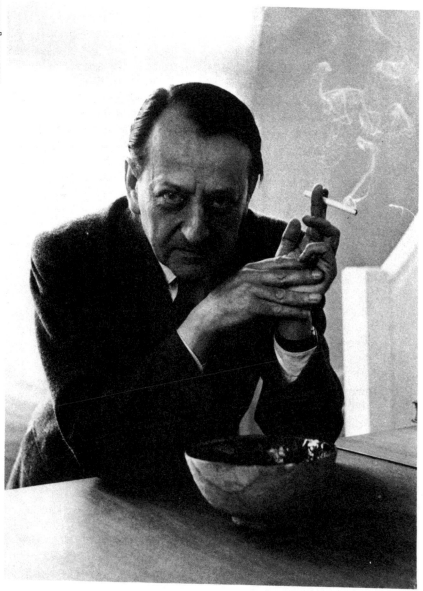

André Malraux's complex, rhetorical way of speaking sprang from a refusal to talk down to people.

erful. It is as if the Roman Empire were dying while still master of the world."

There is a lack of arrogance in Malraux's use of self as microcosm; he only talks of self in order to transcend it. His manner is dignified but completely unassuming. Admittedly, his handling of French rhetoric does not allow one to forget that for more than ten years he was de Gaulle's Minister of Culture. But the volcanic surge of ideas, the intensity that radiates from his person, is barely contained within the language of ordinary discourse. He says that the task of describing such problems is fraught with difficulties. The discontinuity of his speech and his unwillingness to follow a linear argument reveal the complexity and urgency of his ideas and, perhaps more deeply, a rebellion against the limitations of language man has at his disposal.

In *Lazare* he juggled with chronological time, mixing fact and fiction, past and present. In *L'Irréel*, the second volume of *La Métamorphose des dieux*, published in the same month as *Lazare*, he imposes a narrative that describes the temporality and continuity of changing forms of art. This preoccupation with time is reflected both in the titles of the recent art books and in his decision to alter the title of the *Antimémoires* to *Le Miroir des limbes*. "*Les Limbes* means literally the place where unbaptized children go. But in French the word has a certain, ill-defined connotation; it is almost prepositional, something like 'beyond,' 'beyond frontiers,' for example; it also refers to 'the time of the indiscernible.' I chose the title because I wanted to explain *passing time*; the whole book is an attempt to become aware of time as flux."

Malraux has always defined the hero as a man who rebels against his inevitable destiny, in action as well as in words. He tried to embody this ideal in his life. The early art criticism explores an alternative mode of salvation, and in *L'Irréel*, which he began working on in 1957, he returned to this idea. He says that just as no one could understand Proust's *A la recherche du temps perdu* until the posthumous publication of *Le Temps retrouvé*, so it would be impossible to understand fully the meaning of the first two volumes of his trilogy, *Le Surnaturel* (first published in 1957 under the title *La Métamorphose des dieux*) and *L' Irréel*,

until *L'Intemporel* was published. For both Proust and Malraux see in art a justification and a denial of the human condition. "The value of art is that it exists outside time. Only art can give a presence to things dead."

Malraux no longer uses the rebel to embody his own preoccupations. In his autobiography he chooses Lazarus. "The figure of Lazarus is not important in itself. Let us say that it was a useful device. The symbol of Christ is too overloaded with meaning. In Christ you have all symbols all at once (love, resurrection, and so on). The symbol is so vast it no longer symbolizes anything." And the symbol of Lazarus stresses as well the helplessness he felt. In the book memories of past encounters with death and of writing about death as well as real and "false" memories of his period of illness in the Salpétrière seem to impose themselves on the author, bringing him tantalizingly close to the mystery but always receding when he comes too close. *"A l'instant de basculer (j' avais quitté terre) j'ai senti la mort s'éloigner."*

Personal experience gives the book an incisive, naked quality. None of his previous meditations on death is quite as powerful. For the rhetoric stands in awe of the subject matter and even at its heights comes close to understatement. Malraux says that the subject of the book is the fundamental difference between metaphysical speculation about death and death itself. "The word *trépas* expresses the fact of being killed; *la mort* is our metaphysical notion of being dead. For me, the gap is enormous. But I believe that we can somehow rid the notion of 'being killed' of its metaphysical implications."

In *Lazare*, Malraux constantly attempts to approach the fact of dying, trying to go beyond the living man's speculations about death. Paradoxically, he maintains that his own death belongs to the inconceivable (*l'impensable*) and that this notion alone was able to free him from the fear of death. Lazarus lives on the very frontiers of consciousness, straining to go beyond, while knowing that the limitations of the human condition makes this an impossibility.

Leaving Malraux in the quiet of his country house at Verrières-le-Buisson, I had the feeling that the young man who had

rebelled so vigorously against the limitations of life had been resurrected in order to fight a fresh battle against the most fundamental limitation of man's estate.

André Malraux died on the 23rd of November 1976. He was given a hero's funeral. President Valéry Giscard d'Estaing presided over the ceremony and sent a personal letter of condolence to Malraux's daughter, Florence. Françoise Giroud, then Secretary of State for Culture, was in charge of the funeral arrangements. She chose Beethoven's "Funeral March for the Death of a Hero" to be played during the ceremony.

De Gaulle once said that when he died everyone would become a Gaullist. He had also predicted Malraux's fate: The French turned him into a national monument. The governmental pomp was misleading, for Malraux was not a party to the establishment. He was a loner and a thinker who entered government out of a feeling of respect and admiration for General de Gaulle. Malraux's feeling for de Gaulle was reciprocated, and the President gave Malraux an opportunity to put some of his theories into practice. Soon after their first meeting in June 1945, de Gaulle appointed him "technical advisor" to the General as Malraux recounts in his *Antimémoires*. Then, in November 1945, Malraux became Minister of Information. But when he was asked to stand as candidate for the Rassemblement du Peuple Français in 1951, he refused. Malraux only went back into the government when he could work alongside de Gaulle. In 1959, when de Gaulle was returned to government, Malraux became Minister of Culture. When Pompidou was elected in 1969, Malraux was not part of the new government. In 1971, he published *Les Chênes qu'on abat*, in which he describes his last interview with de Gaulle.

His daughter, Florence Malraux, told me that her father had enjoyed the respite from his political duties. He was free to devote himself to his passion, which was writing. During the last years of his life, he wrote continuously. In 1974, he published three books, *La Tête d'obsidienne* together with *Lazare* and *L'Irréel*. In 1975, *Hôtes de passage*, and in 1976, *L'Intemporel*. In 1977, *L'homme précaire et la littérature* was published posthumously.

General de Gaulle (second from left) next to André Malraux at the Mexican exhibit, Paris, June 1961. Malraux entered into government out of a feeling of respect and admiration for General de Gaulle.

Florence Malraux told me that she was particularly thankful that her father never lost his lucidity during his last years. He remained unafraid despite the repeated menace of death. The ideas that he stated concerning death, during our interview and in his books, were the basis of his way of facing approaching death.

Simone de Beauvoir criticizes Malraux in her journal, *Tout compte fait*, for avoiding life. "To look at an object and say honestly what he had seen was an activity that was too modest for his tastes: instead of confronting it, he flees. . . he always has to *think*—about something else. . . . When he's in the presence of Mao, he is *thinking* about Trotsky. When he's in Cairo, he *thinks* about Mexico, Guatemala, or Antigua, or he *has* thought about the beautiful baroque city of Noto. . . ."

Though Simone de Beauvoir's criticism of Malraux is witty and striking, it seems strange for her to criticize a writer for

attempting to describe his response, and his vision of an experience. She presupposes that a writer can actually convey pure facts without a viewpoint. De Beauvoir paints the portrait of a man who lapsed into rhetorical grandiosity.

But his complex, rhetorical way of speaking is not mere rhetoric, for it sprang from his refusal to talk down to people. Malraux did not try to convince me. He respected the interview form, and gave it his best. He had asked me to prepare a list of questions and send them to him. When the interview began, he took out my piece of paper, on which he had made notes, and proceeded to answer each question in turn. I realized that he had responded to my preparatory work in kind.

Florence Malraux also pointed out that Malraux's secrecy in his writings about the details of his personal life, and his refusal to write any form of confessional literature, was borne out in his daily reticence. He would hesitate to use the pronoun "I" when he spoke. He preferred to refer to a situation directly, often eliminating the idea of "self" which he associated with narcissism. He enjoyed dialogue, as I discovered when I met him at Verrières-le-buisson. But he also used it in his books as a way of expressing the complexity of an issue.

Florence Malraux explained that Malraux never changed his highly complex style of speaking to make himself more comprehensible. At times, she found it amusing to see her father discussing an idea with people who could not comprehend him. His refusal to tailor his ideas to an audience sets him apart from Sartre, who always hoped he would be comprehensible to the "proletariat." Malraux would not tailor his ideas to the fashions of the intellectual establishment. His tremendous unpopularity among the intellectuals was proof that he had no interest in becoming a literary monument.

But there were some valid reasons behind the hostility that many intellectuals felt towards Malraux: I did not ask him about his attitude towards May 1968 and the student uprising; Malraux interpreted the events that spring as a sign of "nihilism" rather than a desire for reform. Nor did we discuss his attitude towards the use of torture by the French military in Algeria. Malraux was Minister of Information and refused to accept the authenticity of *La Gangrène*, a book documenting the evident practice

of torture by the French military. When Sartre and other writers signed the Cent-Vingt-et-Un Manifesto, asking Malraux to waive the ban on this book, he replied by attacking Sartre personally: He pointed out that during the Occupation Sartre had never been part of the Resistance, whereas he had made a stand and had been captured by the Gestapo. I did not ask Malraux about his participation in the Resistance either. His political decisions in the past, which were at times courageous, and at times regrettable, had already been made.

His actions during the Algerian crisis and his position had estranged him from many people, including his daughter Florence, who had signed the Manifesto protesting France's involvement in Algeria. But Florence Malraux looks back on those days with some regret too. She now feels that the political passions of Parisian literary life are destructive to the participants. She renewed contact with her father soon after the Algerian crisis, and became aware of the importance of her affection for her father, which had been trivialized by their differing political stands. As Florence Malraux spoke about her own career in journalism (working for *L'Express*) and in films, she made it clear that her father had never exerted any pressure on her to conform to his ideals. She created her own style without feeling that she was living in the shadow of a great man.

Malraux did not hide behind his words. Despite his rhetoric and his legendary reticence about himself, I found him to be an accessible man. ❖

Régis Debray was sitting in his office in the Elysée looking disdainful and extremely bored. I had arranged to meet him the day before he was to leave the Elysée for another post which, as he had stated in the press, had "no political significance." This was quite true. Debray's career had always been a problem for his friend, President Mitterand, because of Debray's guerilla past in Bolivia and his continuing outspoken

resentment of anything American. But the French have the capacity to honor their rebels and eccentrics, and recently, since the death of so many of their *monstres sacrés*, they are searching hard for new genius. Régis Debray was seen, by some, as being the next in line of succession to André Malraux, and there are some evident similarities between the two writers: Both Malraux and Debray accepted jobs in government because of their friendship and respect for the Presidents de Gaulle and Mitterrand, respectively. Both found themselves in prison, early on in their careers, because of their activities abroad.

Malraux's adventure occurred in 1923. He had lost a large sum of money on the stock exchange, and decided to go on an "archeological" expedition to Cambodia. He concocted the idea that he was being sent on a mission by the Minister of the Colonies, but it seems that the Minister knew nothing of the authorizations that Malraux acted upon. Malraux and his wife, Clara, hacked off several sculptures representing the guardian goddesses of the temple at Banteai Srey. They made their way back to Phnom Penh, where they were arrested for stealing national monuments.

Malraux wrote up the incident in *La Voie Royale*, and then he wrote up the trial in Phnom Penh in *Les Conquérants*. He protested that the sculptures were not landmarks, and was sentenced to three years in prison. But the French intelligentsia came to his rescue. André Gide, Mauriac, Max Jacob, Aragon, and the publisher, Gallimard, intervened. Malraux returned to Paris, together with his wife.

In 1967, when Régis Debray was imprisoned in Bolivia for participating in the Bolivian Communist guerilla movement, André Malraux and Mauriac and Sartre intervened. Debray was accused of entering Bolivia illegally and of organizing the communist insurgents. He was sentenced to thirty years in jail. Debray said that he was merely writing an article about the Bolivian guerilla movement. During his stay in Bolivia he had managed to get an interview with Che Guevara, but he would not, of course, disclose to the government the names of the people who had helped to organize the interview. Debray, and the French press, pointed out that it was ridiculous for the Bolivian government to assume that Debray was a Bolivian Fidel

SYGMA

Régis Debray with his friend, President François Mitterrand, during the electoral campaign, April 1981. At the time, Debray was assigned to cultural affairs and third world dossiers at the Elysée.

Castro. The young intellectual had merely intended to be on the spot to witness the revolutionary process at work. Eventually, Debray was released, after three years in prison.

I asked Debray whether his experience of prison had any reverberations on his outlook. He was fiddling with his tie, and with his other hand, he began rocking an empty chair, at his side, backwards and forwards. These were not the gestures of an anxious man, but of a man who enjoyed the bizarre.

"When Mao Tse Tung was asked what he thought of the French Revolution, he said it was a little too soon to tell. In fifty years, perhaps I'll have an idea of the mark it made on me, being in prison."

"I would have thought that time in prison would change your outlook radically. But perhaps I'm searching for something that isn't actually true in your case."

"No," replied Debray. "You are right. Time spent in prison makes one see the vicissitudes of daily life with a sense of distance. It gives you a humorous, sceptical attitude towards the irritations of social life and the things that go wrong in one's career. You become detached, and you can see beyond. And no doubt I have a preference for solitude and introversion, which is not a bad thing in times such as the ones we're living through."

I told Debray that he did not seem to be withdrawing from public life. After all, he had accepted a job in government.

"I'm completely absent from public life. I have never been part of public life. I am committed to working for the defense and blossoming of the French identity. Because I am a patriot. I love my country and I would like to see France remain afloat. But is it really a commitment? Yes, as a citizen. But not politically. It's certainly not a political commitment."

Debray was perhaps referring to the fact that his governmental post had not given him the power to put his ideas into practice. As Olivier Todd explained, "When Debray got into the Elysée, the diplomatic circles were up in arms. I don't think they actually let him deal with many dossiers. And the Americans were not very happy about his appointment. Not only the Americans, but also the French police, because people were asking what his relations with Cuba are. He keeps on suggesting that people are members of the CIA, and one wonders why is he so concerned about other people's affiliations with secret services? But I don't think he's important politically, in any way."

Debray was quite honest about the fact that his government post had been a waste of time: "I've actually wasted my time on things that have no importance, things like passion, anger and trivia . . . which is how I define politics. I wrote two novels too quickly . . . and one serious philosophical book which was much too serious for the public, *Critique de la raison politique*, published by Gallimard three years ago. Those are the only interesting things I've done recently. The rest is without importance. You can become completely devoured by the ephemeral."

I asked Debray whether he had, in fact, worked on third world issues, and for a short time on cultural matters.

"Ah, you believe what the papers say," replied Debray.

"No. That's why I'm asking you the question."

"Yes. That's quite true . . . one always has to question what the press says, particularly when they tend to report lies and sordid fantasies. You have to check on the reality. I quite agree. I took care of cultural affairs here, for two months, while my friend Guimard was away. As for the third world, I have no idea what the term means. I suppose it's the world, minus Europe."

"And America."

"Minus the OCDE [Organization for Economic Development and Cooperation], minus the twenty-four richest countries in the world. Minus the northern hemisphere. No, I dealt a great deal with international affairs, sometimes including the third world and the Soviet Union, but all that is just politics . . . and sometimes strategy. Now strategy, which is a question, the key question to war and peace, it is the relationship of power . . . that's to say there's a military element . . . a question of life and death . . . it has that element which is lacking in ordinary politics. And so, strategic questions, or rather, political military questions interest me a great deal. Actually my next book will be on that subject. But it's not a book that contributes to my personal body of work . . . it's a sort of political document. A diplomatic document."

I asked Debray whether he was joking when he said that politics were no longer of interest to him.

"No, it's not a joke. Domestic French policy doesn't interest me in the slightest. Politics only interest me when there's real fire . . . what I mean is that I'm interested when I'm face to face with the unacceptable, when the devil is knocking at the door. But that's not the case in France. That being said, I love my country and I've always had a sense of certain danger. I had this feeling in 1981, that France would disappear in banality, and anonymity, let's say, in an attitude of liberal chic. And I wanted to work on foreign policy, which seemed to be the key to the singularity of my country."

Debray's interest in military strategy and the excitement that he derives from "the fire" of life and death situations, led him into the maquis in Bolivia. He disdains his own sedentary contribution to politics at the Elysée, and seems also to despise the undramatic and unromantic ways of bringing about change.

Strangely enough, this writer of numerous political tracts, seems to place more importance on direct action than on discussion or writing. Debray does not see himself as an intellectual. I asked him, then, if he sees himself as a writer:

"I would like to see myself as a writer. Yes, I would very much like to see myself as a writer. But to do that I must first begin to write seriously. And one must not let oneself get caught up in political passions. It's very dangerous for a writer, except if he's a pamphleteer, like Maurice Barrès, or others like Jean-François Revel. He's a pamphleteer with a political passion that possesses him entirely, more than Benjamin Constant, or even André Malraux. In principal, Revel has no power. Politically, he is nothing. But in reality he understood that if you are an intellectual, the real power nowadays resides in the media. I have absolutely no power in the intellectual milieu, no writer depends on me to publish his book or to write a sensational criticism of his book or invite him to appear on television. Intellectuals depend on Jean-François Revel much more than on me."

Debray has written several books on the power of the intellectuals in France, like *Le Pouvoir intellectuel en France* and *Le Scribe* (1980).

"I'm an ascetic and an exile in comparison to these people. In the intellectual milieu things do not depend on administrative or political power. They depend on Bernard Pivot, on television, and Bernard-Henri Lévy at Les Editions Grasset. Because he is the person who decides whether a book will make one hundred francs or a hundred thousand francs. There is a power play going on in the intellectual milieu which the intellectuals refuse to admit to. They prefer to attack power with a big P. That's to say, they attack us at the Elysée although they do not depend on us, and we exert no power over them. It's a phantasmagoric alibi that they use, and actually I have found more serenity and self-abnegation and detachment among the ministers here than in the milieu of writers and essayists who are all marked by their nervousness, their love of intrigue, and their obsession with themselves . . . and with the influence that they do or do not exert on others."

Debray was one of the few writers and "intellectuals" to agree to join the government. Most of them reproached President

Mitterrand for his complacent attitude towards communism, and they decided not to accept his offer of a job. Michel Foucault was rumored to have been nominated as a cultural advisor on the United States, and he flatly refused. Gilles Deleuze, the philosopher, said that he wanted to devote himself to writing and was unwilling to give his time to politics. The union of Left Wing intellectuals and the socialist government which Mitterrand had hoped for proved to be a myth. I asked Debray whether these intellectuals were in fact pointing to the necessary conflict between being a writer and an independent thinker and joining the government.

"Listen, there are many fools who say that writers never have political positions, and that by definition a writer is a pariah and a marginal, passive type who lives in the catacombs of his attic. All that is pure myth. People are forgetting Chateaubriand, who was Minister for Foreign Affairs, and de Toqueville, and Lamartine, and Hugo and Saint-John Perse and Giraudoux and Malraux. And numerous other writers like Claudel, who was an ambassador, a deputy, and an administrator who ran an important public administration. There are many writers who have never achieved anything in their lives, and who live a bohemian existence, but all that is not serious living. There is no metaphysical problem about being a writer and working in government. It's merely a question of having enough discipline. Claudel divided his day in two. He would stop short in the middle of a phrase of one of his plays when twelve o'clock chimed . . . because at twelve he closed his study door, and said 'I am now serving the state.' And he would pick up his notebook the next morning at seven o'clock. That is discipline."

The strong tradition of writer-politicians that Debray describes reflects the deep respect that the French feel for their writers. They entrust their poets, novelists and philosophers and playwrights with the responsibility of guiding their country. And, with the advent of television, they have now turned their writers into stars. I asked Debray why the French have maintained this faith in writers and intellectuals.

"The intellectuals have always had importance in France since the eighteenth century. They have a power which they have never exercised in any other country. In the States, an intellectual

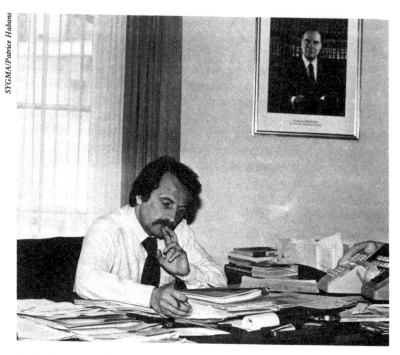

"The intellectuals have a power [in France] which they have never exercised in another country," said Régis Debray, shown working in his office at the Elysée.

is considered an 'egghead,' which is a pejorative term. In England, too. In France, it's completely different. Because France sees herself as a world power that will promulgate the universal values of *Liberté, Egalité, Fraternité*. Only a writer can imagine himself as another, and only a writer can think on behalf of other people. Only a writer can act on behalf of humanity with a big H. A naval officer or an industrialist or a metallurgist cannot think on behalf of humanity."

Debray drew the clear distinction between writers of imaginative literature, and intellectuals. Although he has not yet achieved his ambition of being a writer, he feels that he has avoided becoming an intellectual. In France, writers are often

confused with intellectuals, and intellectuals are often mistakenly thought of as being serious writers. For Debray, the difference is obvious:

"People like Bernard-Henri Lévy are stars. Firstly, because they have an ego which needs satisfying . . . and the job of the intellectual is to exercise an influence on the way other people think. So the actual vector of influence is in the media, nowadays. All the intellectuals are in the media. A few centuries ago you would have found these same people as preachers at Notre Dame, because that was where the action was. Tomorrow, if being in the circus is where the action is, they'll learn how to do a flying trapeze act. These are not people who produce a body of serious work. They are people who want power. Stendhal did not exert any influence on his contemporaries. He wrote books. He created a body of work."

I pointed out that so many French writers had studied philosophy and had used their philosophical training in their fiction: Sartre and Simone de Beauvoir both studied and taught philosophy; both Debray and Bernard-Henri Lévy were Normaliens who had studied under the Marxist philosopher Althusser. I asked Debray why so many would-be writers started off their careers by studying philosophy. Does a French writer feel that philosophy of some sort must enter into his fiction?

"Yes, that's true. In comparison to the English, who are much more concrete and novelistic, the French (in my opinion) have always cultivated the literature of ideas, and the literature of morals, and fiction with a message. It's a weakness, and a characteristic of French culture. One can mention Benjamin Constant, and certain books by Camus that are, in essence, apologies or fables. That's to say, that there is a moral in the story. Many French novels, have, in filigree, running through their texture, a sort of message or idea, like *La Peste*, by Camus.

"But to answer your question about why so many French writers feel obliged to study philosophy, well, it so happens that literary studies are much less creative and much more directive, than philosophical studies. You know you will be able to express your own personality and your own orginality if you choose philosophy, which is taught in a much less academic and scholarly way than literary studies in France. And French philosophy is

much less academic and scholarly than German or English philosophy as it is taught in universities. It's taught in a more literary way than in England or Germany. Here you find a mixture of literature and philosophy that coincides with the French mentality. Most writers who are at university or at the *grandes écoles* know quite well that they would not be given an opportunity to express their own opinions if they studied literature. The professors ask you to do an *'explication de texte'* or to do a dissertation on a historical aspect of a book. It's not an appetizing thought for someone who wants to express an opinion or, later, hopes to invent his own stories."

Debray does not feel that his philosophical training is an obstacle to writing novels. But he admits that there is an obstacle. Why would a man who dreams of being a novelist devote himself to writing a vast number of books about his theories? Debray blames his passion for politics.

"I don't believe there is any difference between the message one is communicating and the novelistic description. In every description there's a message, even in Balzac. You'll find Balzac describing a dining room for ten pages, which contains a philosophical message. He is telling you that a man is his milieu, and that to understand the human animal you must describe the environment he lives in."

But I have often felt that the constant intrusion of philosophy into fiction is an impasse that a French writer has to confront and transcend. As Olivier Todd says:

"A lot of people feel that poetry is a short cut to philosophy, and that, I think, is a disaster. The idea that poetry must be intellectual, that poetry must be understood and not felt. All that contributes to the drying up of the literary scene in France. It's only very recently that some writers are allowing themselves to have a novel with a story and characters. The public accepts it but the literary establishment doesn't. France in many ways is too old. It's an old country with traditions, but its traditions are not useful for a poet. They're institutional traditions. In France there's an a priori idea of what poetry is. And that's fatal. And French literature is not as lyrical as the United States' is."

Writers like Debray and Jean-François Revel and Bernard-Henri Lévy talk of their literature of ideas with the confident

belief that they are following in the tradition of Voltaire and Diderot. For these Parisian writers, as for many Parisians who do not write, the authors of the past are talked of as if they were still alive. Over dinner, people discuss Chateaubriand or Racine as eloquently and knowledgeably as Debray does. The past is not a hindrance to a French writer. Debray's imagination is fired by the examples of a Chateaubriand or Claudel, and the example of Claudel, in particular, seems to help him to face his wearisome days at the Elysée.

"Imaginative literature, in my view, incorporates a writer's experience of a reality that he has experienced. He transposes it into fiction so that the reality can become more alive, attractive, and disturbing. Nowadays, there's so little French fiction that I ask myself whether it is because there is so little French reality, and such a paucity of French history nowadays. When I think of a work of the imagination, I always think of a book that speaks about current realities."

Debray blames the intellectual Mafia, or the "*intellocrates*," as they have been nicknamed by the Parisians, for the lack of genius. And he also blames the lack of life and death situations and dramatic events in recent French history. But this is his particular subject, and one can be thankful that contemporary France does not have such dramatic material to write about. The response of the government to this lack of poets and playwrights and novelists has been to fund the arts more generously than any previous French government.

Since 1959, when de Gaulle and Malraux came up with the idea of a Ministry of Culture, the figure of one percent of the budget was considered by the Minister of Culture to be a goal and a touchstone for government spending. But that goal was never reached. In the sixties, the budget for the arts vacillated around .40 percent. In the seventies, it oscillated around .50 percent, reaching .55 percent in 1978. By 1981, most of the government spending on the arts was diverted to the Centre Pompidou, which meant that the actual spending was around .48 percent. Mitterrand decided to spend .76 percent of the budget on the arts, and he also hoped to include writers in his government.

Mitterrand has a deep sympathy and respect for writers and

is himself the author of several books. But many intellectuals feel uncomfortable about linking themselves with any government. Understandably, they fear that they might be expected to align themselves with the government's policies. Debray, perhaps because of his friendship with Mitterrand, states that he sees no conflict between writing and holding a government post. "Since I am a friend of Mitterrand, I wanted to join him in this house."

Olivier Todd points out that Debray's job allows him the time to write, and gives him a certain financial security, both of which are helpful to any writer of fiction: "Mitterrand will make sure that Debray has a cushy job long before anything happens to the socialist government. Debray, at the moment, doesn't know what's going to happen to him after the elections of 1986. He needs a monthly salary. Where does he go? What normally happens to people like Debray is that there are a lot of nominations before the elections so he's secure."

But it remains to be seen whether one can create genius by funding. And though the Parisians worry that the immediate lack of a Voltaire or Camus reflects a sickness or weariness in their society, I have seen no signs of a diminishing enthusiasm or vivacity among the French writers and intellectuals.

But the socialist government's desire to involve itself in every aspect of culture has some very negative undertones, and implications. As Jean-François Revel pointed out, it is impossible to maintain a free press if newspapers rely on government funding. The press in France is free, but the debate over the state control of television continues and points to an issue that does have some bearing on writers as well as television journalists. Is it possible to maintain true freedom of expression if one is funded by a government? Debray diverts attention from this issue by attacking the "Mafia" of intellectuals who "monopolize" cultural activity. Debray accuses Bernard Pivot, the host of *Apostrophes*, the extraordinarily popular literary chat show, of somehow controlling the media. Debray overlooks the fact that the public chooses to watch Pivot's program. Debray also accuses the media of encouraging "American imperialism."

"The media represent the American viewpoint in France. The programs are made by people who spend half their time in

America. They absorb Amercican ideas, and the American
criteria for selecting news. The French have begun to see
themselves through the eyes of the Californians . . . they now
think of themselves as little Frenchmen with Basque berets, the
loaf of bread . . . they see themselves as rather provincial idiots.
That's the fault of these journalists. But, added to that, the
intellectuals are also becoming like journalists. They're com-
pletely Americanized. They always adopt the views and the
fashions of America. They want to become American. They talk
of liberalism, and of being cosmopolitan . . . and they love
Reagan. Did you know that France is the only country in Europe
that voted for Reagan in the opinion polls?

"America is drowning France . . . on many levels, and in areas
where one cannot even perceive the deep imprint of their
politics. This drowning mechanism is based on the value of the
dollar, and on the exportation of technology. Often the pur-
veyors of American culture have tried to state that the interests
of France lay in a certain direction. But, in fact, they really
meant that it was in the interests of America. When we wanted
to help the Nicaraguans, when we wanted the right of existence
of a Palestinian state to be recognized, the speech that Mitterrand
made at Cancun in Mexico in '81 was well received by the
militant Left Wing, but it was criticized by the French intellectual
milieu. And so was Jack Lang's evocation of the imperialism of
American culture. The intellectuals are always against us, be-
cause everything that is anti-American is seen as dangerous.
But now I must make a confession. I don't give a damn about
intellectuals. I don't care what they think."

As Debray moves rapidly from a discussion about the media
to France's involvement in Nicaragua, one begins to see the
inevitable application of politics to culture. Underneath so many
Parisian debates lies a volcanic political passion. Debray cannot
see that France's ability to assimilate new ideas and technology
from the United States is a sign of flexibility, and a resilient
openness to change. For Debray the issue is political, and his
Marxist roots cause him to feel a gut reaction of hostility towards
America.

Both Debray and Jack Lang, the Minister of Culture, are well

known for their heartfelt attacks on the States, which they are then forced to retract when the government tells them that they have gone too far. Lang greeted an international conference of writers, including some celebrities from the States, by talking of the imperialistic intentions of American culture. Debray publicly retracted his statements about Pivot's "dictatorship," offering the excuse that he had been rambling on over a late dinner. He stated that his feelings were not representative of the government's view.

It is almost impossible for a writer to keep himself apart from the intense political debates. Debray says that he longs to rid himself of his political passions which have wasted so much of his time. He wants to write novels, but he continues to churn out learned diatribes against the intellectuals. Olivier Todd, who does not have the burden of a Marxist past, nevertheless feels obliged to make a stand when he is faced with Debray's attacks on the media's freedom of expression.

"I found Debray's criticism of Pivot extremely suspicious, because all he really wanted was for TV to be controlled by a bunch of state apparatchiki and commissars. And I felt I had to say something. I attacked Debray very heavily. I published a piece in *Le Matin*, defending Pivot. Because I think the Pivot phenomenon is very important and very interesting. When I got to other countries I realized that his programme is probably the best literary programme in the world. And when British publishers see it they are flabbergasted. I have taken part in several of his programmes, either for my books or to question Kissinger with Françoise Giroud or to talk about Naipaul. And Pivot is actually very honest. People have attacked him for using writers from the main publishing houses, but when people get down to the figures and work it out accurately, they find that he's actually been very fair in his choice of guests. Pivot cannot be influenced. But I think it's pathetic that an ex-guerilla like Debray is given a government job. It's like being given a title and money and no work to do. It's absurd. But I will give him one thing, he did manage to get that Cuban poet Armando Valladares out of jail."

Public debates among all these writers are conducted on an intensely personal level. Debray attacks Bernard-Henri Lévy for

SYGMA/*Pavlowsky*

The boat-hospital *Ile de Lumière*, chartered by The Boat for Vietnam Committee, leaves Pulau Bidong and picks up over 800 boat people in the South China sea. Bernard Kouchner, founder of the Médécins du Monde (*bottom right*), was the instigator of this project, which reunited many warring intellectuals.

being an egomaniac. Olivier Todd attacks Debray for being a guerilla who is living off the state. Montand rings up the editor of *Le Monde* to complain about an editorial that has insulted him.

But the writers and the theatre and film people and the philosophers have often put aside their enmities and their political differences when faced with a serious issue that requires a humanitarian response. Malraux and Sartre, who had insulted each other publicly for many years, did come together to sign the petition asking for Régis Debray's release from his Bolivian

prison cell. And an array of prominent Parisians managed to form a team that launched the *Ile de Lumière*, the ship sent to rescue boat people from the South China sea in 1979. Yves Montand announced the project on television. Sartre met with Raymond Aron for the first time since their dispute over their political differences of opinion. Olivier Todd devoted himself to the project, and Simone de Beauvoir did not hesitate because of her dislike of Todd. Brigitte Bardot and Roland Barthes were among the first to support the voyage. Bernard-Henri Lévy rang Mitterrand to get his signature, but Mitterrand refused. Bernard Kouchner, the instigator of the project, and the founder of Médecins du Monde, had few refusals. But he was disappointed by Debray's reaction. Though Debray was a friend, he refused to sign, as did the Trotskyite communists and the extreme left faction of the Socialist party.

The main problem that writers face is that Paris is so bursting with political debate and activism that it is hard to find time to write. Bernard-Henri Lévy exiles himself from France when he wants to write a book. Debray cannot seem to stop himself from defending his political theories. Olivier Todd finds himself spending most of his time writing in his home in the South of France. Françoise Sagan writes at night, so that she does not have to miss out on her beloved walks around Paris. Jean-François Revel spends a great deal of his time abroad, researching and writing his books. Filmmakers complain that they are constantly wasting their time having lengthy lunches with prospective film producers. Parisians are always tempted to discuss their ideas and indulge in the living art of talking. And Paris has the beauty and the life that lures her artists away from their work.

INDEX

About the Author:

British writer Melinda Camber Porter is a woman of remarkable versatility: a journalist, poet, painter, and novelist. She graduated from Oxford University with a First Class Honors in Modern Languages and then moved to Paris to write for *The Times* on cultural affairs.

Her journalism and poetry have appeared in a wide variety of publications internationally, including *The New Statesman*, *The Observer*, *The Times Literary Supplement*, *Le Monde*, and *The Partisan Review*.

She is the author of several novels and has just completed *Badlands*, set in the Pine Ridge Reservation in South Dakota. A collection of her poetry and paintings, *The Art of Love*, was published this year.

She is now based in New York, where she lives with her husband and son.